Dürer

THE ARTIST AND HIS
DRAWINGS

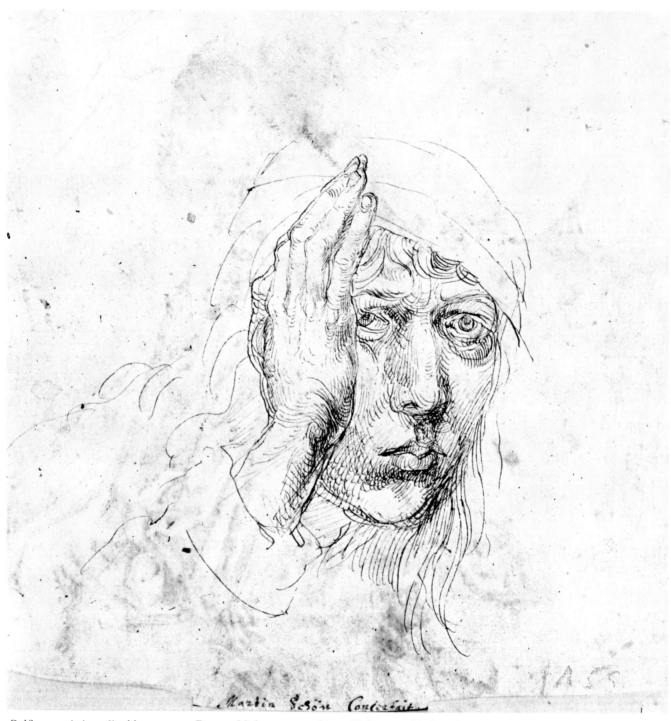

Self-portrait (w.26). About 1491. Pen and ink. 204 × 208mm. Erlangen, University Library

CHRISTOPHER WHITE

Dürer

THE ARTIST AND HIS DRAWINGS

PHAIDON

PHAIDON PRESS LIMITED
5 Cromwell Place London SW7

First published 1971
© 1971 by Phaidon Press Limited
ISBN 0 7148 1436 9

Printed in Holland by
Drukkerij de Lange/van Leer NV, Deventer

Contents

To John Steer with affection

List of illustrations

Plates

Other works by Dürer and works by other artists

The author and publishers would like to thank private owners and directors of museums and galleries who have kindly allowed works in their collections to be reproduced. They are also grateful to all those who have provided photographs.

Biographical summary

1471	May 21. Born at Nuremberg, the third and eldest surviving child of Albrecht Dürer, goldsmith, and Barbara Holper.
1486	November 30. Apprenticed to learn painting under Wolgemut, with whom he remained until 1489.
1490	April 11. Starts on *Wanderjahre*, visiting Colmar (1492), Basle (1492/3) and Strasbourg (1493/4).
1494	after May 18. Returns to Nuremberg. July 7. Marries Agnes Frey. Autumn/Winter. Travels to Venice.
1495	Returns to Nuremberg.
1498	Publishes the series of woodcuts of the *Apocalypse*.
1502	Death of the artist's father.
1504	Engraving of *Adam and Eve*.
1505	(late). Leaves Nuremberg for Venice.
1506	Completes the painting of the *Feast of the Rose Garlands*. Visits Bologna.
1507	January. Leaves Venice for Nuremberg.
1508	Completes *Heller Altarpiece*.
1510	Publishes the series of woodcuts of the *Large Passion*.
1511	Completes the *Trinity* for Landauer, and publishes the series of woodcuts of the *Small Passion*, the *Life of the Virgin*, and the *Apocalypse* (2nd edn.).
1512	Begins work for Emperor Maximilian.
1513	Engraving of the *Knight, Death and the Devil*.
1514	Engravings of *Melancolia* and *St Jerome in his Study*. Death of the artist's mother.
1515	First experiments in etching, including *Christ on the Mount of Olives*. Granted pension by Maximilian.
1517	Visits Bamberg.
1518	Visits Augsburg at the time of the Diet, where he made portraits of some of the famous present, including the Emperor Maximilian.
1519	January 12. Death of Maximilian, who is succeeded by Charles V. Summer. Brief visit to Switzerland with Pirckheimer.
1520	July 12. Leaves Nuremberg on Journey to the Netherlands, visiting Cologne, Antwerp (twice), Brussels and Aachen. In Aachen attends coronation of Charles V and receives renewal of his pension.
1521	Visits Antwerp, Bruges, Ghent, Malines, Brussels and Cologne. July. Returns to Nuremberg.

1525 Publishes the *Teaching of Measurement* in four books.

1526 Completes the two panels of the *Four Apostles*.

1527 Publishes *Treatise on Fortification*.

1528 April. Dies at Nuremberg, and is buried in the 'Johannes-Friedhof'.
Publishes the *Four Books on Human Proportion*, the last two posthumously.

The catalogue numbers in the text refer to works by Bartsch (B), Lippmann (L), Panofsky (P), Tietze (T) and Winkler (W), details of which will be found in the Selected Literature on page 225.

14

Introduction

'WHAT SHALL I SAY of the firmness and accuracy of his hand? You could have sworn that what he drew without other means than the brush, pencil or pen, to the immense astonishment of his beholders, had been drawn with rule and compass. What shall I say of the sympathy which reigned between his hand and his ideas, so that often on the spur of the moment he dashed off, or, as painters say, composed, sketches of every kind of thing with pencil or pen?'

This appreciation of Dürer's mastery of the art of drawing was written a few years after his death in 1528 by Camerarius, a close friend of the artist, in his introduction to the posthumous Latin edition of *The Four Books on Human Proportion*. A panegyric was clearly called for on that occasion, but nevertheless these words of praise do not strike us today as being in any way exaggerated. The tribute to the artist's precision of hand with its implied tribute to his precision of eye appear to us just and deserved. The artist's wonderful certainty, in whatever he is drawing, immediately delights the eye and provides the same kind of sensuous pleasure as that which a virtuoso musician produces, whether he is merely playing the scales or involved in a highly complex fugue. He has a real professionalism, without any suggestion of fumbling towards the truth, which becomes moving in itself, whether he is drawing a few cubes, an area of hatching or a sublime subject such as *Christ in the Garden of Gethsemane*.

Dürer's remarkable powers of expression in drawing give him a unique position, not just in Germany, but throughout Europe. Thanks to his innate curiosity and wide interests as well as his abilities as a creative artist, his drawings give us a more intimate and rounded portrayal of the artist and his times than can be gained from the work of any of his illustrious contemporaries, with the possible exception of Leonardo. German drawings of an earlier date are few in number and limited in scope. Without them our knowledge of the artists concerned would not be greatly impaired. Even the drawings of Schongauer, who can be regarded as Dürer's spiritual predecessor, are basically dull in the narrowness of their range; he appears to have limited his work with the pen to studies of heads or single figures, or very occasionally compositions. These are essentially working studies and do not enlarge our understanding of the artist's personality beyond what can be learned from his prints and paintings. There are no self-portraits of his family, no records of journeys or of things which interested him outside what he could use in his art. The artist himself, his tastes and his personality are veiled.

By contrast Dürer was almost the perfect embodiment of the age of humanism. Whereas earlier artists largely accepted the tradition of their time and were content to practise their art within its conventions, Dürer was highly conscious of the concept of originality: for him, the good artist was one who 'pours out new things, which had never before been in the mind of any other man'. A constant search for the new idea or an unnoticed facet of life provided a stimulus to him until the end of his days, earning him the praise of Lomazzo, who wrote that Dürer had 'more invention than all the other masters put together'. For Dürer, a deeply feeling and enquiring man, the

world started with him, and his thoughts and actions radiated out from this central point. He combines a strong element of self-absorption with a cool detachment, which succeeds in avoiding the purely narcissistic and adds up to a portrait of the person and his age. He was born with a desire to learn and to observe the world around him which intensified with the years. The interests of his mind and the eye struggled for his attention, so that we are presented with a panorama of life virtually unrivalled in its width in the whole history of art. In scientific enquiry he must yield pride of place to Leonardo, while in intensity of noble feeling and grandeur he does not equal the achievements of Michelangelo. But in everyday humanity and humanism he projects himself more vividly, and in no medium more consistently or more illuminatingly than in drawing. Drawing quickly became a complete language to him. No thought or visual impression occurred to him which did not find its way onto paper. Even such a remarkable document as the journal he kept on his visit to the Netherlands is complemented by the drawings he made at the time. What he thought, what he did, what he saw, all found expression on paper, so that it is to his drawings that we turn for a complete understanding of the man and the artist.

Dürer appears to have found painting a struggle. His control over the brush was too tight and he seems to have been unable to relax and feel his way into the medium of oil paint. He was constantly in the grip of a perfectionism which forced him to continue working on a painting as if he were completing a copperplate. Only for one short period during his life, when he was inactive as a printmaker and under the spell of Venetian painters, did he relax and show a true feeling for the medium of oil paint. Otherwise it was drudgery, and this possibly explains his reluctance to undertake new commissions. We may guess it was not just mercenary considerations but a temperamental difficulty and the need to overcome it which prompted his claim that engraving was more profitable to him than painting. A day to be spent on a copperplate or a woodblock was faced with pleasure, whereas the completion of a painting was regarded with less equanimity. Allowing for the fact that he was dealing with a difficult client (whom he wished to impress with what he had done for him) and was trying at the same time to excuse his delay in delivering the painting, his letter to Jacob Heller about the altarpiece of the *Assumption* is deeply revealing: 'No one shall ever compel me to paint a picture again with so much labour . . . Of ordinary pictures I will in a year paint a pile which no one would believe it possible for one man to do in the time. But very careful nicety does not pay. So henceforth I shall stick to my engraving, and had I done so before I should today have been a richer man by 1000 florins.

As he implies and as the results vividly show, printmaking came naturally to him. In his time he experimented with all methods—woodcuts, engraving, etching and drypoint. While his paintings for the most part were limited to conventional religious subjects or portraits, his prints gave him the opportunity to expand and express his enormously wide interests. The woodcuts of the *Syphilitic* (P.198) and the *Rhinoceros* (B.136), the four cuts of the artist using a perspective apparatus to draw different models (B.146-9), the engraving of the *Monstrous Pig* (B.95), and the etching of the *Cannon* (B.99), all show his new spirit of enquiry. Though he had a tendency to conceive certain subjects in a particular medium—such as, for example, humanistic iconography in engraving—his prints display the natural originality of the artist. He was free to express his thoughts, without outside constraint. In execution his prints aim at a polished perfection that may appear cold to some of us today. We greatly admire his achievements but we may initially find difficulty in reaching complete empathy. Only when we turn to the drawings can we freely and immediately appreciate

the mind of the artist. It is his drawings which make us his true admirers and, armed with a knowledge of them, we gain a new understanding of his prints.

If Picasso could boast that he was able to draw like Raphael at the age of 16, Dürer could claim to be the equal of Rogier van der Weyden by the time he was 13, as the remarkable *Self-portrait* in silver point (Plate 1) proves. This immediate desire to draw can be seen again in quite a different kind of drawing, the free chalk study of a *Woman with a Falcon* (w.2), which a contemporary inscribed with the words: 'Albrecht Dürer did this for me a long time ago, before he went to learn painting in Wolgemut's studio [i.e. when he was 15], on the upper floor in the back building'. The display of virtuosity impressed the recipient of the drawing so forcibly that he felt moved to record exactly where the event took place. Both the drawing and the inscription convey the young Dürer's intense desire to draw, and from then on for the rest of his life he constantly had a pen or chalk in his hand, whatever may have been occupying his mind. Painting and printmaking were at different times dropped and then taken up again, but hardly a day can have passed, even on his journeys, without his putting pen or chalk to paper. Today more than a thousand of his drawings exist and they probably only represent a fraction of the total.

As well as being directed towards artistic ends, drawing became a part of everyday communication at every level. One self-portrait (w.482) shows the artist naked half-length, with the forefinger of the right hand pointing to a circled area on the stomach: at the top Dürer wrote, 'the yellow spot to which my finger points is where

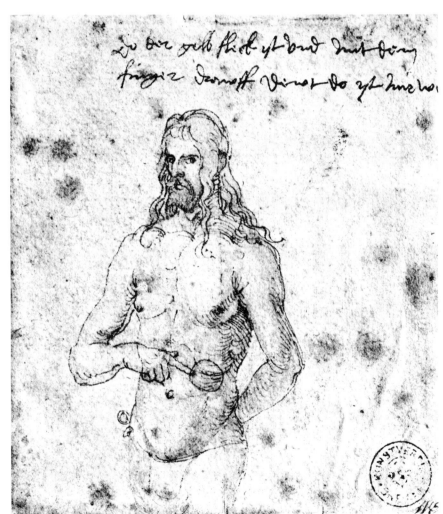

Dürer Ill (w.482). About 1510. Pen and ink with watercolour (original size). Formerly Bremen, Kunsthalle

it hurts me'. This sketch, as Panofsky has suggested, was probably done as a method of consulting a doctor who was absent from Nuremberg. On another occasion Dürer made a careful design of a shoe (W.938) for his shoemaker to execute. On a more intellectual level the astronomer Niklaus Kratzer wrote to Dürer in 1524: 'I want you, dear Herr Albrecht Dürer, to make a drawing for me of the instrument you saw at the Pirckheimer's, wherewith they measure distance both far and wide'—an exchange foreshadowing the communications between Rubens and various scholars of a century later. Even the artist's letters written to his friend Pirckheimer from Venice were accompanied by sketches and hieroglyphics. Drawing became a means of conversing as well as of thinking. Yet unlike some artists Dürer was equally fluent in writing as well as speech. His extant letters and his Netherlands Journal show a considerable command of language, while a nearly contemporary description reveals the artist as far from tongue-tied: 'Dürer was an excessively subtle disputant and refuted his [i.e. Pirckheimer's] arguments, just as if he had come fully prepared for the discussion'. He shows a rare literary and artistic eloquence, which allowed him to give free rein to his thoughts. In other respects Dürer may have been frustrated, but on an intellectual level he was completely articulate.

Dürer looked upon his drawings with the same devotion that he gave to his prints. Indeed their uniqueness probably made him even more chary of handing them out as gifts. The elaborate monograms he often added testify to his belief that a drawing was not invariably just a stage in the working process, to be cast aside when the work in hand was completed. Though many of his extant drawings are working studies, there are an equal number of others which are personal records of things seen or thought of, to be carefully stored away until needed. And in addition there are numerous drawings which must have been considered as much finished works of art as any painting or print. To drive home the value he attached to his drawings, he frequently inscribed them with details about the subject, either at the time or at a later date. Other artists from time to time annotated their drawings but none with the regularity of Dürer. This practice underlines his sense of personal history, which encouraged the desire to enlighten posterity, whether he was keeping his family chronicle or carefully annotating a drawing sent to him by Raphael. He was keenly aware of the future, as when he wrote, 'Would to God it were possible for me to see the work and art of the mighty masters to come, who are yet unborn, for I know I might be improved!' And just as he was thinking of them so he wished 'the mighty masters to come' to be as fully informed as possible about him. His portfolio of drawings provided both him and posterity with a visual record of his own past. His first self-portrait (Plate 1), just mentioned, was carefully inscribed by the artist with full details at a later date. The portrait of his mother shortly before her death (Plate 63) was inscribed at two different times. On other occasions he would dip into his portfolio, sometimes to annotate a sheet, and sometimes to use it or part of it for a work of a much later date. The landscape of the *Pupila Augusta* (Plate 19) was used more than twenty years later for the engraving of *St Anthony* (see p. 72); the marvellous watercolour of a *Horse and Rider* (see p. 148) was clearly the starting point for the engraving of *Knight, Death and the Devil* (see p. 148), even though fifteen years separated them. Many examples far less separated in time occur where a drawing made for its own sake was later adapted to a subject in hand. The study of a *Nuremberg Woman Dressed for Church* (Plate 22), used in a woodcut a few years later, provides further testimony of Dürer's devotion to his drawings. The existence of an almost exact autograph copy of this watercolour suggests that the artist was unwilling to part with the original to a would-be purchaser, and was

forced to make another version for him. The first version, with two others in the series, remained in the artist's possession until his death, after which they were acquired by the Imhoff family. This collection, which included drawings of all periods, as well as some of the most famous, is important as giving a very good indication of what Dürer carefully put aside and kept. The drawings provided his ever increasing capital, which he took good care never to squander.

Earlier German drawings, including those by Schongauer, were exclusively executed in pen and ink, but in the first two drawings made by Dürer which have come down to us he had already turned away from conventional practice. The use of silver point in the *Self-portrait* (Plate 1) was probably the heritage of his father's years with Flemish artists, but the black chalk employed for the *Woman with a Falcon* (w.2) of almost the same date already suggests a certain independence. During the next years, probably encouraged by his masters, Dürer turned to pen as the predominant method of drawing. On his return to Nuremberg in 1494 from his *Wanderjahre* he started to use watercolour and body-colour (see Plate 10), which he had learnt to apply with a true feeling for the medium by the following year on his return from Venice (see Plate 11). Under the influence of Venetian art he learnt to draw with the brush as well as the pen; the *Female Nude* (Plate 9), executed in Venice, was started with the pen and completed with the brush. Increasingly after his return to Nuremberg he came to master the brush not just for laying in the washes but for the actual drawing of the outlines, as in the study of a *Greyhound* (Plate 21). The watercolour of the *Hare* (Plate 23) shows his virtuosity in controlling the brush even more vividly, and it was probably drawings such as this that led to the incident between Giovanni Bellini and Dürer on the latter's second visit to Venice, when Bellini begged to be given one of the special brushes he assumed the German must use to achieve such remarkable results, only to be presented to his amazement with an ordinary brush. During his second visit to Venice Dürer produced some of his most luminous brush drawings, such as the *Female Nude Seen from the Back* (Plate 45) and the studies made for the paintings of the *Feast of the Rose Garlands* (Plates 42–44) and *Christ among the Doctors* (Plates 40 and 41). These gained in colouristic effect by the use of blue Venetian paper, as well as extensive application of white body-colour. The year before he left for Venice, Dürer had started to use prepared coloured paper, in, for example, the *Green Passion* (Plate 37) and the *Self-portrait in the Nude* (Plate 28). This practice continued on his return to Nuremberg, as the beautiful brush drawings for the *Heller Altarpiece* on prepared paper (Plates 48 and 49) show, but from then on with a few notable exceptions—such as the four studies connected with the painting of *St Jerome* (Plates 85–88) carried out in the Netherlands—the brush was less and less in demand.

Though chalk had been employed for the very early study of a *Woman with a Falcon* (w.2), it was rarely used in the early years. Some time later Dürer appears to have caught sight of some of the large charcoal drawings of heads and figures by Grünewald, and in 1503 he executed two large portraits of Pirckheimer and his wife (Plates 26 and 27) in the same medium. From then on chalk or charcoal was frequently used for portraits, most notably on his journey to the Netherlands, as well as for figure studies. He also used chalk as a method of lightly sketching in either the compositions or the figure, over which he would work in pen or brush. Silver point or metal point was occasionally employed from an early date, as in the study of an *Angel Playing a Lute* (Plate 17) of 1497, but it only came into its own during the artist's journey to the Netherlands, when initially practical considerations connected with travelling may have suggested its use. Quite apart from the album executed entirely in silver point it was

employed on numerous other portraits and studies, and was used again after his return to Nuremberg for a number of portrait studies, such as that of *Frederick the Wise* (Plate 97).

As in other fields Dürer was always ready to experiment and to try out any new material which came to hand. But though at one time or another he practised all the various techniques of drawing, undoubtedly the pen, either with brown or black ink, was his favourite instrument. Only during the second visit to Venice did it yield pride of place to the brush. Otherwise whatever other media he was employing, he constantly turned back to the pen, and during his last years it almost became his exclusive method of drawing, whether he was executing marginal illustrations to his theoretical manuscripts or drawing a composition. The pen's precision and simplicity matched his increasingly severe mood, and more generally he found it possessed much the same quality as the burin, which, whatever other techniques he might try out, remained the method of printmaking which answered his temperament most exactly. The abstract qualities to be gained from an area of hatching are to be found equally in lines drawn with the pen and the burin.

At the centre of the world of Dürer stands the artist himself, and it is symptomatic of the man that he should have chosen to reveal himself quite plainly in a number of self-portraits executed at different stages of his career. These exercises in intimate analysis were unique at the time. Though other artists had depicted themselves as spectators in a composition, none had elevated the self-portrait to such an exclusive genre. Moreover, the drawn self-portraits provide us with an intimate survey of the artist's state of mind, to be equalled only by Rembrandt a century later. Both artists seem to acknowledge by this practice that the man himself was at the centre of his art.

Characteristically Dürer's first drawing is a *Self-portrait* (Plate 1), and throughout his life he and his family were of intense interest to him. In addition to the portraits he made of his family, he wrote a Family Chronicle, as well as 'the other book', known today only in a fragment, which gives further details of his family history. He was deeply conscious at all times that posterity would be interested in him, and, with his general neatness of mind, he wished to leave as much information as clearly expressed as possible. In his almost obsessive habit of annotating his drawings, he reveals himself as one of the first true cataloguers of works of art. In maturity Dürer picked out his youthful silver point self-portrait, and carefully inscribed it with the words, 'This I drew of myself in a mirror the year 1484, when I was still a child'—information totally unnecessary to the artist, but an important step in the chronicle of his life. The portrait reveals Dürer's unusually precocious curiosity about himself from an early age. The angelic innocence constrasts vividly with the melancholy tortured aspect of his next two self-portraits, done about 1491 (Frontispiece) and about 1493 (Plate 6). The three drawings are a telling illustration of the loss of innocence and the painful process of growing up.

Ten years elapsed before the next self-portrait (Plate 28), which shows an adult calm and detachment. His aspect may be severe, but no one but a fool grins at himself in the mirror. This self-analysis is all the more remarkable in the way he depicts his whole body naked down to the knees, and not just his head. No other artist of the time or during succeeding centuries has portrayed himself without clothes. Yet as Dürer took stock of his physical well-being there is an objectivity about this intimate revelation which removes it from the realm of self-indulgent narcissicism. It jolts the spectator in the same way as coming face to face, in the nude, with someone one knows well for the first time. Nearly two decades later, in 1522, the year after his return from the

Netherlands, Dürer made another drawing of himself in the nude (Plate 98), this time as the *Man of Sorrows*. As Panofsky has shown, such a representation was far from blasphemy and more an act of devotion. But clearly it required no great effort of will for the artist in his present spiritual and physical state to identify himself with Christ's sufferings. His physical presence is less disturbing than in the previous drawing, but his emotional state, revealed through his physical condition, is the moving and profound image he wished to convey.

Other reflections of his state of mind are to be found in drawings of other themes, such as the *Head of Christ Crowned with Thorns*, of 1503 (Plate 29), with its expression of deep spiritual torment. Beneath the drawing he wrote, 'This face I have made for you . . . during my illness'. Inspiration probably came not only from his own illness but also from the prevailing atmosphere of unrest. The latter, combined with the artist's own experiences at the recent outbreak of the Plague, undoubtedly put him in the mood to produce that grim haunting drawing of *Death on Horseback* (Plate 38) of two years later. But where his own state of mind is concerned, undoubtedly the most remarkable and revealing drawing is the record he made, twenty years later, of a dream (Plate 102) of 'how many great waters fell from heaven', which he not only drew in watercolour, but described in detail in words below. Until the age of Freudian psychoanalysis, there can be few such insights into the human mind. And what is particularly remarkable is the mixture of imagination and scientific observation, in which he studied himself as his own patient.

The severity of Dürer's appearance in all these drawings might seem to suggest that he was of a perpetually gloomy disposition and had a morbid self-interest. Though there was a strong strain of melancholy in his character, combined with his deep engagement in the troubled atmosphere of the times, he was not devoid of humour and gaiety. His heartfelt outbursts at the news of Luther's supposed murder, the feeling reaction of anybody to the assassination of somebody they revere, is balanced by the remainder of the Netherlands journal—in which he expressed pleasure and interest in all that he saw and in all that was done to entertain him—and, earlier, by his playful letters to Pirckheimer from Venice. Camerarius summed up his character: 'He was impelled with intense earnestness of mind to purity of morals, and to such a mode of life as justly earned for him the reputation of the best of men. He did not, however, affect either a gloomy severity or a repulsive gravity; on the contrary, throughout his whole life he encouraged, and in his old age showed his approval of, everything which he thought could produce pleasure and delight'.

Those around him were also studied and chronicled with the same spirit of detachment. However close the subject of his drawing might be to him whether it was his wife or his mother, he retained a supreme ability to scrutinize accurately, undisturbed by personal feeling. He drew Barbara Dürer during her last days (Plate 63), not as you might affectionately look upon your own mother who had led a hard and suffering life, but as an interesting specimen of an old woman facing death. It accompanies the clinical description of her reactions during her last hours given in the second fragmentary 'Family Chronicle', in which he notes down the exact occurrences during her last anguished moments on earth. One part of him was in mourning for his dying mother while another was coldly analytical. And, as if to forestall the observations of a detached spectator looking at this hideous old woman, he writes, 'in her death she looked much sweeter than when she was still alive'. The drawing was inscribed at the time it was made and then again shortly afterwards, when she had died. His very accuracy of observation in the drawing provides the framework for which the spectator

can, if he wants, provide the suitable sentiment. For the artist there was no difference in his attitude between portraying his suffering dying mother and studying 'the hale and hearty 93-year-old' (Plate 85) in Antwerp.

A similar observation can be made about the much earlier sketch of 'mein Agnes' (Plate 7), as she sits, hand pressed against her mouth, deep in thought. Such a charming drawing argues a warmth of affection which the events of their life together seem to belie. And if one is touched by this intimate 'betrothal' portrait, one should remember that immediately after their marriage he went on a long journey, leaving her in the midst of a plague-stricken city. In later years (Plate 78) she is calmly compared to a pretty young housewife from Cologne, providing a telling portrayal of youth and age, without giving any indication that one sitter had shared his life for the last twenty-seven years, while the other was a model or chance acquaintance of only a few hours' standing.

Dürer's friends are also paraded before us 'warts and all'. The grossness as well as the intelligence of his intimate friend Willibald Pirckheimer is plain to see in the two portrait drawings done in 1503 (see Plate 27), and even more so in the engraving (B.106) of twenty-one years later, where the face has become heavier and coarser. And to the delicate silver point study (W.286), which catches the rolls of flesh on the sitter's face, Dürer added a clinical homosexual observation in Greek, possibly taken from Aristophanes, which Brigid Brophy has freely interpreted as an exhortation, 'up boys and at 'em.' Dürer's desire to record the appearance of those he liked or admired was expressed very clearly in a letter: 'if ever I meet Dr Martin Luther, I intend to draw a careful portrait of him from the life and to engrave it on copper, for a lasting remembrance of a Christian man who helped me out of great distress.' The reference to Dürer's own feelings will not be missed. In the event, although he must have met or at least caught sight of Luther at the Diet of Augsburg, he never had an opportunity to portray him. Nevertheless he gave his features to St John, who was Luther's favourite evangelist, at the foot of the Cross in a drawing (W.859) made for the uncompleted engraving of the *Crucifixion*. He had better luck in meeting another of his heroes, Erasmus, but the results were not entirely successful, as the sitter and probably the artist were aware.

Yet another aspect of the artist's activities, which is both highly revealing of his own character, and almost unique in the history of art, may be called 'Dürer the traveller'. He was not only more widely travelled than any other major artist of his time, but also undertook journeys in an entirely new spirit. As Michael Levey put it, 'All Dürer's journeys were in search of knowledge and "secrets"; he was always travelling hopefully rather than arriving.' Donatello, Leonardo, Michelangelo and Raphael may have moved from one Italian city to another, but the *raison d'être* was nearly always either an actual commission or a search for work. Even Leonardo's journey to France was undertaken at the behest of Francis I, and he left us little reflection of what the journey meant to him personally. Dürer, however, was an inveterate traveller, who was always prepared to undertake a journey largely for its own sake, even though a reason might be found for encouraging this decision. His *Wanderjahre* were of course the conventional practice of the times, yet he seemed to wander further and longer than his contemporaries. Both visits to Venice were given a certain encouragement by the outbreak of the Plague in Nuremberg, but this was clearly not the main reason for them. Never once does Dürer refer to the Plague in his letters written to Pirckheimer on his second visit to Venice. And finally, though the visit to the Netherlands was given a fillip by his desire to meet the new Emperor in order to obtain the renewal of

his pension, this was merely an excuse, albeit a relevant one. His travelling undoubtedly reflects a keen sense of *Wanderlust*, combined with an intense curiosity to observe the different aspect and way of life of other people and countries. Even the simplest, most down-to-earth feature of another land appealed to his curiosity, and in the same way that his remarkable and imaginative spirit of independence fired him with the idea of breaking with convention and publishing his own books, so he was inspired to set off on journeys in a mood of creative exploration and discovery, whether his object was to see new things and places or to meet and consult people.

Some of this desire to see the world must have come from the very nature of Nuremberg itself. Today the prosperous provincial city is a shadow of its former self. In Dürer's time it stood at the centre of the trade route in Europe. All goods reaching Venice from India and destined for northern Europe passed through Nuremberg. In addition it was a thriving manufacturing town on its own, busy exporting to eastern Europe. The constant traffic to and from the city must have greatly widened the horizons of its citizens. They could not but be daily aware of the existence of other cities and other countries. And matching the activity of trade was the intellectual atmosphere. Even without a university Nuremberg was rapidly becoming a centre of learning, attracting distinguished scholars from all over Europe, who in their turn stimulated the patricians of the city to undertake studies of classical literature or astronomy. At one time it was the centre of mathematical studies in Germany, an interest which was echoed by Dürer increasingly in his later years when he became absorbed in theoretical studies. Something of the excitement of what was going on beyond the perimeters of the city must have communicated itself at an early age to Dürer.

Apart from the cosmopolitan atmosphere in the city itself, the artist's desire for knowledge beyond what was immediately required for his art, led him to build up contacts and make friends with a wide circle of scholars. Undoubtedly letters between such men as Kratzer in London and Dürer must have existed. In order to further these relationships, the artist had every encouragement to move around Europe. And in doing so, drawing was the natural means of recording his impressions and developing his ideas *en route*. Printmaking was entirely reserved for Nuremberg, while paintings were occasionally executed outside his own studio, when he went on longer journeys. But drawing remained a constant activity, though the kinds of studies he made varied from place to place. They were dictated by the needs and interests of the moment.

Unfortunately none of the drawings which can be certainly connected with his *Wanderjahre*—when he visited the cities of Colmar, Basle and Strasbourg, and conceivably went as far as the Netherlands—portray the people and places he saw, even though they reflect the works of art he studied. He was too busy learning the fundamentals of art to cast his eyes around more widely. It was on the first visit to Venice, which he undertook only six months after he had returned to Nuremberg, that his independence as a trained artist suggested a new approach to his art. Probably on both the outward and return journeys he made watercolour studies of the towns and landscapes he passed on the way, a habit he had already started, if the two landscapes of the *Wire-drawing Mill* (w.61) and the *Johannisfriedhof* (w.62), both of which are situated near Nuremberg, are correctly dated within the six months prior to his departure. But a very marked difference can be seen between these two watercolours and those that Dürer made on the outward journey, such as the view of the Castle Courtyard in Innsbruck (Plate 10), and the drawings made on his way back to Nuremberg, such as the views of Trent (w.95–97) and the Alpine Landscape, inscribed

by the artist '*welsch pirg*' (Plate 12). Instead of the variety of local colours used at first which served to isolate each part of the landscape, Dürer restricted his range of colour, laying it on in thin translucent washes of watercolour, with far less use of body-colour. The result has a coherence and width of vision, combined with a marvellous feeling for light, which are lacking from his first studies of landscape. It was as if a soft haze fell below the artist's eyes, muting the hard clear northern light. The inspiration for this change of vision came without doubt from the landscapes he saw in the backgrounds of paintings by Cima and Giovanni Bellini. And back in Nuremberg Dürer continued his studies of the scenery around him in such watercolours as the '*Weiherhaus*' (Plate 11), the *Willow Mill* (Plate 13) and the *Lake in the Woods* (Plate 14). Back home north of the Alps the local colours may have intensified but his sense of poetry and comprehension of the whole vision before his eyes did not leave him. On the contrary he imbued the scene with a depth of feeling which would not, for example, make the *Lake in the Woods* out of place in an exhibition of Romantic art. And his knowledge of landscape came to be expressed in other media, perhaps never more overpoweringly than in the panoramic Alpine scene which stretches out beneath the figure of Nemesis in the engraving of about 1502 (B.77).

But what did the artist do in Venice apart from look at the works of art around him, an activity which we can determine by the impact of what he saw on his own work? Our impressions of his interests are unfortunately scrappy. Though he made landscape studies on the way there and back, Venice to our knowledge was not portrayed by Dürer. Nor on this visit did he execute any portraits of the people he met. A *Female Nude* (Plate 9), a highly important exercise containing the seeds of style and interests of years to come; some costume studies, including that telling comparison between the women of Nuremberg and Venice (W.75); a few studies of Orientals; some copies after works of art, such as the *Female Rape* after an engraving of Pollaiuolo (W.82) and probably the copy after Mantegna's *Battle of the Sea Gods* (Plate 8); a sketch of a Venetian house (W.93); and watercolours of shellfish—these represent the sum total of his interests on this occasion.

'That which so well pleased me eleven years ago pleases me no longer', wrote Dürer to Pirckheimer when he was back in Venice in 1507. And the drawings he has left us on this occasion reinforce these sentiments. Instead of the curiosity value of Venice with its different costumes, its oriental inhabitants and its marine life, it was the art of the city and a different kind of art, as Dürer's remark specifically shows, which engaged the artist's attention. And his activities during the two years were largely concentrated on absorbing this change and offering his own interpretation of what he saw in the painting of the *Feast of the Rose Garlands* (see p. 116). Giovanni Bellini may 'still [be] the best painter of them all', but he had changed also, and Dürer was privileged to witness the early stages of what was possibly the most exciting evolution in Venetian art, when Bellini took on a new lease of life in old age, producing paintings of great originality, and Giorgione and Titian were about to emerge into the limelight.

The drawings Dürer made were for the major part studies for the pictures he was engaged on during his stay, above all the large altarpiece of the *Feast of the Rose Garlands*, commissioned by the German community in Venice for the church of San Bartolomeo. But in addition to this preoccupation with painting, the second Venetian visit also saw the real beginning of the artist's passion for the theory of proportion, as a study in its own right, which led him to make a new kind of construction drawing, such as in the latest studies of *Adam* and *Eve* (Plates 46 and 47) about which more will be said below. The remaining handful of drawings made during

his stay include two portrait studies of an old man and woman, a copy after a Venetian painting, and two very imposing studies of Slovenian peasant women (see Plate 39), both of which were executed in a highly elaborate manner and intended as finished drawings, probably to be kept by the artist as part of his collection of portraits of the different people of the world. The second Venetian visit was therefore essentially a working and not a sightseeing visit. He paid no attention to the curiosities he saw and the places he passed through on his earlier journey, but, as before, his work after his return to Nuremberg was coloured by his activities south of the Alps.

Apart from a short visit to Bamberg, Dürer did not undertake another journey until 1518, when in company with two friends, Caspar Nützel and Lazarus Spengler, he went to Augsburg. In neither place did he display any inclination to record the landscape. They were, after all, local cities without much curiosity to a man from Nuremberg. The purpose of his visit to Augsburg was to obtain ratification of his pension from the Emperor, and at the same time to be present at the Diet, which witnessed the first major confrontation between a representative of the Pope and Luther. Though the three friends greatly enjoyed themselves and wrote lightheartedly back to their mutual friend, Pirckheimer's sister, who was abbess of a convent in Nuremberg, the atmosphere must have been tense, and Dürer was no doubt as fully aware as anyone else of the significance and importance of the occasion. He paid recognition to this fact by portraying as many of the participants as he could get to sit for him. Though Luther eluded him, he had greater success with Cardinal Albrecht of Brandenburg, Cardinal Lang of Salzburg, Jacob Fugger the Rich, and, above all, Emperor Maximilian (Plate 73), 'portrayed at Augsburg in his little cabinet, high up in the palace'. Probably on this occasion the artist came to realize the importance of portraiture as a means of propaganda, whether political, religious or intellectual. His study of the Emperor was transformed into a woodcut, and the Emperor's image, as seen by Dürer, was spread throughout Europe, while the likeness of Cardinal Albrecht of Brandenburg was transferred to a copperplate with the burin. ('I sent the copper plate with 200 impressions as a present to his Electoral Grace.') Dürer felt deeply engaged in the events of the mounting crisis, and he wished to be there to help those he admired; he saw himself as being responsible for spreading their image throughout Europe. Previously he had made portraits when he was asked or when it took his fancy, but from now on he shows a veritable urge to record the appearance of the people he came across, both high and low. His stay in Augsburg probably represents the moment when he conceived the new role for portraiture.

In a more personal way his visit to Augsburg was crowned with success, since Dürer obtained confirmation of his pension. By the following year Maximilian was dead and had been succeeded by Charles V. Once again the artist was faced with the problem of trying to intercede with a new Emperor, and the forthcoming coronation at Aachen in 1520 not only seemed the right moment for doing this but also provided a good excuse for a journey to the Netherlands, a country which he had probably never visited. Moreover, a recent illness had left him with a need for convalescence. Whereas most other German artists, including his father, had been trained in the Netherlands, Dürer had turned to Italy for instruction and inspiration. The South provided a contrast in every respect to the artist's life in Nuremberg, whereas the Netherlands was temperamentally part of the same civilization. This journey reveals Dürer as a modern artist/traveller. All preoccupations were put aside, and he set out to enjoy himself in a relaxed spirit, ready to absorb and admire all he saw around him. He kept a journal, which varies from an account book, listing the prices he paid for board and lodging and

the value of the prints which he gave away, to a record of the exchanges with people he met, with vivid descriptive passages when he was moved or excited; the account of his visits to the pleasure gardens in Brussels, of the display of Mexican gold, and of his part in the hunt for the stranded whale in Zeeland, all represent literary reporting of a high order. Dürer was, however, only concerned with describing personal experiences, and when he came to Aachen and witnessed the coronation of the Emperor, a ceremony of some magnificence, he merely reports the event briefly and says that he leaves it for others to describe. To discover what he saw and admired one has to turn to the drawings he made, which complement and fill out the account given in his Journal. Though he painted the panel of *St Jerome* (see p. 186) in the Netherlands, he did not make any prints at all during his twelve months away from home. All his artistic expression was concentrated on his drawings. Winkler lists just under one hundred drawings done within these twelve months, which represents just under a tenth of his total existing *œuvre*. The people he met, ideas for new religious works stimulated by the paintings of local artists, and the views and curiosities he saw, all were recorded in numerous studies, executed in a variety of media. As he arrives in each new place, one senses a quickening of his pulse as he gets ready to put down what he saw on paper, conveying the same sense of excitement as Sickert in Dieppe, sharpening his pencils in anticipation of the ferry-boat's arrival.

As Dürer moved from town to town he received the kind of welcome that is accorded today to a visiting celebrity in the United States. A banquet was given in his honour by the painters of Antwerp and all doors were open to him. He quickly developed the habit of making large portrait drawings in black chalk or charcoal with the background shaded in, either on commission or as a gift to a generous host. He made a much treasured but unfinished study of Erasmus (Plate 81), which he carefully took back with him to Nuremberg. Similarly the silver point portrait of Lucas van Leyden (Plate 84) was also probably undertaken for Dürer's own portfolio of portraits. But though mixing with the most distinguished inhabitants of the country, his curiosity about human beings was not socially blunted, and he drew all sorts, provided they were facially interesting, such as the Portuguese consul's 'Moorish woman' (Plate 83), executed in silver point and then carefully inscribed. Though he worked to no hard and fast rule, one suspects that the chalk and charcoal portraits were made for the sitters and the silver point studies for himself to take home to Nuremberg.

He was keen to record the places he visited, as the celebrated view of Antwerp exemplifies (Plate 79). In each town he was on the lookout for all it had to offer. 'Middelburg is a good town; it has a very beautiful Town Hall with a fine tower. There is much art shown in all things here,' and 'the town was besides excellent for sketching.' Compared with the views made on his way to and from Italy, his Netherlandish landscapes have a marvellous precision and conciseness. No watercolour or wash was was required in order to gauge the lie of the land and the buildings on it. Everything could be expressed in line. The Brussels zoo, Irish peasants and soldiers, Lapland women, both rich and poor, and the walrus 'taken in the Netherlandish sea' (Plate 80) were also things seen and recorded. But apart from the Journal the most personal document of his journey is the silver point sketchbook he took with him. Small, oblong in shape, it was his 'vade-mecum', which, owing to the nature of silver point, could be easily used at all times during his journey. It was in this little book that some of his most personal notes were made; a coffer, a table and some pewter pots, a horse in festive garb, the lions of Ghent (Plate 77), a dog, Aachen Town Hall (Plate 76), Bergen op Zoom seen from a distance, and a close-up of the choir, young and old men and

women, and—probably last in the book—his wife (Plate 78), portrayed when they stopped in Boppard on the Rhine on their way home. Dürer must have returned refreshed and satisfied with his journey, and no less with the results of his work in pen, silver point and charcoal. Not only is it the best documented and illustrated period in the artist's life, but probably the most vivid and intimate record of a journey a major artist has undertaken. Hollar's journey down the Rhine a hundred years later remains to us only as a topographical record, and in the following century Hogarth's trip to Gravesend was a boisterous social occasion of little artistic importance. Not perhaps until Delacroix's visit to Morocco are we presented with such a full account of the artist as sightseer. Armed with Journal and drawings, it requires little imagination to relive those twelve months spent by Dürer on the road. And though the artist himself during the last years of his life retired increasingly into a world of theoretical speculation, recollections of his visit still occur in his work, as, for example, when St Margaret, as part of the *Sacra Conversazione* (w.855), found herself attended by a walrus rather than a dragon proper.

The traditional role of drawing was conceived as a method of preparing for painting, sculpture or a print. Though Dürer was one of the first to realize the intrinsic qualities of the medium, which made it worthy of being considered as a finished work of art in its own right, he was no exception to the general practice of employing it as a method of preparing for his paintings and prints. In fact probably the majority of his drawings connect with another work, either as a premeditated study or a drawing taken over in retrospect.

Dürer's intense activity as a draughtsman combined with his innate curiosity meant that he quickly built up a collection of visual information on which he could draw when the time came. He showed a squirrel-like mentality towards the ideas or subjects expressed in his drawings, and had no inhibitions about turning back to a drawing of many years before. The landscape in the drawing of the *Pupila Augusta* (Plate 19), itself based on two other landscape studies, and the watercolour of a *Horse and Rider* (see p. 148), which were both adapted for much later prints, have already been referred to (see p. 18). More often he drew on more recent studies, which initially were made for their own sake. Shortly after his return from Venice in 1495, Dürer executed a drawing of a *Women's Bathhouse* (Plate 16). Though he did nothing with the subject as a whole, he nevertheless took details from this female academy and used them in two engravings of those years. This habit of using his drawings as a storehouse of information is particularly apparent in his numerous studies of animals. An ardent lover of nature, he took every opportunity to record the appearance of any animal which he came across, and likewise had a predilection to include them in compositions whether they had iconographical significance or not. His watercolour of the *Virgin and Child with a Multitude of Animals* (Plate 25) is almost an encyclopaedia of natural life. Just after his return from Venice Dürer had made a drawing of a bullock (w.239) (see p. 70), studied from nature. When working out the composition of the engraving of the *Prodigal Son* (see p. 70) in a drawing (Plate 18), he included the bullock amongst the farmyard animals. Since he already had a careful study of the animal to hand, he only made an outline sketch of it in the compositional drawing. The beautiful brush drawing of a greyhound (Plate 21) made a few years later was most likely made for its own sake, but shortly afterwards taken over almost exactly, though greatly reduced in scale, in the engraving of *St Eustace* (see p. 76).

The watercolour of a *Nuremberg Woman Dressed for Church* (Plate 22) was indisputably made as an end in itself, but three or four years later we discover the same

figure reproduced verbatim as one of the Virgin's handmaidens in the woodcut of the *Marriage of the Virgin* (see p. 78). Or again, from the drawing of a *Knight and his Wife* (Plate 52), made as a design for a tomb, Dürer took the study of the woman for one of Salome's female companions in the woodcut of the *Beheading of John the Baptist* (see p. 132), where she appears identically and rather inappropriately with the same look of dreamy unconcern. For the never executed *Sacra Conversazione* (w.855), he imaginatively adapted the head of the walrus (Plate 80) he had so lovingly studied on his journey to Zeeland to serve as a dragon.

Sometimes it is more difficult to establish the exact division between a drawing made as a record and later used for another work, and a working study. When in Antwerp, Dürer made an elaborate study of the head of a 93-year-old man (Plate 85) in brush and ink on a purple prepared paper, which he inscribed with details about the sitter, leading one to infer that the drawing was made for its own sake as a record of an object of interest. But at the same time Dürer must have decided to use the head as a model for the painting of *St Jerome in Meditation* (see p. 186): the drawing is dated 1521, and in his Journal in March of that year he refers to the painting as being finished. On the same occasion and in the same medium, he made another study (Plate 86), showing the bust of the old man, now apparently asleep, in the background; in the foreground, there is a study of his arm and hand, with his forefinger touching a circular object, which by reference to the painting can be identified as a skull. Again he altered his studies in the painting, but nevertheless the representation of St Jerome must already have been at the back of his mind. He then went on to make similarly executed brush drawings of the skull (Plate 88) and the lectern (Plate 87), which must clearly have been done specifically for the painting. In this instance one can perhaps surmise that the artist had the painting in mind when he hired his model, yet nevertheless his attention was sidetracked by his interest in such an unusual pheno-menon as a 'hale and hearty 93-year-old'. Such a duality of approach is characteristic of Dürer's attitude and emphasizes how he increasingly came to treat drawing as an activity as complete as painting and printmaking. The painting in question was given to his friend, the Portuguese consul, while the drawings were almost certainly taken back to Nuremberg.

When one turns to studies made specifically for a painting or a print one discovers different kinds of drawings, which reveal not only the variety in Dürer's approach— sometimes there are compositional sketches, while on other occasions only studies of individual details—but also his extreme care and thoughtfulness as he carefully plotted his way towards his final goal. As the years went by he developed a freedom of thought on paper, which he then proceeded to control and confine as he moved nearer his final object. His love of the burin expresses much of his artistic character. Engraving, even more than etching, is not a medium tolerant of last minute inspiration; it requires precision and forethought. The artist must be prepared down to the last detail, and such demanding work was no hardship to Dürer. Many of his surviving drawings both for prints and paintings contain meticulously accurate indications, which must have been close at hand when the final work was carried out. Taking into consideration the likely destruction of such working designs, one can infer that more often than not the artist had a detailed guide at hand when he was working on a print or painting. But on closer inspection some of these working studies lack the freedom of execution which one naturally associates with an 'original' drawing of a great master. The earlier drawings particularly have a dryness which, without taking their ultimate purpose into consideration, could lead one into believing that they were only copies. The drawing of

the foreground figures in the *Pupila Augusta* (Plate 19), or the preparatory outline drawings for the *Green Passion*, such as the *Nailing to the Cross* (Plate 36), lack the flowing continuity of line one normally associates with Dürer's pen. The preparatory drawing of the *Prodigal Son* (Plate 18) exemplifies both kinds of drawing. Most of the sheet—such as the figure of the Prodigal Son himself and the pigs—is freely and boldly drawn, but in the case of the bullock on the right Dürer was following a separate study, to which he could refer back when necessary, and he therefore contented himself with a dry outline. Whereas his paintings and prints have a standard, high level of finish, there is greater flexibility, both in finish and quality, in his drawings. When discussing these, therefore, one must take their ultimate aim into consideration.

As well as discussing the kind of preparatory drawings the artist made, it is appropriate—since he produced studies for paintings, woodcuts, engravings and etchings—to enquire how far he took their final destination into consideration when making them. Do his drawings, in other words, emulate or look forward to the qualities of the finished work—the brush-strokes in the case of painting, the bold outlines with simple shading of the woodcuts, the fine network of hatching in engraving, and a quality somewhere between the last two in the case of etching? Did he, one might ask, foreshadow Rubens's mastery in prophesying the strokes the engraver would make with his burin, the cutter of wood-blocks with his knife, or the sculptor with his chisel? What was he searching for when he sat down to draw with a composition in mind? Obviously with an artist of Dürer's stature and diversity there is no simple answer, but one can plot the general changes of course in his working method, as well as his reasons for making such changes, over the forty years of his career. At the outset one can say that Dürer tended to favour one medium at a given period, and this coloured his drawing style. But the pattern changed frequently and, driven by his restless temperament and usually under some outside influence, he shifted his allegiance from one field to another after only a few years. He stands out as one of the most versatile of artists.

The drawing of the *Holy Family* (Plate 4), made during or very shortly after Dürer's visit to Colmar, was done in emulation of Schongauer both in style and execution. Like the works of his spiritual master, it is an engraver's drawing, and though probably executed for its own sake it can be looked upon as a preliminary idea for the engraving of the *Holy Family with a Butterfly* (see p. 46), which must have been executed a few years later, just after his return from Venice. The drawing, like others of the same period, shows that the artist started his career orientated towards engraving, with the emphasis on outlines and areas of elaborate cross-hatching. Yet Italy intervened between the drawing and the engraving and though the arrangement of the figures and their relation to the landscape background are similar in both works, the engraving has a more classical composition and in execution reveals Dürer's knowledge of Mantegna's engravings. His copy (Plate 8) after Mantegna's *Battle of the Sea Gods* was not, however, done slavishly, and his creative interpretation of Mantegna's method of hatching, whereby he retained the unity provided by the latter's system of shading yet introduced more modelling by using rounded strokes, is reflected in the engraving of the *Holy Family*. Where the full forms of the Virgin's dress had a life of their own in the drawing of the *Holy Family*, they are closely related to the remainder of the composition in the engraving. Both works, however, are true engraver's drawings, and the same mentality informs Dürer's study for the *Prodigal Son* (Plate 18), where he basically draws in the same manner as he did with the burin when he executed the subject on the copperplate (see p. 70). The artist had already made a less finished

drawing of the Prodigal Son himself (w.146), and though he now included the whole composition, this drawing does not represent the final stage; the engraving shows a tightening up of the various elements in the subject, attaining greater integration of detail. And probably the present drawing was succeeded by another drawing which was at his side whilst he worked on the plate.

There was a relaxation in Dürer's strictly 'engraver's outlook' shortly afterwards, as both the drawings themselves and their relationship with other works of art prove. His ability to transpose the '*Weiherhaus*' (Plate 11), executed with the brush in watercolour and body-colour, into the background of an engraving (see p. 60), and the watercolour drawing of the *Nuremberg Woman* (Plate 22) into a detail in a woodcut (see p. 78), show the artist's greater flexibility. He drew inspiration from reconciling the irreconcilable, a strain in his thought processes which came increasingly to the fore in later years.

But these were details, and where it was a question of considering and developing the whole composition fine pen work was still preferred, as in the series of studies leading up to the engraving of *Adam and Eve* (see p. 102) of 1504. This print represents the culmination of Dürer's search for ideal representations of the human figure, starting with the drawing of *Apollo and Diana* (Plate 34) and ending in the latest study for the print (Plate 35) which has come down to us. Proportion, gestures and the arrangement of figures together were all tried out and modified in drawings, which are remarkable for the very fine pen work. His work on paper could almost literally be transferred line for line onto the copperplate. The style and technique of engraving determined the character of his drawings, whether the finished work was in fact an engraving, or a painting, or a woodcut. But about this time the artist started to show an awareness in his drawings of the medium for which he was preparing. For the *Green Passion*, finished *modelli* in pen on prepared paper, he made outline drawings (compare Plates 36 and 37), and for woodcuts such as the series of the *Life of the Virgin* (B.76–95) he made sketches (W.292–294) which took into account the more open, simpler shading required by the medium.

A second visit to Venice changed everything quite dramatically. Painting suddenly became the major preoccupation and nearly all his activity was directed towards preparing for and executing the *Feast of the Rose Garlands* (see p. 116), and, to a lesser extent, *Christ among the Doctors* (see p. 110). To match this new bent, and in recognition of what he saw around him in Venice, the artist embarked on an entirely different method of drawing. Though the *Feast of the Rose Garlands* was his largest and most complex painting to date, no compositional sketches appear to have survived; there is only a series of twenty-two detailed studies of figures, heads and hands (see Plates 42–44). Presumably the general composition had already been fixed in some kind of drawing, so that the artist was free to study in detail the individual parts of the painting, piecing them together like a jigsaw. Moreover, their ultimate destination is acknowledged by the fact that the pen has been exchanged for the brush and, to enhance their pictorial qualities further, they are executed on blue Venetian paper, and given an additional tonal range by the extensive use of white body-colour. And in one case, the *Study of the Pope's Pluvial* (Plate 43), he went one stage nearer the painting by working in watercolour. The other studies are virtually grisaille paintings on a blue ground, but executed with a luminosity which was the special creation of Venice at the turn of the century. But for all their Venetian qualities they are still essentially Dürer in their intense feeling for individual detail. To us they appear as works of art in their own right, and even Dürer must have felt that they had an independence of their own. The same qualities are evident in the studies (Plates 40 and 41) for *Christ among the Doctors*

(see p. 110), a work which the artist proudly inscribed with the words 'painted in five days'. The pictorial orientation of his work at this time is well illustrated by the two studies of heads (Plates 40 and 42), one for each painting, which were originally together on a single sheet of paper. The urge to paint was the driving force of the moment, and it hardly mattered that he was working on two pictures simultaneously.

Dürer returned to Nuremberg full of pictorial resolutions, but inspiration with the brush did not follow him. As his correspondence with the patron painfully shows, the execution of the *Heller Altarpiece* (see p. 126) became a heavy and laborious burden. Following his practice in Venice, Dürer made a number of detail studies, drapery, feet (Plate 48) and hands (Plate 49)—eighteen survive today—all executed with the brush, and with the addition of white body-colour. He failed to bring back any blue Venetian paper with him, and he was obliged to prepare his white paper with colour, but he took advantage of this necessity and enlarged the range of colours by using green, blue and grey washes on different drawings. But in spite of the use of both brush and colour, most of the studies for the *Heller Altarpiece*, with their very fine outlines drawn with the brush imitating the pen line, indicate for him a natural return to linearism, as is revealed by comparing the *Hands of the Young Christ* (Plate 41) executed in Venice with the *Hands of an Apostle* (Plate 49), done for the *Heller Altarpiece*. This natural penchant for line remained a permanent characteristic of the artist's work and even asserted itself in the Venetian drawings.

With the completion of the *Heller Altarpiece* and the painting of the *Trinity*, Dürer returned to graphic art, probably with a sense of relief. But the effect of Venice in shaking up his artistic metabolism continued to produce new results. He became more restless and experimental, trying his hand at drypoint and etching as well as woodcuts and engravings. And his working drawings tend to be related more closely to the technique of the medium of the finished work. The woodcuts of the *Fall of Man* (see p. 134) and *St Jerome* (see p. 136) were preceded by compositional studies (Plates 53 and 54) which show a much looser pen stroke, with open parallel shading characteristic of the woodcut. Both drawings show many differences from the finished work, and in the case of the *Fall of Man* the drawing may have been made as an end in itself and only adapted afterwards to the woodcut. Both engraving and painting had had their turn in setting the pace, and now the medium of woodcut led the way. And one cannot help wondering whether this latest taste may not have encouraged Dürer to experiment with etching, which, with its wider lines and more open shading, provided a half-way house between engraving and woodcuts. Be that as it may, the preparatory studies for etchings such as the *Agony in the Garden* (Plate 71) and the *Rape of Proserpina* (Plate 72) are drawn in long bold lines of shading, with some open cross-hatching, so that they accurately forecast the appearance of the etchings (see pp. 164 and 166). Once again the artist altered the composition, in the case of the latter work changing the subject of the drawing from an unidentified and unspecified rape into the Rape of Proserpina. The drawing of the *Agony in the Garden* was preceded by another study (see p. 164), but like all the drawings just mentioned it is a well thought-out compositional study which does not contain any changes of mind as he worked on the actual drawing. In no way do we witness the artist developing his ideas on paper. Modifications were introduced but only when he reached the next stage in his work. He had a patience and lack of urgency—unlike, for example, Leonardo or Raphael—which allowed him to finish what he had in mind before moving on to the next improvement. Dürer seems to have been almost reluctant to spoil a drawing by correcting and altering, even though it meant making another drawing to express his new ideas.

The woodcuts of 1511 and the earlier drypoints of 1512 are separated from the etchings of 1515 and later by the three '*Meisterstiche*', which, when compared with the *Adam and Eve* (see p. 102) of 1504, show how much Dürer had assimilated the lessons of both his later Venetian visit and his experiments in drypoint. Several preparatory drawings allow us to follow the genesis of the *Knight, Death and the Devil* (see p. 148) in more depth than in the other works just mentioned. For the basic subject of the knight on horseback the artist turned back to a watercolour of many years earlier (see p. 148); but in order to bring the representation of the horse up to date from the point of view of proportion and stance, he subjected it to careful study in a drawing in which the geometrically constructed outline on the recto (Plate 60) was afterwards traced through on the verso (Plate 61). This method allowed him both to develop his design in pictorial terms as opposed to mere geometry, and at the same time to provide himself with a drawing in reverse, which would be in the correct direction for working on his plate. On the recto the artist followed the unusual course of making a very noticeable *pentimento* in the drawing of the hind leg. The 'fair copy' on the other side appears much the same, except for the introduction of a dog, taken from a sheet of sketches (Plate 59) done about this time. But the engraving contains such richness of detail that these studies must have been followed by more detailed drawings, which have not survived.

Except for the portraits in chalk or charcoal, the drawings done during the second decade of the century were executed in pen and ink. The pen exactly fitted Dürer's graphic mood. But though he widened his range of techniques on his journey to the Netherlands, when he made the brush drawings on purple prepared paper connected with the painting of *St Jerome in Meditation* (see p. 186) and the silver point studies already mentioned, the pen remained his favourite instrument for drawing. In the Netherlands he appears to have conceived the idea of a new Passion series in woodcuts, designed under the influence of Flemish art, in an oblong format. Though only the *Last Supper* (B.53) was ever executed, Dürer made a number of drawings of various subjects connected with the Passion. The style of penwork, with broad open shading, is consistent with his woodcut style, but instead of the decorative flourishes he often introduced with the pen in the previous decade, the actual execution of these sheets conveys a starkness and a sense of drama which match the artist's mood in these years. Though the composition was altered in the woodcut, the drawing of the *Last Supper* (W.889) provided the exact style of the final work. In several cases, such as *Christ Carrying the Cross* and *Christ on the Mount of Olives*, the artist made more than one drawing of each subject, but now there was no question of one being a development of the other, and in that respect they cannot be categorized as working drawings. Each version is a finished work of art, offering a different interpretation of the story expressed through a different arrangement. One version of *Christ Carrying the Cross* (Plate 89) is static while the other (Plate 90) is intensely *mouvementé*. One version of *Christ on the Mount of Olives* (Plate 91) gives prominence to the sleeping apostles, while the other (Plate 92) concentrates on Christ's spiritual anguish. Whether or not Dürer intended this series of drawings of the Passion to be executed in woodcuts, they are undoubtedly the most outstanding and moving religious drawings of his whole *œuvre*. He had always treated the subject of Christ's Passion with devotion, but it was suddenly as if he had become personally involved. The crisis of his own life and the times in which he lived stirred within him an intensity of feeling and imagination that was previously lacking.

In the year he returned from the Netherlands, Dürer appears to have been commissioned to carry out an altarpiece on the theme of the *Sacra Conversazione*,

which would have been the most splendid work of his career. In a series of drawings, which can truly be described as compositional sketches, he tried out various formulae before abandoning the project, largely, one may assume, because of the changed religious situation in Nuremberg, which would hardly have welcomed such a Catholic picture. During the whole of the previous decade Dürer had meditated in numerous variations on the theme of the Holy Family (see, for example, Plates 56 and 74), and in a drawing of 1521 the subject was enlarged to include saints and music-making angels (Plate 93). This was to be the theme of the altarpiece, and preparatory work started in earnest with an outline sketch (see p. 198) depicting the Virgin and Child enthroned, surrounded by a large company of saints, most of whom are identified with inscriptions. A second sketch (Plate 94) shows a reworking of this arrangement with fewer saints and an increased sense of space. Both these sketches were variations on the theme of the *Feast of the Rose Garlands* and are ultimately Venetian in inspiration. But in the next two compositional sketches (see p. 199) the horizontal shape was abandoned in favour of an upright format, once again with a further reduction in the number of saints and the omission of the donatrix who had appeared before, suggesting that some external change had been made to the commission. These later 'upright' sketches are even freer and sketchier in execution, and the inscriptions refer to the colour of each figure and not to the identification of the saint. The iconography of the painting had been fixed, and the artist was now able to concentrate on the pictorial problems. The result would have been hieratic and monumental, qualities echoed in the wings, for which there is good reason to believe the two panels of the *Four Apostles* (see p. 210) were destined.

At the same time as the artist was evolving his composition in these pen sketches, indeed before he had finally settled the arrangement, he was preparing large-scale chalk studies on prepared paper of some of the heads and of the fall of the drapery over the knees. St Apollonia, who was portrayed in one of these studies on prepared paper (Plate 95), can be clearly recognized in both the 'horizontal' compositional sketches (see p. 200). The appearance of each saint was clearly of great concern to the artist and in the second of the sketches (Plate 94) Dürer worked over the heads of three of the saints, including St Apollonia, with these chalk studies done from life beside him, in order to emphasize their individuality. St Apollonia, for example, became more recognizably like her 'portrait'. The saints were not to be the usual stock figures, who play the role of attendants in most religious pictures, but were conceived with their own personality. It is characteristic of Dürer's mentality that even with the general arrangement uncertain, his thoughts were moving ahead to the details of the composition. And it is perhaps because of his constant awareness of detail that there are so few compositional working sketches in his *œuvre*. By the time he put pen to paper both the pattern and the detail had been carefully considered in his mind, and he was able to elaborate his conception of the subject without feeling the need to abandon his first sheet and introduce 'improvements' on another sheet of paper. The actual act of drawing does not appear to have stimulated his thoughts.

From the time of his visit to the Netherlands until his death, Dürer prepared for woodcuts with pen drawings, and for paintings and engravings with large-scale chalk studies and the occasional compositional sketch. Whereas the scale of the chalk studies matched the size of the paintings, this was far from being the case with the engravings. For an unfinished print of the *Crucifixion* (Passavant 109), which got no further than outline, he made a number of large chalk studies of figures and heads (w.858–869), some of which are three times the size of the actual figure on the plate. And possibly the fact that the engraving remained unfinished was not unrelated to the problem of

condensing and reducing what the artist had drawn in preparation. Exactly the same degree of magnification is found in the two preparatory studies (see Plate 100) in the same technique for the engravings of *St Bartholomew* (B.47) and *St Philip* (see p. 210), which are only a third of the size of the drawings. He was searching for a monumental scale beyond the possibilities of the medium, and it is symptomatic that, having used the drawing (Plate 100) for the engraving of *St Philip*, he went on to employ the same study for the figure in the right-hand panel of the first version of the *Four Apostles*. The grandeur of conception in the drawing was now matched by the scale of the panel, and when, in 1526, he came to alter the two panels, adding two figures and changing the identity of St Philip to St Paul (for the history of the painting see note to Plate 100), he developed his feeling for a large scale by drawing three of the heads life-size. Here the immense size of the drawing was appropriate, and no reduction was required. Apart from some woodcuts connected with his treatise on Fortification, 1526 marked the end of Dürer's career as a painter and printmaker, and in these last drawings one can watch him working towards a simplicity and monumentality which almost became an antithesis of all that he had previously sought from artistic creation. And in the following year, if the large and imposing portrait of *Ulrich Starck* (Plate 106) is correctly identified as a preparatory design for a medallion a fraction of the size of the drawing, he reached, if one may adapt the phrase, the *magnificatio ad absurdum*.

Though Dürer's creative activity was devoted to painting, drawing and printmaking, he nevertheless showed a keen awareness of other media by making designs for a variety of purposes. He took great interest in designing suitable frames for his paintings, as one of his letters to Heller informs us. As soon as he had completed the *Heller Altarpiece*, he made a preparatory study (Plate 50) for his next large altarpiece, the *Adoration of the Trinity*, which includes the projected design for the very elaborate frame with a carved tympanum of Christ in Judgement. Painting, sculpture and architecture were conceived as a unity, and, just as the composition of the painting was changed, so he made modifications to the design of the frame. In this instance, Dürer was commissioned to complete the decoration of the chapel, for which it was destined, by designing the stained-glass windows. A more three-dimensional project was the commission from Cardinal Lang of Salzburg to make a design for a throne, which we know from an elegant pen and wash drawing (Plate 96), with the artist's dedication to his patron inscribed at the top of the sheet.

In 1510 Dürer was active designing tombs for the Fugger family in Augsburg, which were to be carried out by the sculptor Adolf Daucher. Dürer's designs for the same purpose can be seen in another drawing of the same date (Plate 52), representing a tomb for a knight and a lady which was executed by Peter Visscher the Elder. Earlier in his career he had made the large drawing of a *Table Fountain* (Plate 20), which may have been executed for his father-in-law, Hans Frey, who specialized in designing mechanical devices. In the middle of the second decade of the century the artist made a number of designs for armour, including the beautiful study of the *Visor of a Helmet, Decorated with a Bagpiper and a Fantastic Bird* (Plate 69), which was probably intended for a silvered armour which Emperor Maximilian had ordered from the Augsburg armourer, Koloman Colman. About the same time he made the charming design for two pendants with Saints George and Christopher (Plate 70). In spite of its size, the profile portrait of *Ulrich Starck* (Plate 106) may have been designed for a medal, as has been already mentioned. Dürer shows himself to have always been willing to make designs for numerous other purposes, such as coins, seals, furniture, goblets, chalices, scabbards and jewellery. But even if his intense curiosity about other works of art made

him a good designer, one is nevertheless left with the feeling that, particularly where sculpture was concerned, he lacked a real understanding of the medium. His drawings remained two-dimensional patterns, and it would, for example, have required considerable imagination on the part of the carver to interpret his design for Cardinal Lang's throne in the round. It is symptomatic of his approach that he was able to transpose part of his design for a tomb slab to a woodcut without any change of style.

Dürer had more than a passing interest in architecture. On his second visit to Venice he made detailed plans and elevations of a house in the city. On another occasion he made a cross-section of a cupola (T.936) and a draft report on the construction of the vault of a church exists in his handwriting. Charitas Pirckheimer humorously refers to the artist as someone who 'if some day we want to alter our choir, will know how to give us advice and help in ample side windows'. In Antwerp Dürer records that 'I have had to draw the design of a house for her [Lady Margaret's] physician the Doctor, according to which he intends to build one'. And, to add to his achievements, he dabbled in poetry. But though all these activities add up to the necessary qualifications of a *uomo universale*, he merits this status more for his intellectual interest than by what he actually achieved. His curiosity was unbounded in scope, and in the final analysis one admires him for width of knowledge rather than profundity on any particular subject. And nowhere is this limitation more keenly felt than in his theoretical writings about art.

The theory of art was the prerogative of Italy, whether during Dürer's own century or in classical times. The northern tradition in which Dürer was brought up paid it little attention, but his very first visit to Italy had already awakened in him a natural scientific spirit of enquiry. Gradually it became of increasing importance, occupying more and more of his time, so that the last few years of his life were virtually given up to theoretical writing. And in this enquiry drawing played a very important part.

In the introduction to a book he planned to publish on painting in 1513, Dürer wrote that 'the sight of a fine figure is above all things pleasing to us, wherefore I will first construct the right proportions of a man'. And though uncompassed and unruled, the drawing of a female nude of 1493 (Plate 5) already contains the seeds of the artist's spirit of enquiry. The standing female nude seen from the back that he made in Venice two years later (Plate 9) offers a more idealistic conception of the female figure in *contrapposto*, and for the first time he traced through the outlines onto the other side of the paper, at the same time converting the rear view of the model into a front view. But the real spark of ignition for this lifelong research into human movement and proportion came from his contact with Jacopo de' Barbari, either in Venice in 1495 or five years later when the latter visited Nuremberg. Much later Dürer wrote that Jacopo de' Barbari 'showed me a man and a woman which he had done by rule and measure', but he 'would not show me his reasons clearly, and I set myself to find out what I wanted to know, and read Vitruvius, who describes briefly the proportions of the human body'.

In 1500 Dürer made the first properly constucted study of the female nude on a double-sided sheet (W.411 and 412) with a 'fair copy' traced through on the verso and elaborated with shading in pen and brush. It was also in this year that Vitruvius had come to his attention, and one can look upon this drawing as the application of a rule which, though formulated by him in words much later, nevertheless guided the artist during the first years of the new century. 'It is perfectly true, as Vitruvius says, that unless care be taken to keep the measurements exact the work will be faulty, even though it be original.' These were exactly the failings which Dürer no doubt considered

the pre-Venetian female nude (Plate 5) suffered from. For the next five years ruler and compasses were in constant demand as he sought to realize the ideal man and woman in the spirit of Vitruvius. In both cases the poses were taken from classical models—the man from the recently discovered Apollo Belvedere, and the woman from the Medici Venus. These studies found various outlets such as the engraving of *Nemesis* (B.77) and the drawings of *Apollo* (Plate 34), but the final and most considered expression of this search was the engraving of *Adam and Eve* in 1504. At the same time Dürer had turned his attention towards a similar study in the proportions of the horse. Two drawings of 1503 of a horse in movement (W.360 and 361) clearly reveal Leonardo as the source of inspiration, studies which found more considered representation two years later in the engraving of the *Great Horse* (B.97) and the *Little Horse* (B.96), particularly the latter. And in the field of perspective, both the drawing of the *Virgin and Child with a Multitude of Animals* (Plate 25), with its carefully measured distant landscape, and the small engraving of the *Nativity* (B.2) of 1504, with its welter of orthogonals leading undeviatingly towards the vanishing point, gave visible expression to Dürer's thoughts on the subject.

By the time Dürer returned to Venice he was already well primed in the theory of art and ready to receive further instruction. This may well have been one of the reasons which encouraged his second visit, and it is clear that by this date scientific enquiry had become his presiding private passion. Writing to Pirckheimer towards the end of his stay about the date of his return home, he says 'I shall have finished here in ten days, after that I should like to ride to Bologna to learn the secrets of the art of perspective, which a man is willing to teach me. I should stay there eight or ten days and then return to Venice. After that I shall come with the next messenger.' Such an event was a bonus to his visit which he was determined not to miss, and we know from a citizen of Nuremberg who was in Bologna that not only did he get there but he was much fêted by local artists. Just who taught him 'the secrets' is not known, though the most likely candidates for the role are the architect Donato Bramante and the mathematician Luca Pacioli. In addition he must at some point have come across a number of Leonardo's studies in proportion and physiognomy, so that he could truthfully claim that he had been exposed to all the serious thought on these subjects which had taken place in Italy. What he learnt on this pilgrimage was of a much higher scientific order than he had been able to glean from Jacopo de' Barbari and Vitruvius before. Moreover he became aware that the theory of art was a legitimate study in its own right and not merely as a background to practical application. It must have been at this time that he conceived the idea of putting into words what he had learnt in Italy. As if to seal this new bargain with learning, on his return to Venice from Bologna he purchased a copy of the latest edition of Euclid, on the fly-leaf of which he wrote: 'This book have I bought at Venice for a ducat in the year 1507—Albrecht Dürer'.

Already in 1506 Dürer had made studies of both *Adam* and *Eve* (Plates 46 and 47) which show fundamental differences from his drawings leading up to the engraving of 1504. In the earlier works everything had been determined by ruler and compasses, but now only the proportions and the pose were constructed, so that the contours, no longer built up in a series of arcs with the compasses, flow uninterruptedly. A comparison between the attenuated dancing figure of Eve of 1506 (Plate 47) and the Eve of two years earlier (Plate 35) brings out the freedom with which the artist allowed the figure to develop its own natural proportions. It represented a basic realization that no longer was it possible to determine ideal beauty by careful mathematical measurement. 'What Beauty is I know not, though it dependeth upon many things', he wrote shortly

afterwards in a draft introduction to a book he planned to write on the teaching of painting.

Developing Leonardo's ideas, Dürer proceeded to study the variety of different types of human being. This was in direct contrast to his previous efforts, which had been directed towards the one ideal type. As he wrote in the draft introduction, 'no single man can be taken as a model of a perfect figure, for no man liveth on earth, who uniteth in himself all manner of beauties'. His study of physiognomy, for example, can be seen in the sheet of studies (Plate 59) containing three caricature male heads in profile, an exercise derived directly from Leonardo. He made numerous studies in this vein which allowed him to build up a repertory of different types of figure in different positions. The Dresden sketchbook of about 1513, from which the *Standing Male Nude* (Plate 62) comes, contains proportion studies clearly worked up with the publication of a treatise in mind. He went as far as to compose a long introduction in draft form, a passage from which has already been quoted. This was later to become the first of *The Four Books on Human Proportion*. At the same time Dürer planned a treatise on the proportions of the horse but his thoughts on this subject got no further than the two drawings which he made on either side of the sheet of paper (Plates 60 and 61) for the engraving of *Knight, Death and the Devil*. In spite of all this activity Dürer

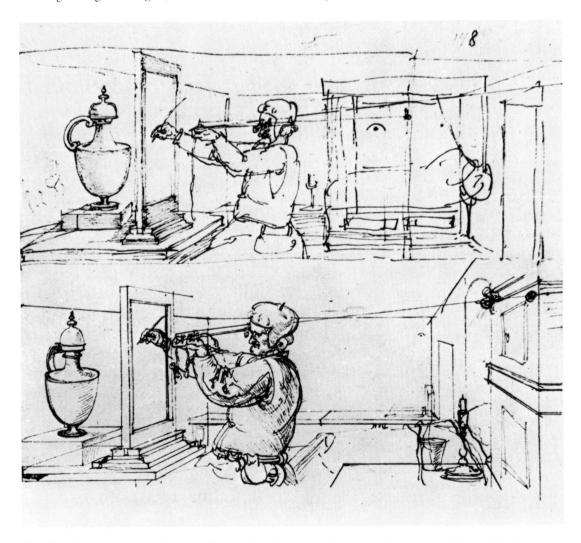

Two Studies of an Artist Using a Perspective Apparatus (w.937). About 1525. Pen and ink. 187 × 204mm. Dresden, Sächsische Landesbibliothek

temporarily abandoned his projects to publish a treatise. From the way he expanded his writings later, one can deduce that he must have come to realize that his approach contained certain limitations. Probably more relevant to his immediate plans, however, was his introduction to the Emperor Maximilian, who commissioned him to undertake a number of time-consuming works, totally different in spirit from his theoretical studies. The elaborate series of woodcuts for the *Triumphal Arch* and the *Triumphal Procession* would have allowed him little opportunity to indulge in what was still a spare-time activity, and during the next few years, until the Emperor's death in 1519, Dürer appears to have given little thought to the theory of art.

Only towards the very end of his life did Dürer succeed in bringing some of the vast material he had been working on for so long to the point of publication. The decreasing number of paintings and prints during his last years is partly attributable to the artist's growing sense of urgency that at least some of his intensive thinking and experiments should see the light of day. In a sense it was a wish to rationalize all that his work had meant to him, so that others could benefit from his experience and knowledge. At last in 1525 he published the *Treatise on Mensuration*, which was more a series of comments on the uses of geometry and measurement than a thoroughgoing treatise. All his thoughts on the subject were not expressed solely in words, and in connection with the books he made a number of drawings, such as the sheet with *Two Studies of an Artist Using a Perspective Apparatus to Draw a Vase* (W.937), the designs of which he transferred to woodcuts (B.146–9); these, though, were not used for the first edition and only appear in a posthumous edition. Two years later the treatise on 'Fortification' was published, for which he made a number of drawings and woodcuts, including probably the last and most austere of his landscape studies, the *Landscape with Cliffs* (Plate 105). And finally in 1528, just before his death, Dürer was able to witness the publication of the first two books of *The Four Books on Human Proportion*; the last two were taken care of by friends. Two large schematic pen drawings in outline of the male nude in movement—one from the front and the other in profile (W.929 & 931), both with traced 'fair copies' on the verso and worked up with rigid shading and green wash—were probably done with the treatise in mind. They represent the final triumph of theory over the pictorial qualities which had previously broken through, however geometrical the initial conception may have been. Preoccupation with scientific or mathematical enquiry was a temptation which faced the Renaissance artist. It was still possible for one man to move firmly and authoritively over several disciplines. At the time that Dürer was devoting more and more of his energies to the theory of human proportion, Leonardo's thoughts were increasingly absorbed by scientific enquiry and speculation. And not many years before, Piero della Francesca had allowed his fascination with perspective to give his last paintings a cold mathematical precision.

How far Dürer had progressed along the same road as Piero della Franscesca can be gauged by comparing these last studies with a similar study of a male nude, seen from the front (Plate 62), in which the beautiful hatching executed with the brush has a pictorial quality of its own belying the strictly mathematical construction on the other side of the sheet. And the comparison becomes more telling when it is remembered that this earlier study came from the Dresden sketchbook which represented the treatise on proportion that the artist had planned to publish in 1513. But over and above these published works there is a large quantity of manuscript material, illustrated with sketches and diagrams, much of which is now in the British Museum, proving that what we know from the printed works is only a part of what Dürer had planned to publish.

In sum one is full of admiration for Dürer's diligence and pertinacity in formulating

scientific rules for artists, but there is a deadening academicism about his attempts. He lacked the sheer inventiveness of Leonardo, whose scientific observations show an imagination and foresight which makes him truly a remarkable thinker of his time. And one is left with the same impression if one compares the illustrations in their respective manuscripts. There is a fascination in Leonardo's marginal illustrations, even if they are beyond our comprehension, whereas one admires the neat penwork in Dürer's drawings, without our imagination ever really taking wing. One is inclined to agree with another of Pirckheimer's sisters, who was also a nun. In a letter to her brother she wrote, 'There has just come to hand a book by Dürer, dedicated to your name, about painting and measurement . . . we had a good time with it, but our paintress says she does not read it, because she can paint just as well without it.' And she was not alone in this opinion, as we know from other comments made at the time. No one, perhaps, was more scathing than Michelangelo. And yet Dürer's labour was not entirely in vain, and in the seventeenth century he received support from an unlikely source, namely Pacheco, who in his treatise on painting recommended artists to study the female figure from Dürer's drawings, rather than from the living model.

It is, however, unfair to portray Dürer as ultimately the victim of a dry academicism. The formulation of rules was not done entirely for itself, but reflects something of his

Male Nude in Profile. 1526. Recto (w.929), pen and ink; verso (w.931), pen and ink with green wash. 445 × 242mm. London, British Museum

attempt to capture the indefinable. At the same time that his thoughts became more mathematical, so his awareness of a dimly perceived but unobtainable beauty increased. In the draft introduction to the projected treatise in 1512 Dürer wrote, 'Ah, how often in my sleep do I behold great works of art and beautiful things, the like whereof never appear to me awake, but so soon as I awake even the remembrance of them leaves me.' We know that these were not merely the fine words of a dreamer, and this Platonic search for the ideal remained with the artist. It was clearly something of an obsession, and ten years later Pirckheimer wrote to a mutual friend, 'Do you remember what Dürer told us lately of his dreams? We were standing by the window in my house beholding the military train pass by. All the air was filled with the blare of trumpets, the clang of arms, and the shouts of men. And then he told us how sometimes in his dreams he seemed to live amongst things so beautiful that if such only really existed he would be the happiest of men.' This experience is perhaps the basic emotion of any great artist, seated before his paper, canvas or sculpture, who, because he is never satisfied, constantly moves on to something new, impelled by the belief that in the distant recesses of his being there is an idea to be grasped which he can never totally express.

Underlying both Dürer's life and his work there is a dichotomy, which provided much of the motivation for his art. At whatever level one examines his career, one becomes aware of an initial struggle between opposing interests which he composed into a finely balanced harmony, as if to begin with he were uncertain of his true identity. His temperament was torn between North and South. Though Venice may have provided the greatest stimulant to his life, he was nevertheless a man of the North who in spite of many tempting offers to remain south of the Alps felt drawn to return to Nuremberg. And when he finally went to the Netherlands, the experience was one of relaxation rather than stimulation. As he grew older, there was an increasing tug of war between theoretical speculation and practical application, between the intellect and a passionate interest in the natural kingdom, between ideas conceived by the mind and everyday objects perceived by the eye. At yet another level he did not confine himself to one medium, but switched from one to another, using painting, drawing and printmaking. And in the case of the last two he obtained further variations in artistic expression by experimenting with as many different techniques as he knew. No one medium or influence is allowed to dominate his thoughts for too long. He constantly returns to the previous sphere of activity but always enriched by the most recent experience. One strain tempers another so that his work cannot easily be divided into broad spans. Behind this restlessness there is an underlying tension in his work which, so well is it finally harnessed and concealed by the artist, only becomes apparent on close inspection. And in no field are we more keenly aware of the various pulls, the individual stresses and strains than in his drawings. They present us with the key to his art and personality.

The Plates

I

Self-portrait

W.1 L.448 T.1 P.996
Silver point. 275 × 196mm.
Later inscribed (see below), signed and dated 1484
Provenance: Imhoff. *Vienna, Albertina*

DOUBTLESS in a moment of pride in later years at such a remarkable achievement for a boy of 13, the artist inscribed the drawing with the words, 'This I drew of myself in a mirror the year 1484, when I was still a child. Albrecht Dürer.' Apart from being his first self-portrait, it represents one of the earliest self-portraits in the history of art. Moreover, whereas other artists waited until maturity to indulge in this self-examination, Dürer showed an unusually precocious curiosity in the world around him as well as in himself.

The boy looks to the right, pointing like a St John at the foot of the Cross, a witness to the event. The other hand is tucked behind, the artist thus avoiding the difficulty of portraying the actual hand used for drawing. A similar silver point drawing of the artist's father (w.3)—probably by the father, though often claimed as the work of the son—shows the same glassy stare, owing to the eyes having been added afterwards, and uses a similar arrangement of the hands, except that the right hand holds a silver statuette, acknowledging his profession as goldsmith. Probably the young Dürer took his father's drawing as a model of how to solve the problems of self-portraiture. One can still clearly see the free underdrawing as he felt his way towards a definition of the head and arms. Though Dürer may have failed to equal his father's technical proficiency, he surpassed him in the freshness and naturalness of expression. The father was portrayed within the convention of Flemish art, but in the son's portrait a new personality shows signs of breaking through.

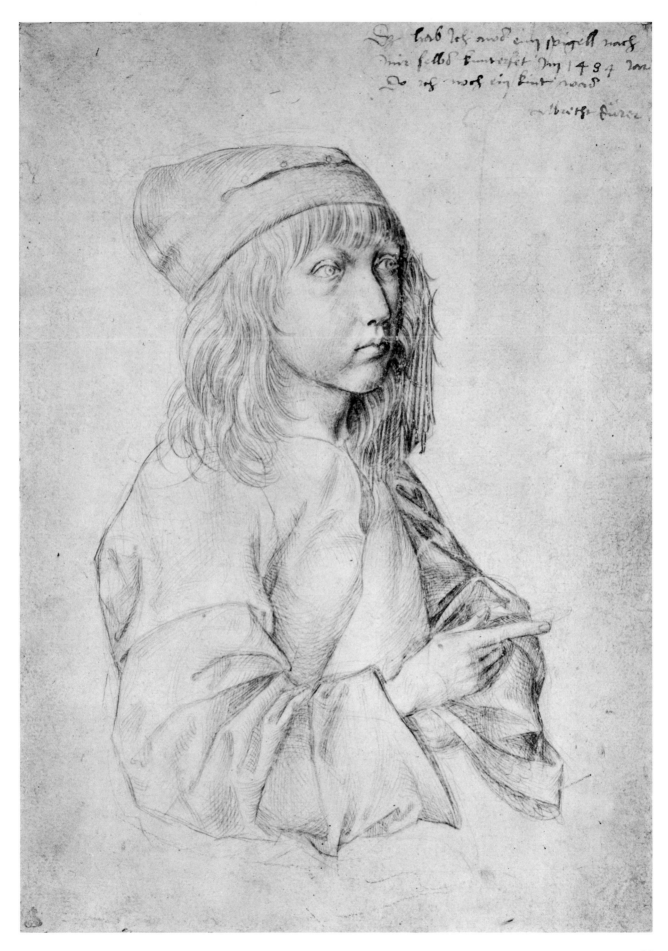

Dz hab ich aws eim spiegell nach
mir selbst kunterfet Im 1484 jor
Do ich noch ein kint was

Albrecht Dürer

43

2

Hunters

W.16 L.100 T.5 P.1244
Pen and brown ink. 209 × 301mm.
Dated 1489
Provenance: J. Grünling. *Formerly Bremen, Kunsthalle*

DRAWN AT THE END of Dürer's apprenticeship to Wolgemut. Though three years were to pass before Dürer made his abortive pilgrimage to Schongauer in Colmar, the present drawing shows that he must already have studied the master's engravings closely. But in this instance the drypoints of the Master of the Housebook were even more influential. The rider in the centre with his arm raised, seen from behind, might have been copied directly from one of the Master of the Housebook's prints. Dürer achieved considerable freedom of drawing in the landscape, though the riders in the foreground are executed in the carefully worked manner of the artist's earliest engravings, such as the *Great Courier* (B.81) and the *Conversion of St Paul* (Dodgson 2), both of a few years later. Moreover, the composition displays a rather awkward agglomeration of individual studies of men on horseback.

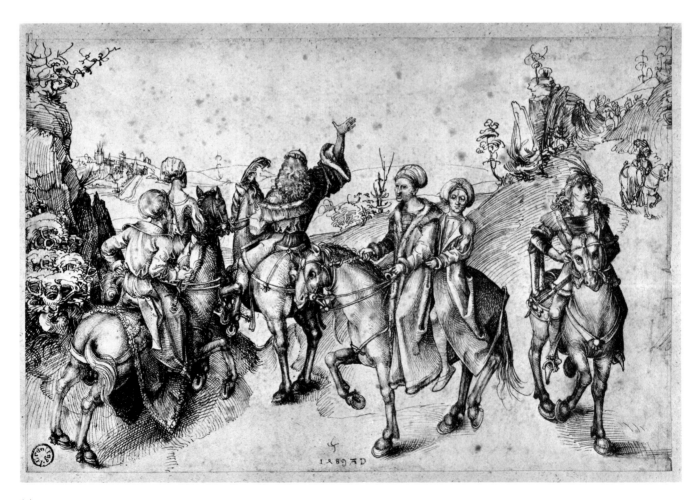

3 *Man on Horseback with a Whip and Curved Sabre*

W.52 L.304 T.AI60 P.I225
Pen and brown ink. 205 × 203mm.
Provenance: Crozat. *Paris, Louvre*

THE PRESENT STUDY, drawn about 1493, shows the same kind of subject as the
Hunters (Plate 2), but the individuality of type and fluency of execution mark the
artist's maturity as a draughtsman. As the rider relaxes, his whip nonchalantly resting
on his shoulder, and gazes towards the distance, his close connection with the landscape
is enhanced by the feeling that any moment he might spur his horse forward to join his
companion in the middle distance, who, his lance lowered, is charging at an imaginary
enemy. The horse itself, seen nearly in profile, appears to have been modelled from
nature and not from the prints of earlier artists.

4

The Holy Family

W.30 L.615 T.24 P.725
Pen and black ink. 290 × 214mm.
Provenance: W. Esdaile; Galichon; Rodrigues. *Berlin, Kupferstichkabinett*

THIS DRAWING, probably executed in 1492 or 1493 shortly after Dürer's fruitless visit
to Schongauer in Colmar, was clearly drawn in homage to the master he never saw. But
if he did not meet the man, he closely scrutinized his works, such as, for example, the
Virgin and Child on a Grassy Bank (B.30), so that, compared with the stilted assimilation
of individual motifs in the *Hunters* (Plate 2), he here shows himself a master of
composition. The figures of the Holy Family securely inhabit the landscape, which
recedes from them towards an enchanted background. A castle, situated beside a river
leading into a large lake, nestles at the bottom of a rocky hill. The distance is subtly
suggested by the line of trees and the paths, as well as by a delicate variation in the
degree of finish of the pen work, so that the eye is enticed on a smooth, continuous
journey into the landscape. Already Dürer's drawing of details has acquired its own
individuality. The long, tapering fingers of Joseph's hand, on which he rests his head,
are almost identical to those of Dürer's own hand in his *Self-portrait* in Erlangen
(Frontispiece), itself on the verso of another version of the *Holy Family* (w.25). Indeed
the artist's exercise in the mirror may have served directly when he came to treat the
problem of the sleeping Joseph.

*Holy Family with a
Butterfly.* Engraving, about
1495. 236 × 185mm.

46

When making this drawing, Dürer may have already had a print in mind, so that when he came to engrave the *Holy Family with a Butterfly* (B.44) two or three years later, he adopted the same arrangement as here. The Virgin is seated on a wooden plank resting against a grassy bank, on which Joseph is peacefully slumbering, all of which is set before a deep landscape composed of water, rocks and a castle. The engraving represents the culmination of Dürer's early studies of the Holy Family, but unlike the drawing shows the influence of Italian art in the more classical composition with its clearly stated vertical and horizontal divisions.

5

Female Nude

W.28 L.345 T.39 P.1177
Pen and brown ink. 272 × 147mm.
Dated 1493
Bayonne, Musée Bonnat

A SHORT, SQUAT MODEL, unadorned and unidealized, representing a woman on her way
to the bath, or an attendant at the baths. It represents the earliest study of the nude,
both in Dürer's work and probably in German art, a theme of the maximum importance
in Renaissance art and of absorbing interest to Dürer, who constantly strove to create
correct canons of proportion. Here however the inspiration appears to be everyday
reality and not one of the constructed nudes of later years. Natural curiosity and not
theory was the starting point. Indeed the clearly visible underdrawing of the upper half
of the body shows how he felt his way before the model, changing considerably as he
proceeded. A different coloured ink—very apparent in the original—was used to work
over areas on the upper thigh and to complete the dangling end of the towel. He found
particular difficulty with the elbows. And yet with all the hesitations and corrections,
the final result shows a marvellous sense of light falling over the body.

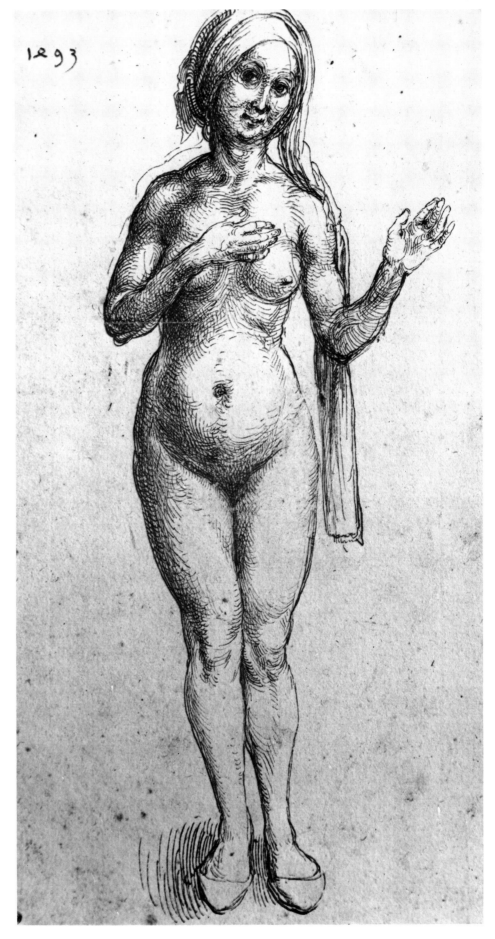

1493

49

6

Self-portrait, with Studies of the Artist's Left Hand and a Cushion

W.27 L.613 T.32 P.998
Pen and brown ink. 276 × 202mm.
Signed by another hand
New York, Robert Lehman Collection

THE PAINFUL PROCESS of Dürer's growing up is marked very clearly for posterity by three portrait drawings. After the innocent boy of 13 (Plate 1), we are next confronted with a self-portrait head, now in Erlangen, in which the hand is held up to the head as if to help it contain the intensely troubled, tortured thoughts of one who is searching for his true identity (Frontispiece). And now a year or two later, about 1493, at the end of his *Wanderjahre*, the artist appears calmer, but the mood is sombre and aloof. He conveys the feeling that if we care to, the mask of his face is ours to scrutinize, but his thoughts are his own, to be shared with no one. The youthful sprouting beard, the incipient moustache, the full, sulky lips, provide a poignant contrast of the world-weary look of someone who is no older than 22. The long sensitive fingers, two of which touch the top of the thumb as if clasping a flower, appear acutely nervous to the touch. Only the study of the inanimate cushion absorbs some of the emotion with which this sheet is charged. It was almost certainly used for the painted self-portrait dated 1493, now in the Louvre, bearing the fatalistic inscription, 'my affairs will go as ordained on high', presumably referring to his forthcoming engagement to Agnes Frey.

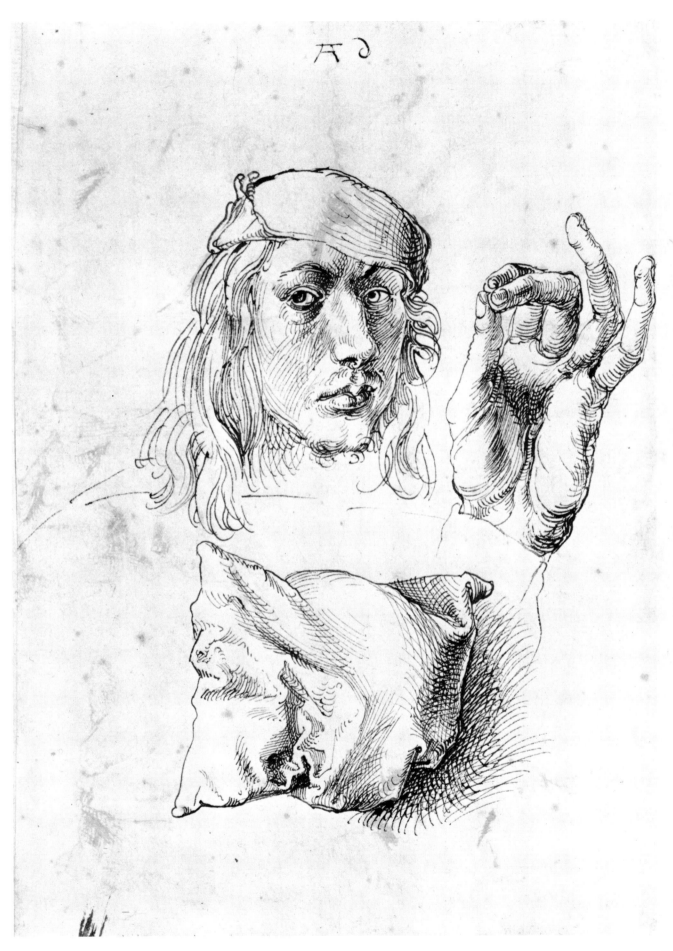

7

Agnes Dürer

W.151 L.457 T.62 P.1046
Pen and brown ink. 156 × 98mm. (reproduced original size)
Inscribed by the artist: *mein agnes*, and signed by another hand
Vienna, Albertina

DÜRER reached Nuremberg at the end of his *Wanderjahre* shortly after Whitsun, 1494. In his *Family Chronicle* he records that 'When I returned home, Hans Frey treated with my Father, and gave me his daughter, Mistress Agnes by name, and with her he gave me 200 florins, and we were wedded; it was on Monday before Margaret's (7 July) in the year 1494.' At the time it must have seemed a good match, since his father-in-law was a wealthy citizen of Nuremberg, but the marriage was not a happy one, and Agnes survived her husband as an embittered old woman, cherishing a particular dislike for Dürer's lifelong friend, Willibald Pirckheimer. The latter wholeheartedly reciprocated her feelings in a letter to a friend at the time of the artist's death, which though clearly prejudiced must contain more than a grain of truth.

'In Albrecht Dürer I have lost the best friend I ever had on earth; and nothing grieves me more than that he should have died so cruel a death. I can ascribe it to no one but his wife (after the decree of God), for she so gnawed into his heart and to such a degree tormented him that he departed hence sooner than he would have done. He was shrivelled up like a bundle of straw, and dared never seek for amusement, or go into company, for she was always uneasy, though there was no need for her to be so. She watched him day and night, drove him to work hard for this reason alone that he might earn money and leave it to her when he died. . . . I often besought her myself about her ungenerous, criminal conduct, and I warned her and told her what the end of it all would be, but I got nothing but ingratitude for my pains. She was the enemy of all who were kindly disposed to her husband and fond of his society; and this indeed was a great trouble to Albrecht and brought him to his grave. . . . She and her sister are not indeed loose, but doubtless, honourable and most God-fearing women; still one would prefer a loose woman, who bore herself friendly, to such a gnawing, suspicious, and scolding pious one, with whom no rest can be had day or night.'

But even if their life together became increasingly sour, the present portrait conveys an atmosphere of affection and informality, suggesting that the match, though arranged, did not necessarily begin on a disagreeable note. The absence of any underdrawing in pen or chalk emphasizes the directness and intimacy of this spontaneous sketch of 'mein agnes', sitting with her hand on her mouth, seemingly lost in thought and unaware of her husband's attention—a scene that was not to be matched until Rubens and Rembrandt provided us with similar intimate family records.

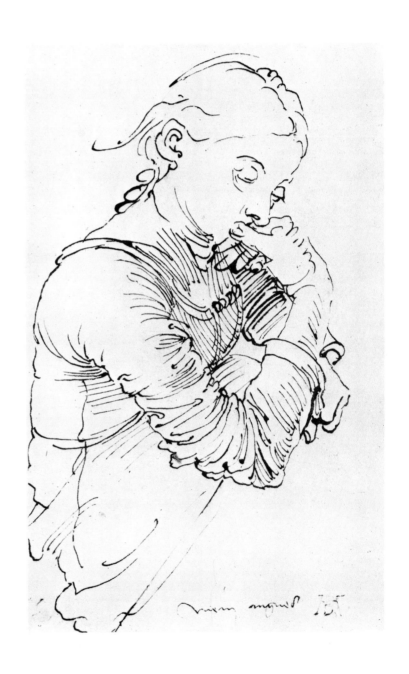

8

Fighting Sea Gods (after Mantegna)

W.60 L.455 T.63 P.903
Pen and brown ink. 292 × 382mm.
Dated 1494. *Vienna, Albertina*

EITHER shortly before leaving on his first journey to Italy in the autumn of 1494, or during his actual visit, Dürer made two copies after engravings by Andrea Mantegna. The present drawing is copied from the *Battle of the Sea Gods* (B.17), and though he followed the outlines of the original closely, he replaced Mantegna's uniform straight, diagonal shading with curved, more modelled hatching. His creative understanding of Mantegna's method of hatching was to have a lasting influence both on his engravings and his woodcuts. A century later both Rubens and Rembrandt, who undertook similar exercises, showed themselves hardly less impressed and influenced by the chiselled perfection of Mantegna's work with the burin.

In earlier drawings, such as the *Hunters* (Plate 2) and the *Holy Family* (Plate 4), inspiration had come from Schongauer and the Master of the Housebook. As a change from the religious courtly world of these two essentially medieval artists, Dürer now avidly turned to and absorbed the pagan mythological world of Mantegna. Direct reflections in subject-matter, style of drawing, and individual figures, taken from his two copies after the Italian artist, are visible in two engravings he made a few years after his return from Venice, *Hercules* (B.73) and the *Sea Monster* (B.71). The female figure seated on the back of the centaur on the extreme left is echoed in the *Sea Monster* and even more directly in the figure of the nude woman seated beside the satyr in the engraving of *Hercules*.

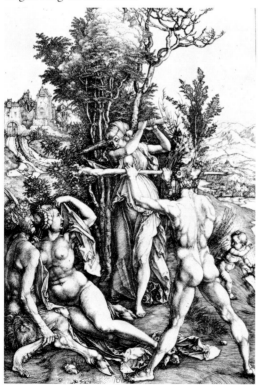

Hercules. Engraving, about 1500. 318 × 227mm.

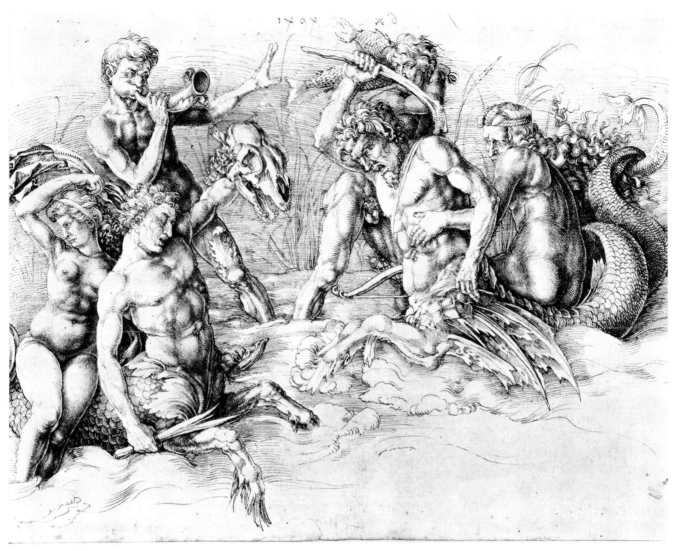

Andrea Mantegna (about
1431–1506): *Battle of
the Sea Gods*. Engraving.
328 × 440mm.

55

9

Female Nude

w.85 l.624 t.87 p.1178
Brush and pen in black ink. 320 × 210mm.
Signed and dated (subsequently, but correctly) 1495
Paris, Louvre

ALMOST CERTAINLY executed in Venice, this drawing reveals more forcibly than any other the first impact of Venetian art on Dürer. Compared with the short stocky woman in the nude study of two years earlier (Plate 5), the figure is tall and sinuous, and arranged in an elegantly serpentine pose, showing a tacit understanding of classical proportion and *contrapposto*. Recognition of the luminary aims of Venetian art is made by the use of the brush as a means of drawing, as well as by the suggestion of a source of light coming from the upper left, casting shadows across the upper thighs, the drapery to the right of the body and on the ground. The artist appears to have started by drawing in the torso in pen and ink, leaving the head, arm and lower legs virtually undelineated. The body was modelled, but instead of the short curving hatched lines of the earlier drawing, Dürer now used longer, straighter lines, which, as well as building up the form of the body, emphasized the flowing elegance of the pose. It was then that he took up the brush and completed the drawing of the figure, working over the outlines of the head and body to bring them into harmony with his increasingly pictorial conception. In the manner of Mantegna, he introduced the length of flowing drapery, conceived with the purpose of providing a foil to the body, at the same time brushing in the shadows. The effect of what Dürer saw immediately around him probably led to a result he had not entirely visualized when originally, pen in hand, he started this nude study. The engraving of *Fortune* (B.78) (see p. 66), made shortly after he got back to Nuremberg, shows a return to a more Germanic type of nude, though radically different from what he had done before, owing to his assimilation of all that he had seen and learnt on his journey to Italy.

On the verso (w.89) of this sheet Dürer traced through the outlines of the nude on the other side, but then proceeded to convert it into a frontal view of the figure, a trick which he used on several occasions later in his career.

Detail from *Female Nude* (verso).
Pen and brown ink

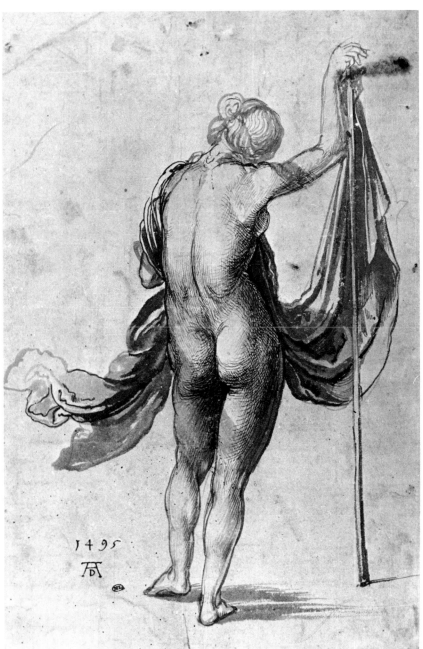

Castle Courtyard, Innsbruck (?)

W.68 L.452 T.AI72 P.1371
Watercolour. 335 × 267mm.
Vienna, Albertina

THIS DRAWING must be among the earliest landscape studies made by the artist and dates from the early 1490s. If the castle is really that in Innsbruck, as has been suggested but not proved beyond doubt, the sketch must date from the artist's outward journey to Venice in 1494. At first his interest was in details of landscape, and with his desire for accuracy and completeness he made a drawing of the courtyard from the other end as well (w.67). The clouds, which appear only in the present drawing, were probably a later addition by the artist to impart a more pictorial finish to an otherwise sober architectural record. Here he was basically concerned with the varying colours and textures of grey stone, red brick, brown wood and blue and red tiles. The view was probably taken from a window at the other end of the courtyard, and therefore represents what he saw, and not what he had to reconstruct with the aid of perspective.

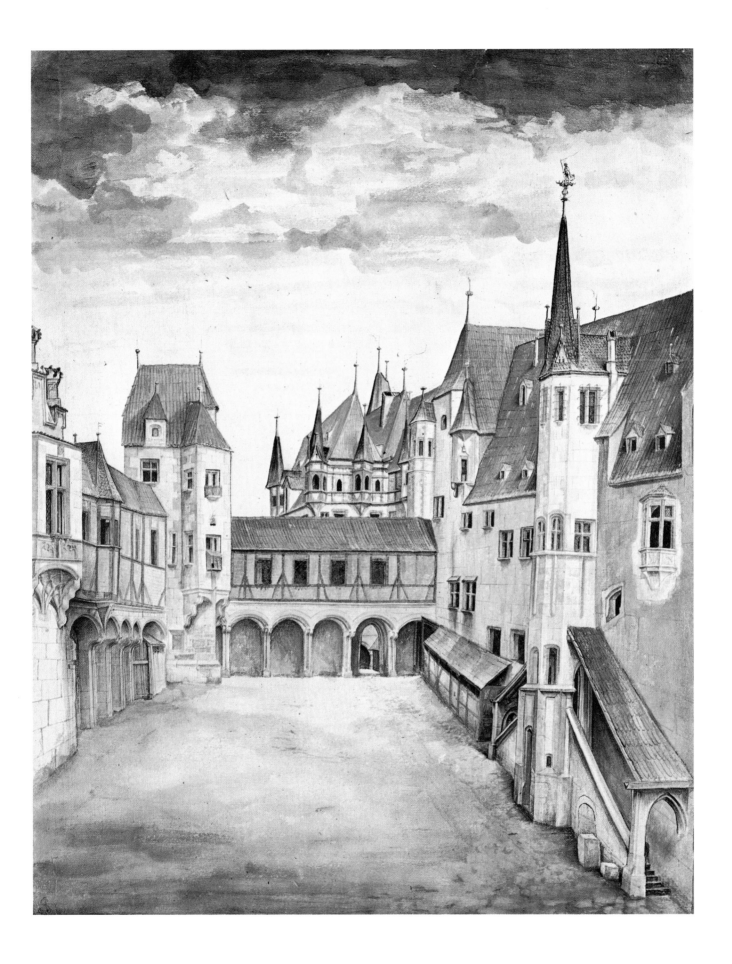

The 'Weiherhaus'

W.115 L.220 T.65 P.1386
Watercolour and body-colour, heightened with white. 213 × 222mm.
Inscribed by the artist: *weier haws*. Signed by another hand
Provenance: Sloane. *London, British Museum*

PROBABLY DRAWN shortly after Dürer's return to Nuremberg in 1495. Inspired by the numerous views he made on his journey to and from Venice, he turned to the countryside around his home town and made a number of similar watercolour studies.

The *Weiherhäuser* were small country houses, surrounded by water, which in time of war were often used for stationing troops. The rendering of evening light and reflections in the water combined with the feeling of solitariness, emphasized by the empty boat, make this one of the most poetic of Dürer's landscapes. There are no guiding lines visible, and he must have freely laid in areas of different coloured washes, and then worked up the details of the scenery with fine strokes of the brush, and body-colour. Local colour was now softened by the prevailing light and atmosphere. The highlights were then finally added in white body-colour.

Though clearly made as a study of landscape in its own right, Dürer used this watercolour for the background of the engraving of the *Virgin and Child with a Monkey* (B.42), of about 1498/9. He took over the motif of the 'Weierhaus' almost exactly, but in order to match the bright sunny day with fast-moving clouds, which replace the stillness of the watercolour, the trees around the house are made to bend under the impact of the stiff breeze. But as yet he was unable to convey with the burin the translucent reflections in the water seen in the watercolour.

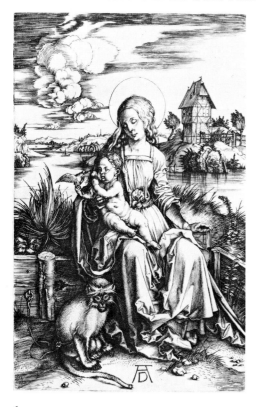

Virgin and Child with a Monkey.
Engraving, about 1498. 191 × 122mm.

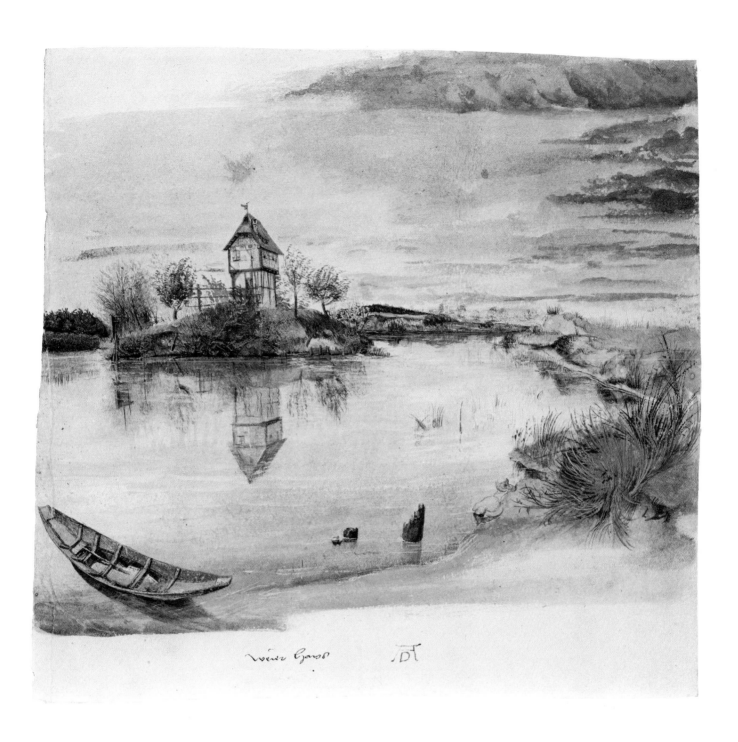

weier Hauss

61

Alpine Landscape

W.99 L.392 T.345 P.1384
Watercolour and body-colour. 210 × 312mm.
Inscribed by the artist: *wehlsch pirg*
Provenance: Lefevre; Chambers Hall. *Oxford, Ashmolean Museum*

THIS VIEW, which has been identified as showing the Valle di Cembra, between
Cembra and Segonzano, was probably drawn on the artist's return from Italy in 1495.
It miraculously conveys the clear freshness of the light and colour of a spring day, when
Dürer travelled back to Nuremberg. Instead of the variety of local colours used in
earlier landscapes, he confined himself to greens and blues, with a very translucent
reddish brown, suggesting the earth in the fields, and white and blue for the snow-
covered mountains in the left background. Only the central hill was worked up in
detail and thickened with body-colour, while the remainder was brushed in with
translucent washes, probably afterwards. The feeling for light as well as the panoramic
conception of the landscape owes much to the landscape backgrounds of Cima da
Conegliano and Giovanni Bellini.

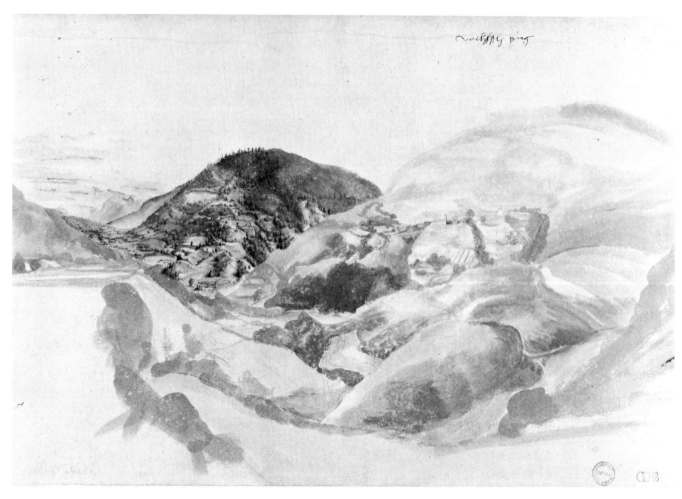

13

The Willow Mill, near Nuremberg

W.113 L.331 T.158 P.1388
Watercolour and body-colour. 251 × 367mm.
Inscribed by the artist: *weyden mull*. Signed by another hand
Provenance: Abbé de Marolles. *Paris, Bibliothèque Nationale*

LIKE THE '*Weierhaus*' (Plate 11) and the *Lake in the Woods* (Plate 14), probably drawn shortly after the artist's return to Nuremberg. The mill is situated beside the River Pegnitz, just outside the city, near the church of St John, where Dürer was buried. The landscape was executed in the same way as the '*Weierhaus*', though he has used broader areas of wash and less body-colour. Instead of the drier, more factual pre-Venetian landscapes, the motif is portrayed before a sunset in red, yellow and blue. The drawing records not just a particular place, but also a particular time and light.

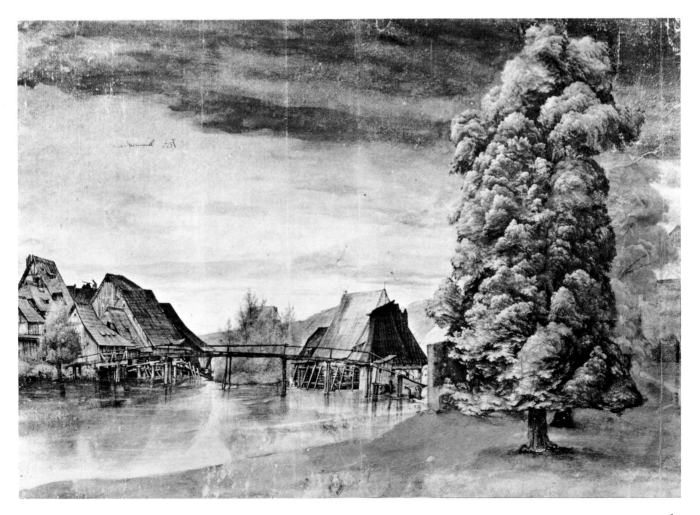

Lake in the Woods

W.114 L.219 T.157 P.1387
Watercolour and body-colour. 262 × 374mm.
Signed by another hand
Provenance: Sloane. *London, British Museum*

LIKE THE '*Weierhaus*' (Plate 11) and the *Willow Mill* (Plate 13), this was drawn shortly
after Dürer's return to Nuremberg. Here the motif is an empty pool, bordered on one
side by a pine forest and on the other by the trunks of a few pine-trees, whose tops
appear to be lost in the clouds. The water recedes indefinitely towards the horizon,
changing colour from grey to brilliant blue. The combination of the stark simplicity
of the foreground and the vivid orange of the setting sun on the horizon conveys the
immensity of the scene, heightened by the intense sensation of solitariness and silence.
It stands as the most romantic of all the artist's landscapes.

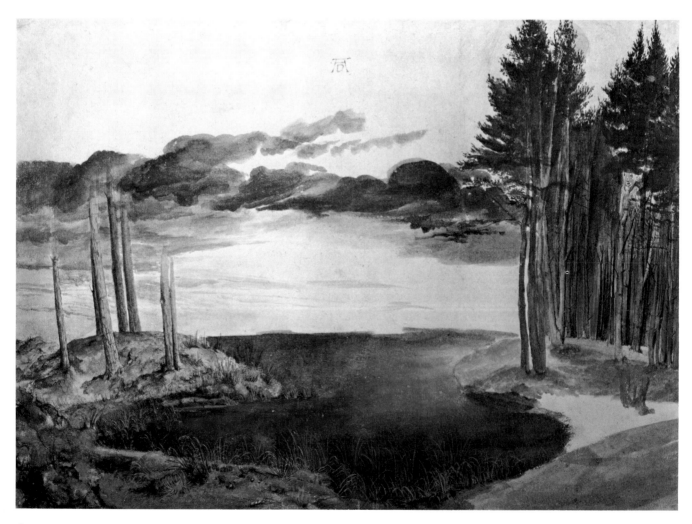

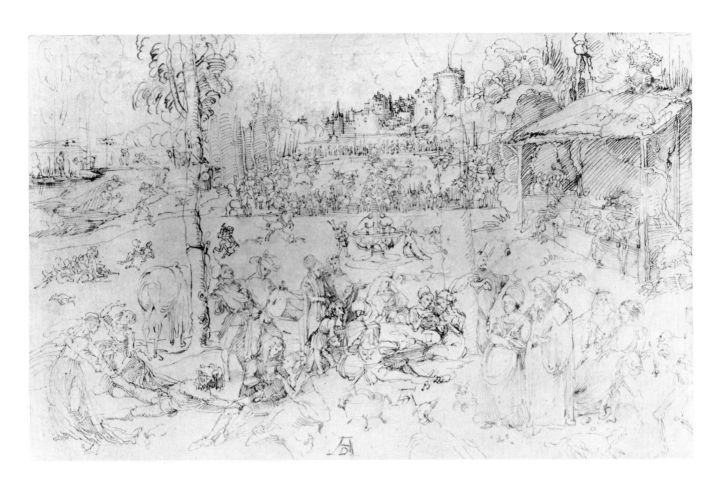

15 'The Pleasures of the World'

W.163 L.644 T.A150 P.874
Pen and black ink. 211 × 330mm.
Signed twice by another hand. *Oxford, Ashmolean Museum*

THE SUBJECT of this drawing, executed either just before Dürer's first visit to Venice or shortly afterwards, remains unexplained. In essence it derives from the Love Garden scenes of earlier German prints, but the mood is more extrovert, as witnessed by the behaviour of the two women dragging off a reluctant and struggling man on the left. In the centre lovers are seated around a table; on the right figures freely disport themselves in a bathhouse open to the air, while in the background a knightly joust takes place watched by spectators before a large castle. Three men are busy dragging a fishing-net from the river in the upper left. The setting is a courtly Garden of Eden, where everyone is concentrating on pleasurable activities. But the key to the subject lies in the lower right-hand corner, where a girl is escorted by an old man, followed by the figure of Death. Clearly the artist intended some moralistic allegory. Lucas van Leyden's engraving of the *Dance of the Magdalen* (B.119) echoes this drawing, particularly in the figures of the old man and the girl. Dürer's own uncertainty is emphasized by the numerous *pentimenti*, such as the large tree trunk, lightly drawn in later on the right, as well as by the fact that he drew the subject on two different occasions, using different pens and different coloured inks. For the first time Dürer combined a large number of small incidents within one composition. Though there is much in common with the drawings he made before he went to Venice, this drawing has a unity which stems from his study of Italian art.

65

The Women's Bathhouse

W.152 L.101 T.119 P.1180
Pen and brownish-black ink. 231 × 226mm.
Signed and dated 1496
Formerly Bremen, Kunsthalle

A HIGHLY FINISHED DRAWING of a women's bathhouse. The artist started with a freely outlined sketch, which he gradually built up, changing details where necessary, such as the left knee of the sitting woman in the foreground. The elaborate pattern of hatching and shading, recording every nuance of light and texture, matches that of an engraving, and this drawing was turned into a woodcut by a later artist. The very sensitive rendering of tone in this dark, panelled room shows the heritage of Dürer's visit to Venice. It was probably in the same year that he produced a male version of this subject in a woodcut of the *Men's Bathhouse* (B.128). This, however, lacks the self-conscious motif, found in the present drawing, of a bearded man peeping in through a window in the left background.

LEFT: *Four Naked Women*. Engraving, 1497. 194 × 136mm.
RIGHT: *Fortune*. Engraving, about 1497. 121 × 66mm. (original size)

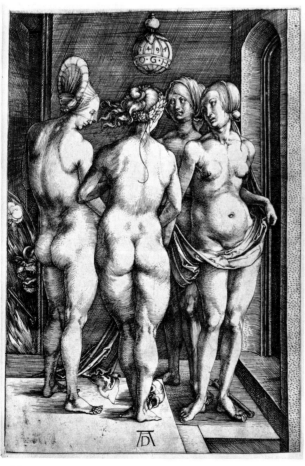
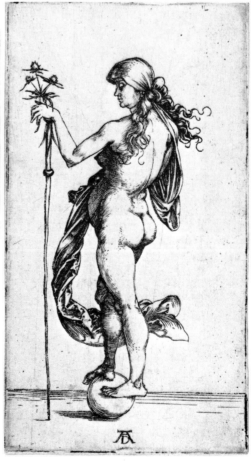

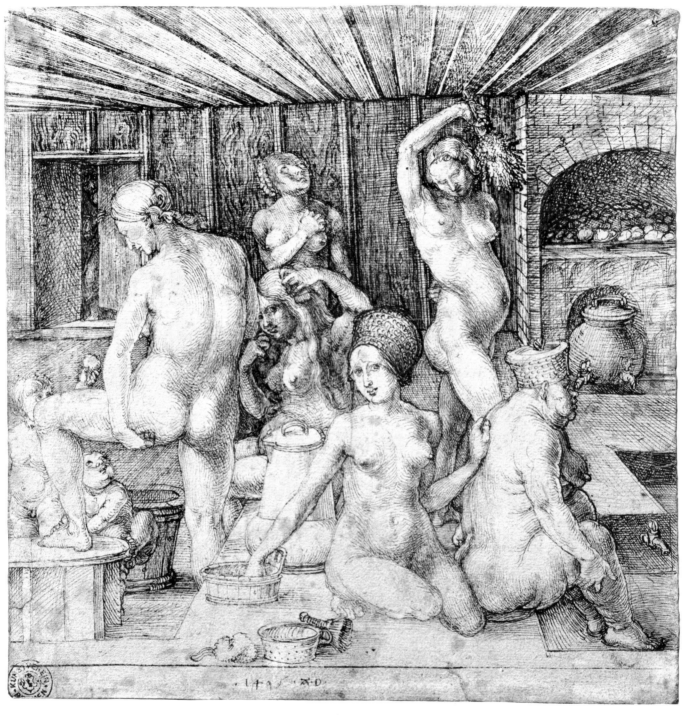

Dürer treated this drawing as a kind of female academy. When he produced two engravings in the following year, he extracted individual details and adapted them to the subject in hand. The upper part of the torso of the standing woman on the left of the drawing was used for the figure of the woman on the left in the engraving of *Four Naked Women* (B.75), dated 1497; in the same print the torso and arm of the woman on the right were based on the seated woman in the centre foreground of the drawing. In the engraving of *Fortune* (B.78), of about 1497, both the stance and the body are strongly reminiscent of the standing woman, arm raised above her head, holding a bunch of twigs on the right of the drawing.

Angel Playing a Lute

W.144 L.73 T.124 P.869
Silver point, heightened with white, on purplish prepared paper. 268 × 195mm.
Signed and dated 1497
Provenance: Sir T. Lawrence; S. Woodburn; Mitchell. *Berlin, Kupferstichkabinett*

THOUGH DÜRER made another silver point drawing on prepared paper with white
heightening (W.143), probably in the same year, it was not a medium he was to employ
often until his visit to the Netherlands. The angel with his gaunt, serious expression is
similar in appearance to some of the angels in the woodcut series of the *Apocalypse*
(B.61–75), first published in 1498, on which Dürer must have been working at the same
time as he made this study. Thausing has ingeniously suggested that the model for this
drawing may have been the artist's father-in-law, Hans Frey, who, according to a
contemporary, 'was famous for his harp-playing'.

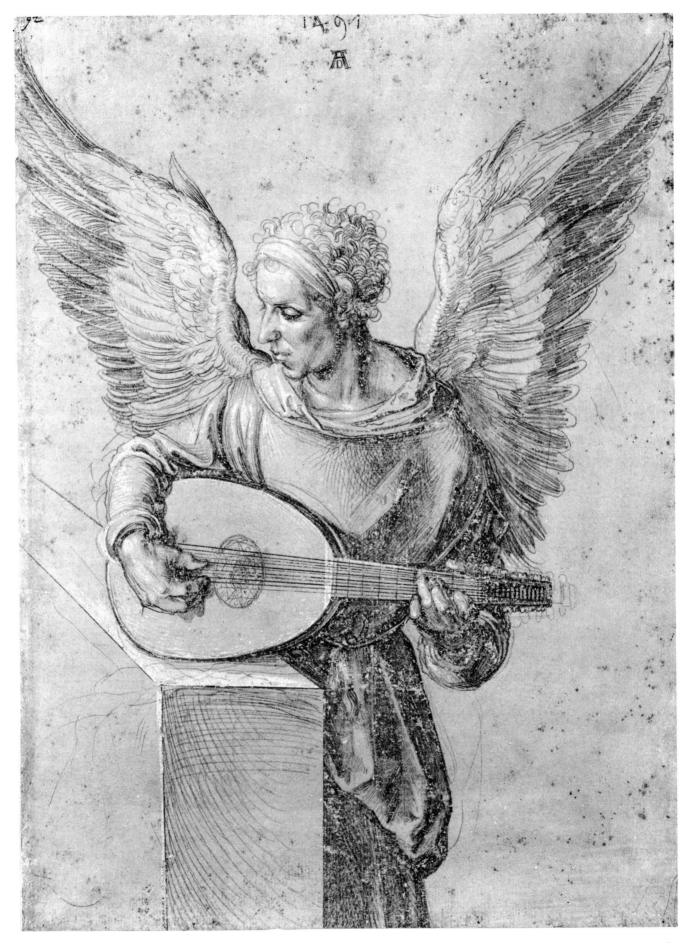

69

The Prodigal Son

W.145 L.222 T.48 P.647
Pen and brownish-black ink. 217 × 219mm.
Provenance: Sloane. *London, British Museum*

A COMPOSITION STUDY, of nearly the same size, for the engraving of the *Prodigal Son* (B.28), of about 1497. Dürer had already made a less finished study of the figure of the Prodigal Son by himself, formerly in the O. Gutekunst collection (W.146). A drawing of a bullock (W.239), worked up in detail with the pen, was used for the animal which appears only in outline on the right-hand side of the present drawing. When Dürer finally came to the engraving, only the hind quarters were shown on the extreme left. Though the present drawing shows the composition largely as it was engraved, the artist made a number of changes, such as the arrangement of the pigs, the introduction of piglets, the raising of the position of the Prodigal Son in relation to the buildings and the reduction of the amount of middleground, all directed at integrating the various elements of the composition more closely. Before starting work on the copperplate, he probably made another more careful and exact study, similar in character to the *Pupila Augusta* (Plate 19). These drawings show the painstaking thought and preparation undertaken before setting burin to copper.

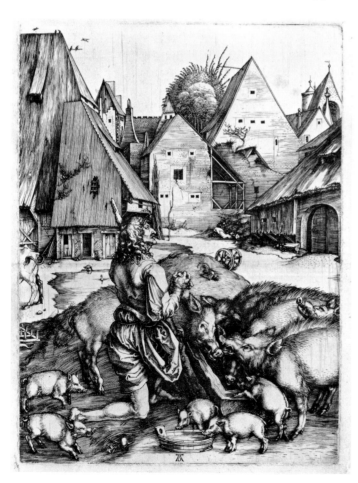

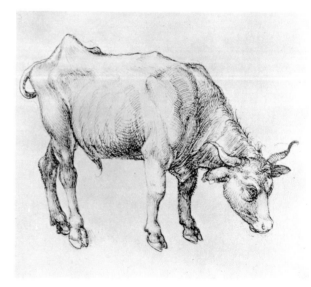

LEFT: *The Prodigal Son.* Engraving, about 1497. 246 × 190mm.

RIGHT: *Bullock* (detail). Pen and black ink, about 1497. 175 × 140mm. Formerly Lemberg, Lubomirski Museum

Pupila Augusta

W.153 L.389 T.90 P.938
Pen and black ink, with corrections by the artist in brown ink. 250 × 194mm.
Signed; and dated by another hand 1516
Windsor, Royal Collection

THE SUBJECT of this mysterious drawing, done about 1497, enigmatically inscribed
'PUPILA AUGUSTA' (literally 'august ward') on a basket, has never been satisfactorily
explained, though recently G. de Tervarent (*Burlington Magazine*, 1950 (xcii) p. 198)
has suggested that the three women in the foreground are the Horae, welcoming Venus
as she rises from the sea on the island of Cyprus. As Lamberto Vitali has shown
(*Bollettino d'Arte*, 1950, p. 309, repr.), Dürer was clearly inspired by an anonymous
fifteenth-century Ferrarese engraving of the same subject (see p. 74), since the reclining
figure with a winged head-dress, pointing to the dish, as well as the basket beside her,
are copied directly from the print. Dürer also included the motif of the pointing *putto*
in the lower right-hand corner of the drawing. Since both the monogram and the
inscription on the basket are written in reverse, it has generally been assumed that this
sheet must have been a preparatory study for a never executed engraving, possibly
conceived as a pendant to the *Sea Monster* (B.71) of about 1501. Both are approximately
the same size, and the subject, when reversed, would have provided a balanced
composition to the print of the *Sea Monster*. Moreover both works share the same
kind of mythological subject-matter. The hesitancy of line in the drawing offers an

St Anthony the Hermit. Engraving, 1519. 96 × 143mm. (original size)

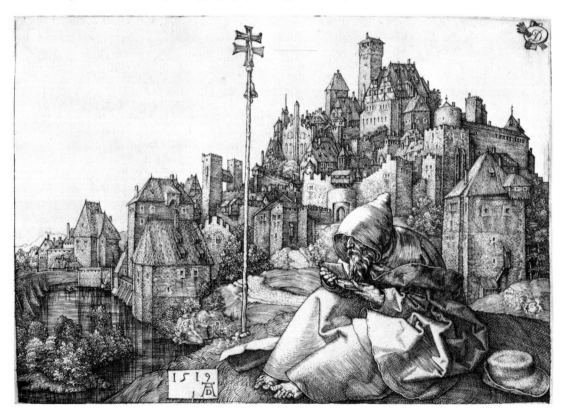

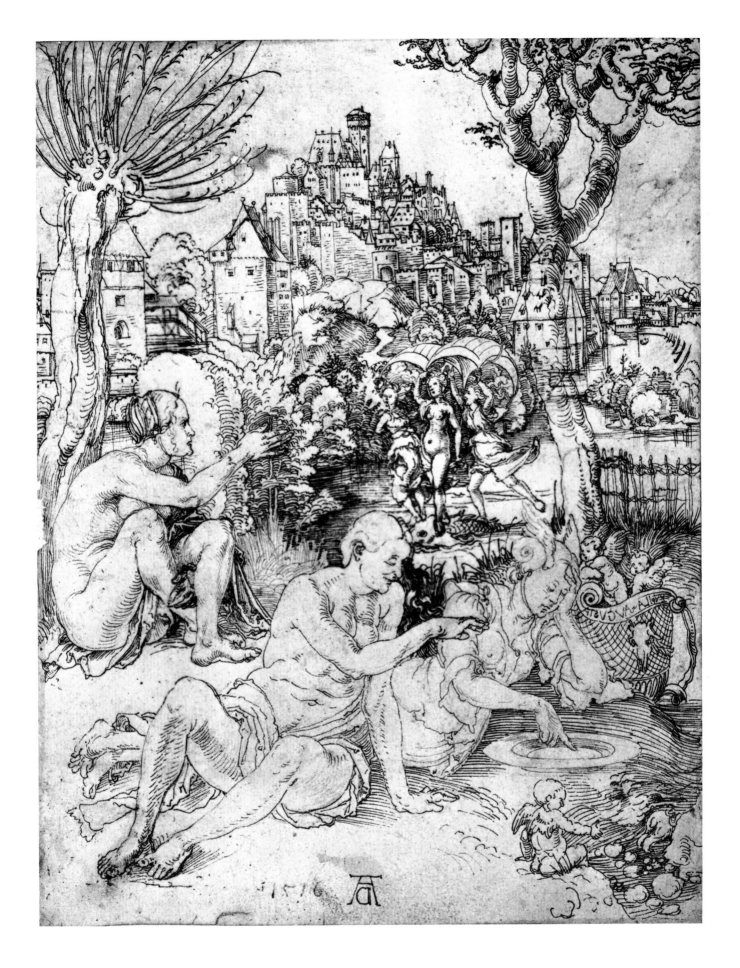

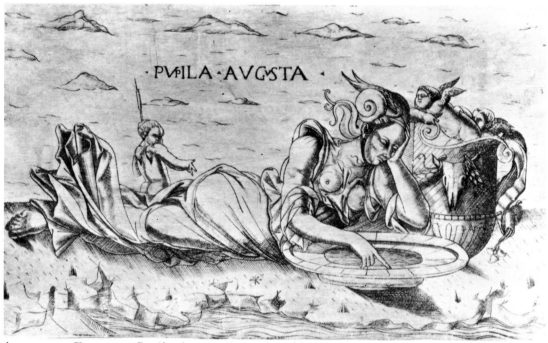

Anonymous Ferrarese: *Pupila Augusta*. Engraving, fifteenth century

example of the type of careful drawing the artist made before he actually started work on his copperplate. Probably another more freely drawn sheet preceded this study. The present composition is a careful compilation of motifs studied in other drawings, the buildings in the landscape being partly based on two watercolour drawings, the *View of Trent* (w.96), and the *View of Innsbruck* (w.66), which date from his Venetian journey.

Though the print was never executed, Dürer must have carefully preserved the drawing, for nearly twenty years later, when he came to engrave *St Anthony the Hermit* (B.58), dated 1519, he used the landscape as a background (see p. 72). (He had already used a variation of this town in the right-hand background of the painting of the *Feast of the Rose Garlands* in 1506.) Though he followed the design of his old drawing closely, both in detail and size, he realized in an entirely new way the individual cubic volume of each building. The hill town, which now resembles 'a cluster of crystals', to quote Panofsky, not only echoes the triangular shape of the figure of the crouched-up saint, but seems to advance and enclose him in an indissoluble bond. The corrections in brown ink, adding details of the landscape hidden by the right-hand tree in the drawing, were probably made by the artist at this time, so that nothing was left to guess-work when he took up the burin to start engraving.

Detail from the *Feast of the Rose Garlands* (see page 116)

74

20 *Design for a Table Fountain (detail)*

W.233 L.223 T.A122 P.1557
Pen and brown ink with watercolour. 560 × 358mm.
Provenance: Sloane. *London, British Museum*

THE LARGE SIZE of this drawing, done about 1500, is unusual in Dürer's work, and it may have been executed for his father-in-law, Hans Frey, who specialized in making mechanical water devices and table fountains. In view of the very high quality of draughtsmanship throughout, Panofsky's suggestion that it was executed by a well-trained assistant is unconvincing. The base of the fountain is decorated with scenes of country life, such as haymakers, hunters, shepherds, wayside robbers, travelling bands, and *Landsknechten*.

Greyhound

W.241 L.388 T.181 P.1321
Brush drawing in grey ink. 145 × 196mm. (reproduced original size)
Provenance: P. Sandby; Sir T. Lawrence. *Windsor, Royal Collection*

THIS STUDY, done about 1500, is one of the first drawings executed exclusively with the brush, a legacy of Dürer's visit to Venice. On this occasion he worked with the tip of the brush, without any visible underdrawing. Afterwards the artist used the drawing as a preparatory study for the large engraving of *St Eustace* (B.57), of 1501, in which the greyhound appears unchanged, apart from the reduction in scale. Dürer's incredible dexterity in handling the burin allows him to transfer from the drawing onto the copperplate his acute observation of the texture of the animal's coat.

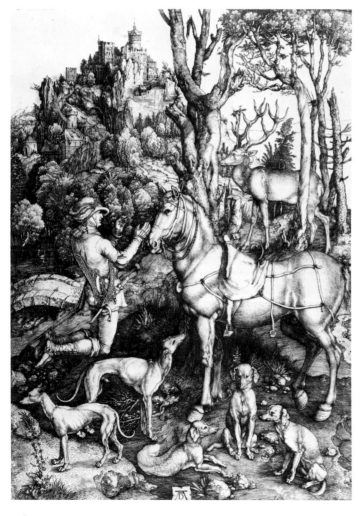

St Eustace. Engraving, about 1501. 357 × 260mm.

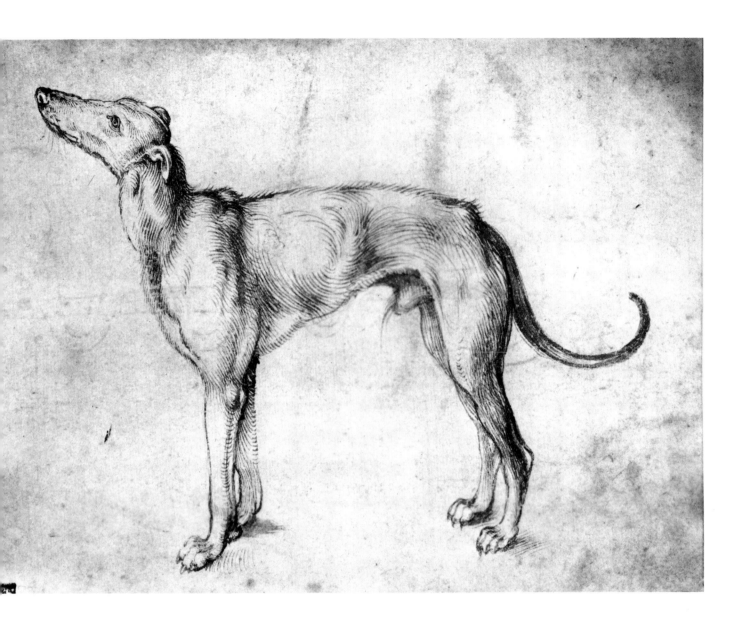

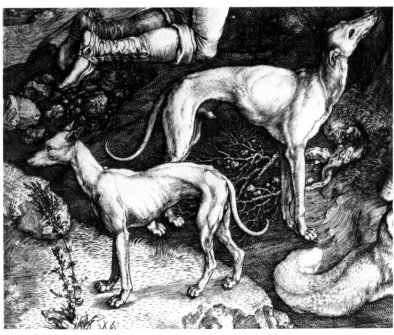

Detail from *St Eustace*

Nuremberg Woman Dressed for Church

W.224 L.464 T.187 P.1281
Pen and black ink with watercolour. 320 × 205mm.
Signed and dated 1500, and inscribed: *Gedenckt mein in Ewerm Reych 1500 Also gett zw*
Normerck in Die Kirchn
Provenance: Imhoff. *Vienna, Albertina*

ONE OF FIVE STUDIES—executed with a broad pen and watercolour, over an
underdrawing in fine pen lines—of Nuremberg women wearing various costumes
suitable for church, dancing and the house, for which the artist possibly used his wife
as the model. Though clearly made as a study in its own right, the identical woman in
the same dress appears in reverse as a fashionable companion of the Virgin on the right
hand side of the woodcut of the *Marriage of the Virgin* (B.82) from the series of the
Life of the Virgin, which Dürer must have executed three or four years later. One may
remark how skilfully and successfully the artist transposes the soft shading of the
head-dress and dress, drawn with the brush, into the far less tractable medium of
woodcut. Three of the drawings have always been together, and were only sold from
the artist's studio after his death. This suggests that they were never for sale and may
explain the existence of a nearly identical autograph replica of the present drawing,
executed entirely with the brush, without any pen work (W.232), which a would-be
purchaser of the original drawing may have commissioned from the artist.

Marriage of the Virgin. Woodcut,
about 1504. 293 × 208mm.

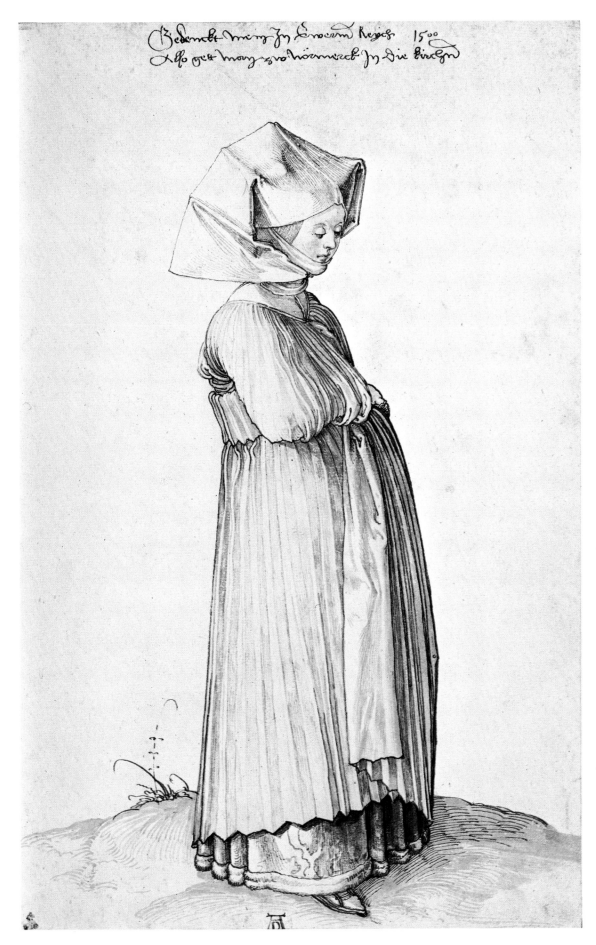

23

Hare

W.248 L.468 T.197 P.1322
Watercolour and body-colour. 251 × 226mm.
Signed and dated 1502
Provenance: Imhoff. *Vienna, Albertina*

THE MOST FAMOUS of Dürer's studies of animals in water and body-colour, of which numerous copies were made; one of these was a treasured possession of the seventeenth-century Roman sculptor Pietro Tacca and was specifically commented on by Baldinucci. Working entirely with the brush, Dürer first laid in the general outline in broad strokes, then with a fine brush added the animal's hairs, finally applying the highlights of white body-colour. Though the drawing achieves a perfection of detail, the shadows on the right emphasize that it was not undertaken merely as a scientific study. The animal was portrayed as part of the living world, with the light subtly picking out the colours in its coat.

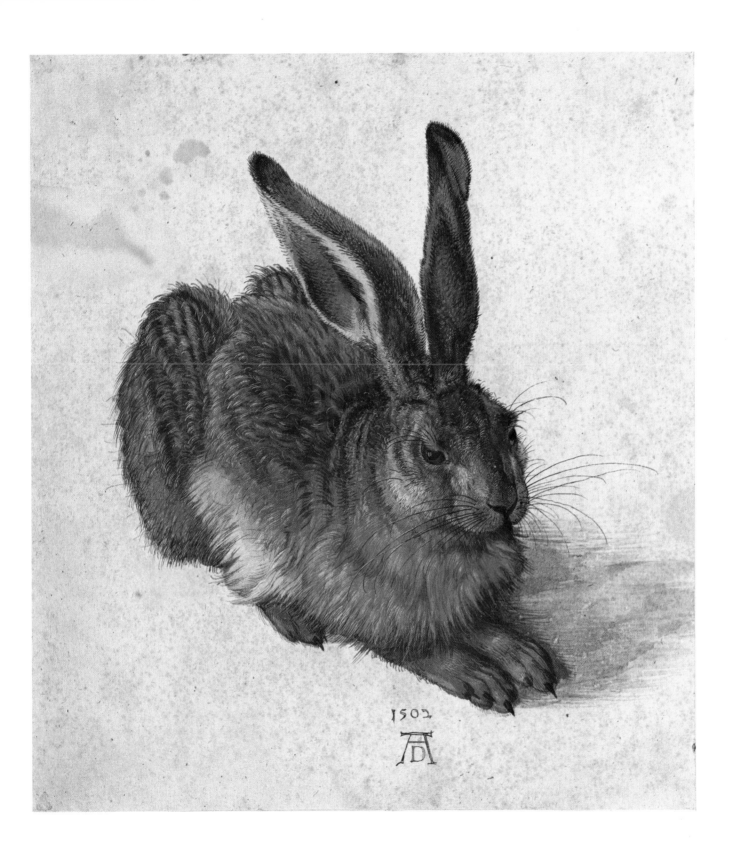

24

Elk

W.242 L.641 T.253 P.1319
Brush and pen in black ink with watercolour, heightened with white. 210 × 260mm.
Inscribed: *Heilennt* (i.e. Elk). Signed and dated 1519 by another hand
Provenance: Sloane. *London, British Museum*

THE OUTLINES were lightly sketched in pen and ink and then worked up with the
brush and watercolour. Some of the hairs were drawn in white body-colour.

Though an animal park existed in Venice, where Dürer probably studied large animals,
and possibly flowers, it is more likely, in view of the pen drawing of the bison (W.243)
on the verso of this sheet, that the drawing was executed in Nuremberg several years
later. (Five bison were presented to the Emperor Maximilian on his visit to Nuremberg
in 1501.) In 1504, when Dürer came to engrave the *Adam and Eve* (B.1), with which a
number of drawings are connected (see also Plate 32), he used the recto as a preparatory
study for the elk, which can be seen behind the tree-trunk in the centre. Though Dürer
followed his drawing closely, he altered the animal's head to give it an older and
gloomier look. Four of the animals which appear in the engraving—namely the elk, the
cat, the ox and the rabbit—were probably intended as symbols of the four humours,
with the elk representing melancholy. (For further iconographical discussion, see
Panofsky, pp. 84ff.)

Detail from *Adam and Eve*
(see page 102). Original size

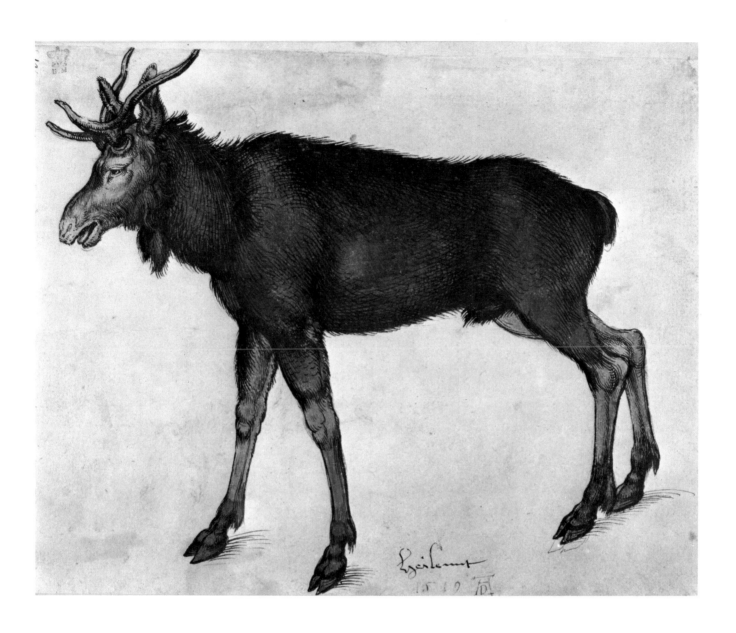

25

Virgin and Child with a Multitude of Animals

W.296 L.460 T.200 P.658
Pen and black ink with watercolour. 321 × 243mm.
Vienna, Albertina

THE SUBJECT of the Holy Family was popular with the artist throughout his career.
Though earlier drawings and prints had been devoted to the theme, none had been
executed on such a grand scale, or had included such an extensive landscape, with such
a plethora of natural life. The fecundity of the earth with its animal kingdom has
virtually become the subject of the drawing. St Eustace (see p. 76) had been portrayed
with numerous animals, but they were his companions. Here the animals, birds and
flowers belong to the landscape itself, and the Infant Christ seems to acknowledge this
by leaning forward and admiring a plant.

 This drawing must have been executed about 1503 at the same time as Dürer was
working on the woodcuts of the *Life of the Virgin* (B.77–95); it shows the same
combination of gentle domesticity and charm of subject-matter, with a theoretical
interest in perspective. No previous landscape had achieved such measured depth or
variety of terrain. The cautious hesitancy of the pen drawing, similar in character to the
Pupila Augusta, and careful application of watercolour indicate the thought given to the
drawing. Moreover there are traces of squaring on the figures of the Virgin and the fox.
Were it not for the addition of watercolour, one would suspect that it was intended as a
final preparatory study for a print.

 Apart from borrowing from earlier studies, such as the drawing of the *Stork* (W.240),

*Virgin and Child with a Multitude of
Animals.* Pen and brown ink, about
1503. 364 × 277mm. *Berlin,
Kupferstichkabinett*

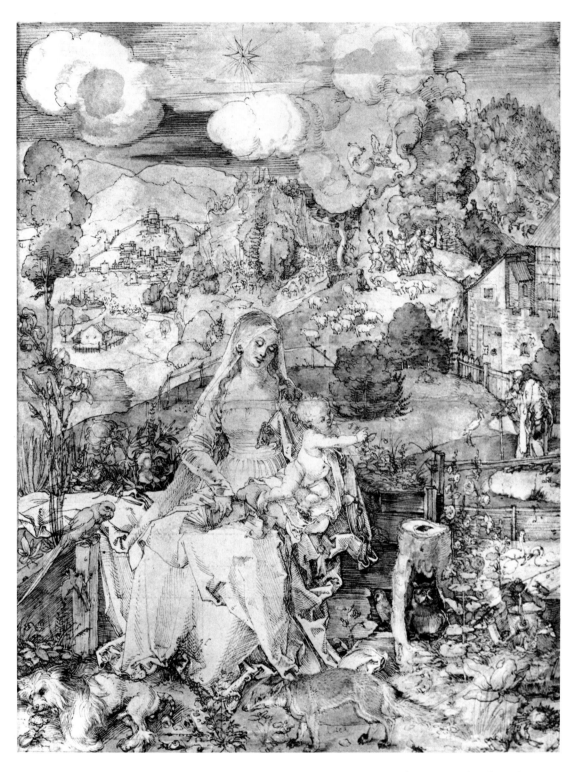

in Ixelles, the *Parrot* (w.244), in the Biblioteca Ambrosiana, Milan, and the *Sea Crab* (w.92), in Museum Boymans–van Beuningen, Rotterdam, Dürer took the trouble to make a free preparatory sketch, now in Berlin, of the whole composition. Though he retained the general layout in the present drawing he enriched and altered numerous details. More animals, such as the crab, the stork and the parrot, were added, while the sleeping griffin was moved from the bottom right-hand corner to the opposite side. The landscape was generally altered and articulated, and the scene of the *Annunciation to the Shepherds* was brought down from the top of the mountain in order to be in closer relation to the Holy Family.

Creszentia Pirckheimer

W.269 L.5 T.222 P.1056
Charcoal. 314 × 242mm.
Signed and dated 1503
Provenance: Imhoff (?); Nagler. *Berlin, Kupferstichkabinett*

THE SITTER of this imposing portrait is now generally identified as Creszentia Rieter, the wife of Willibald Pirckheimer. The portrait of Pirckheimer himself (Plate 27), also dated 1503, is identical in presentation and execution. (The discrepancies in size are probably due to both drawings having been trimmed later.) Profile portraits are rare in Dürer's work at this date and since they balance one another, they must have been conceived as a pair. A portrait of Frau Pirckheimer certainly existed 'drawn on paper with charcoal' and belonged to the Imhoff family, who also owned the drawing of her husband.

This and the following drawing are amongst the first non-family portraits made by Dürer. And to draw them he used the medium—new to him—of charcoal. This medium was particularly appropriate to large-scale drawings such as these, and he used it frequently thereafter. Grünewald employed a very similar method for his drawings of heads and single figures, and Dürer may well have taken the idea from him (see also note to Plate 29).

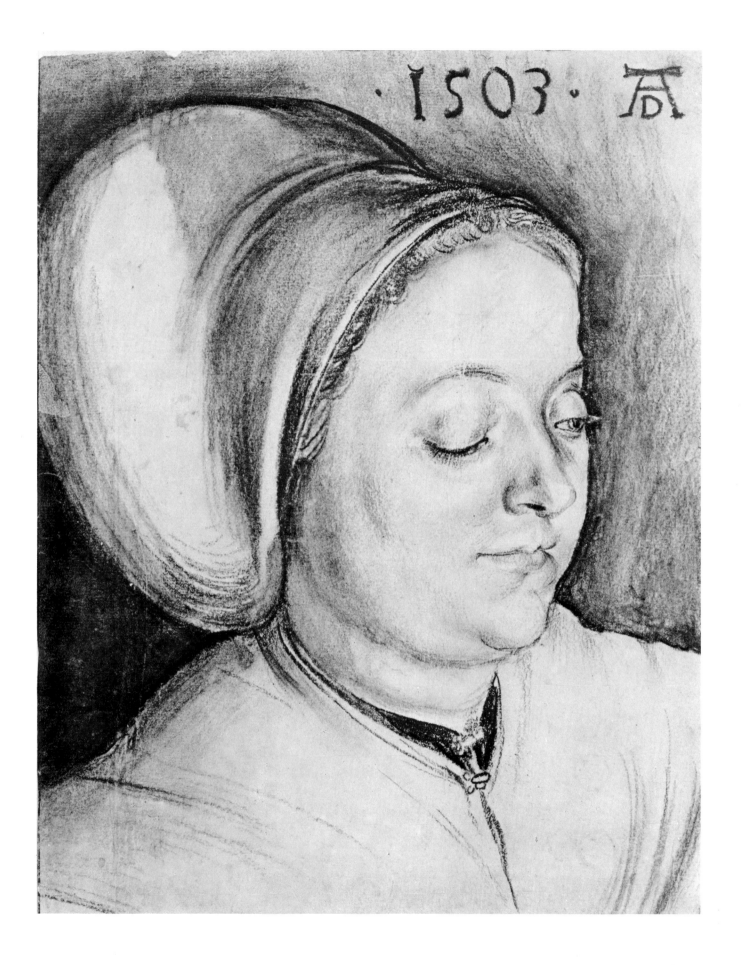

87

Willibald Pirckheimer

W.270 L.376 T.220 P.1037
Charcoal, with touches of white body-colour under the eyes and on the forehead.
281 × 208mm.
Dated 1503
Provenance: Imhoff; Zoomer; Defer-Dumesnil. *Berlin, Kupferstichkabinett*

SO BOLD AND FREE is this powerful portrait, almost certainly executed as a companion piece to the previous drawing, that it comes as a surprise to discover that it was probably based on another more delicate and 'searching' study, drawn in silver point, which was made from the life (w.268). Without changing the details of the face, the artist has very subtly altered the strict profile view of the silver point, so that the sitter now looks a little towards the spectator. It has been suggested that it was made as a preparatory study for a medal. No contemporary medal is known but one was cast at a later date.

Willibald Pirckheimer, who was a year older than Dürer, was the son of a rich Nuremberg merchant. The rear part of the Pirckheimers' large house had at one time been let to Dürer's father, where the artist was born. The Dürer family moved shortly afterwards to a house of their own, but the sitter and artist were probably brought up together and remained lifelong friends. Pirckheimer was married in 1495, a year after Dürer. Well educated, with a rare knowledge of Greek, and widely travelled, spending seven years in Italy, Pirckheimer had much to offer Dürer. In 1504 he boasted that he owned a copy of every Greek book which had been printed in Italy. He became a town councillor and an influential figure employed on foreign missions. He was a passionate and full-blooded man, whom Agnes Dürer heartily disliked. A devoted humanist and believer in religious reform, he received the 'accolade' of a special papal excommunication. The most intimate contact which survives between the two friends is the series of letters written to Pirckheimer by Dürer during his second visit to Venice. Twenty-one years after this portrait was drawn, when Pirckheimer was 54, Dürer did an engraving of him (B.106), which the sitter used as a book plate.

The names of the sitter and the artist were inscribed on the back of the sheet (w., vol. II, plate II) by Pirckheimer's grandson, Willibald Imhoff, who later owned the drawing. Imhoff, who died in 1580, succeeded in buying a large group of works from Dürer's studio after his death, including many of his most famous drawings and watercolours, which Dürer must have greatly treasured and refused to part with. These were later bought by Rudolf II, and most of them remained in the imperial possession, forming the basis of the Albertina, which as a result houses the finest and most extensive collection of Dürer's drawings, bearing a pedigree traceable back to the artist's own day.

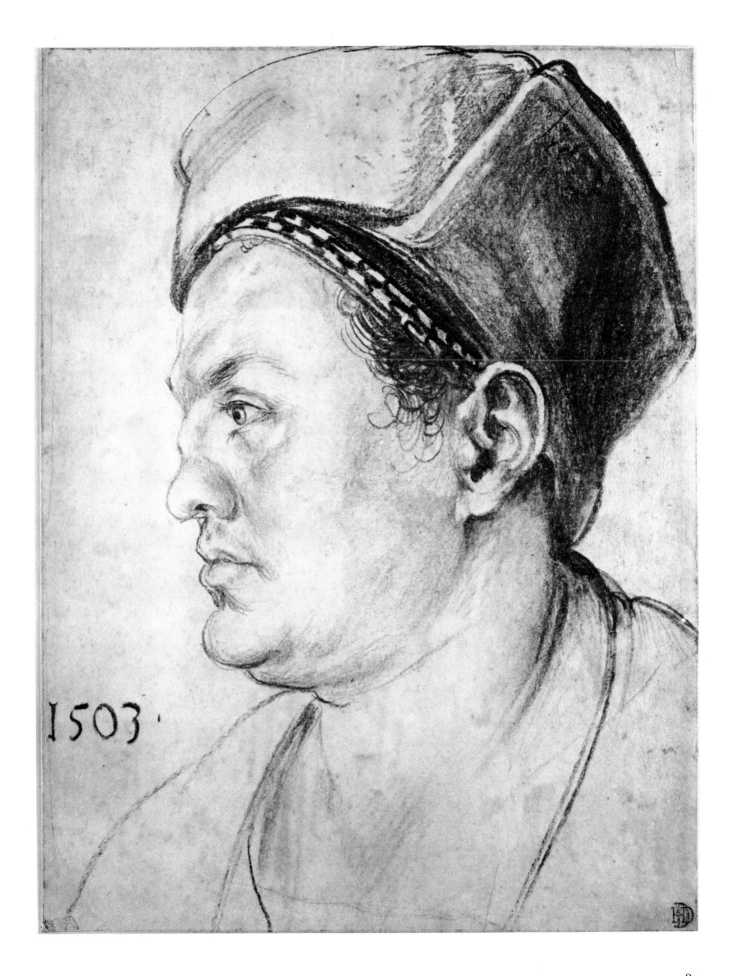

1503·

Self-portrait in the Nude

W.267 L.156 T.327 P.999
Pen and brush in black ink, heightened with white, on green prepared paper.
292 × 154mm.
Signed by another hand
Provenance: Grünling. *Weimar, Schlossmuseum*

THE MOST REMARKABLE and intimate of all the artist's self-portraits, probably drawn in 1503. The artist stands naked before the mirror, examining his emaciated body and haggard face with a cool detachment. This exercise was probably prompted by his recent illness. Like many others in Nuremberg and elsewhere, Dürer had suffered from one of the plague epidemics which had started to circulate in 1503 and were to grow to alarming proportions two years later. They had been heralded by what at the time seemed to be evil omens, the appearance of a comet and a 'blood rain' which fell on many people in Nuremberg. An atmosphere of panic and terror prevailed, which is vividly expressed in other works by Dürer of these years. But on this occasion he wished to take stock of his physical state. This drawing, largely executed with the brush on coloured paper, is highly pictorial and foreshadows the brush drawings he was to make on his second visit to Venice.

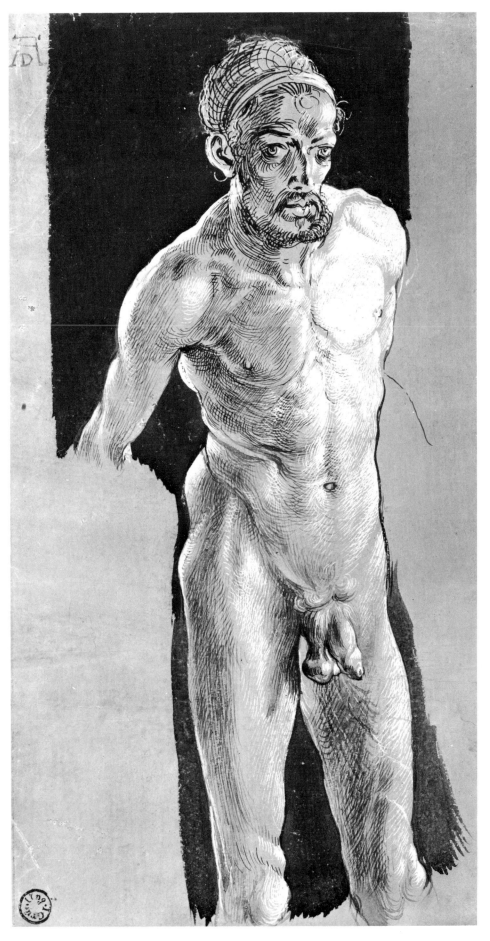

Head of Christ Crowned with Thorns

W.272 L.231 T.225 P.621
Charcoal on discoloured brownish paper. 360 × 210mm.
Signed and dated 1503; inscribed (see below)
Provenance: Sloane. *London, British Museum*

PROBABLY CONNECTED with the *Head of a Suffering Man* (W.271) in the British
Museum, of the same date and in the same medium. As in the other drawings in
charcoal, such as the portraits of the Pirckheimers (Plates 26 and 27), the artist appears
to have started work with a lighter coloured chalk or charcoal, rubbing in the half-tones,
so that the uncovered areas of paper act as highlights. He then worked over the outlines
and other darker accents with charcoal, as well as adding the monogram and date.

 The present drawing was inscribed by the artist, 'This face I have made for you . . .
during my illness', and this and the *Head of a Suffering Man* represent Dürer's first
studies of facial expressions of suffering, probably inspired by his own recent experience
and that of others (see note to Plate 28). Both studies were probably done with a
representation of the *Lamentation* in mind. Dürer had painted this subject (now in the
Alte Pinakothek, Munich) in 1500, but the expressions of sorrow and pain were far less
keenly realized. Here the strongly foreshortened head, the very real and viciously
barbed crown of thorns, the eyes only showing the whites, and the open, hanging
mouth, convey a feeling of anguish far beyond the conventional, and must result from a
deep emotional experience on the part of the artist.

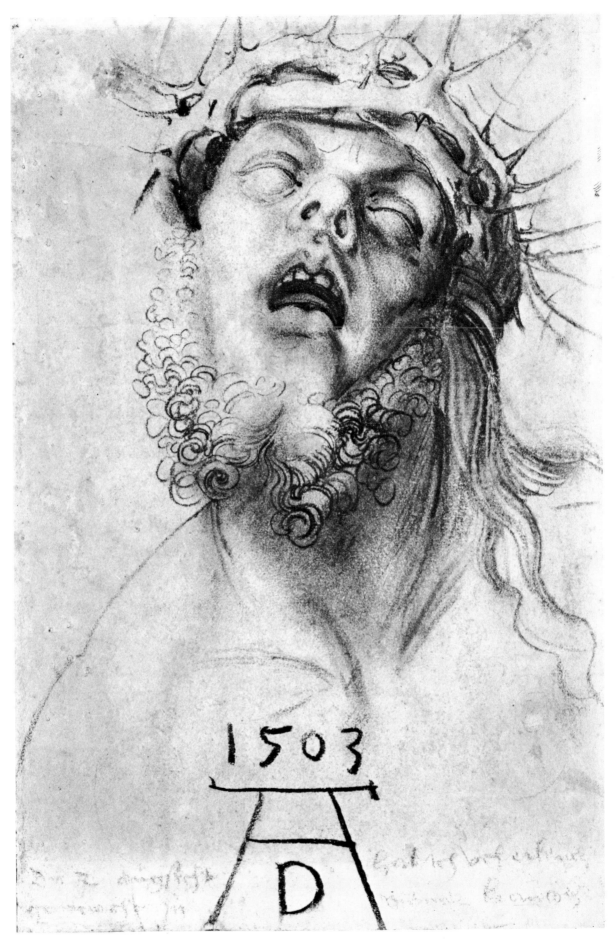

30

Head of a Roe-deer

W.365 L.358 T.197A P.1348
Watercolour. 228 × 166mm. (reproduced original size)
Signed and dated 1514 by another hand (Hans von Kulmbach?)
Bayonne, Musée Bonnat

ONE OF THE MOST attractive of the group of animal studies Dürer made in the years
1503 to 1505, some of which, as here, were executed in watercolour. The present
drawing was executed entirely with the brush, in a very limited range of colours—
brown for the antlers, and grey and white for the skin. Dürer made another study of
the head of a roe-deer—though seen almost in profile and drawn with brush and ink—
which was in the Lubomirski Museum, Lemberg (w.364).

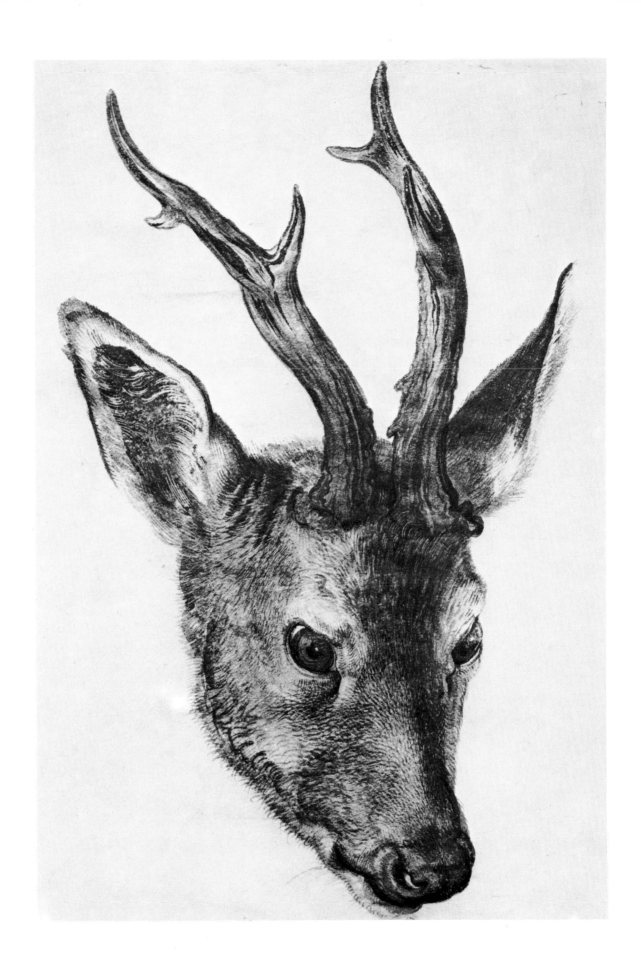

31

Venus on a Dolphin

W.330 L.469 T.234 P.930
Pen and black ink. 215 × 212mm.
Signed and dated 1503
Vienna, Albertina

THIS DELIGHTFUL DRAWING of Venus harks back to the world of the *Sea Monster*
(B.71), a subject of pure fantasy set in an accurately realistic setting. She is seen on the
back of a dolphin, riding out to sea away from the wooded coast on the right, bearing
a cornucopia surmounted by the figure of a blind cupid firing an arrow. Venus, both
in type and in her profile view, recalls the engraving of *Nemesis* (B.77), probably done
in the same year. Both figures were constructed, with the protuberant outlines of the
body drawn with the compasses, and show the beginnings of the artist's studies in
proportion.

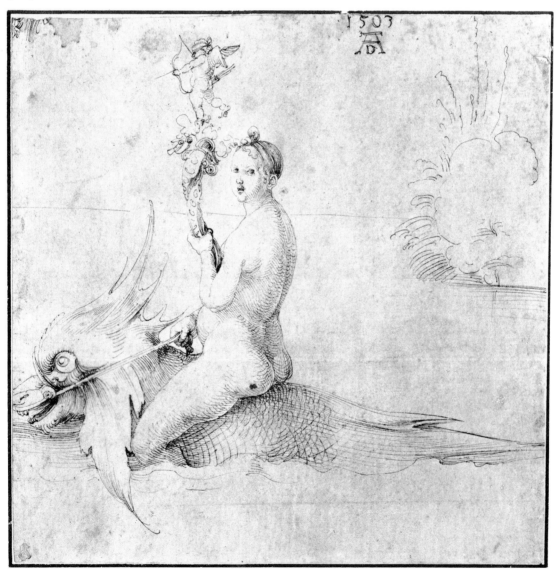

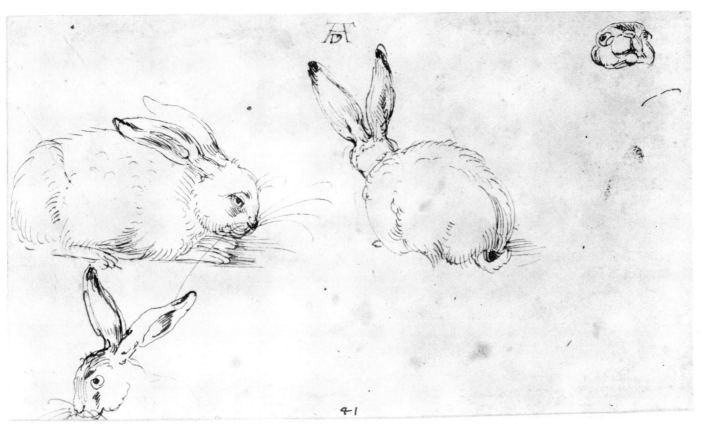

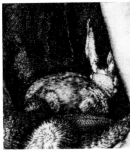

Detail from *Adam
and Eve* (see page 102).
Original size

32

Studies of Rabbits

W.359 L.782 T.255 P.1346
Pen and black ink. 123 × 220mm.
Signed by another hand
Provenance: Sloane. *London, British Museum*

FOUR RAPID SKETCHES, done from nature about 1503, studying a rabbit from side and
back views, as well as details of the head from front and side. The study of the rabbit
on the right, seen from behind, was used in the engraving of *Adam and Eve* (B.1),
where it was probably intended to symbolize the sanguine temperament (see note to
Plate 24).

The Great Piece of Turf

W.346 L.472 T.238 P.1422
Watercolour and body-colour. 410 × 315mm.
Dated 1503
Vienna, Albertina

THE MOST FAMOUS of the artist's studies of plants. The other watercolours were
limited to individual plants or flowers, freshly dug up from the garden and studied
with their black earth still clinging to the roots, and only on this occasion did the artist
extend his range and produce what is virtually a view of a river-bank. Apart from
various grasses and ferns, Dürer portrayed yarrow, dandelion and plantain, indicating
that the drawing was probably executed in May.

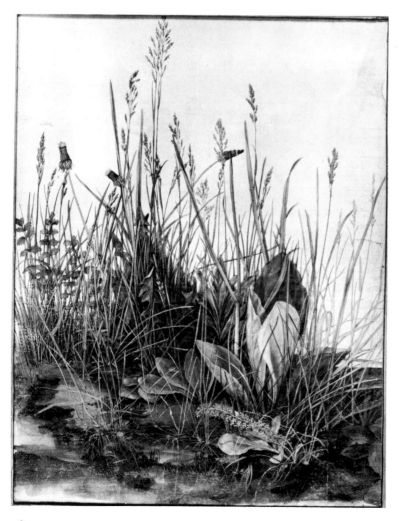

The Great Piece of Turf

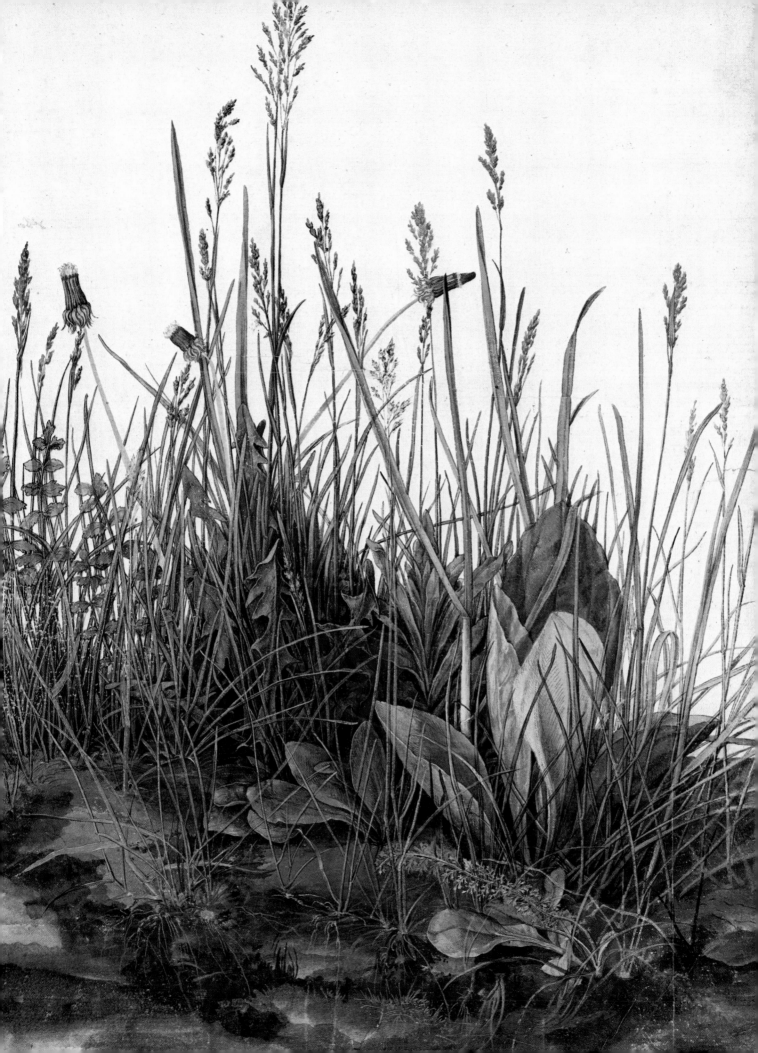

34

Apollo and Diana

W.261 L.233 T.231 P.1599
Pen and brown ink with touches of white body-colour (oxidized). 285 × 202mm.
Inscribed by the artist upper left: *ein 3 teil von 5. . . .*
Provenance: Sloane. *London, British Museum*

AROUND 1501/2 Dürer made four 'constructed' studies of the male nude, three representing Apollo (the present drawing, and w.262 and 264), and the fourth Aesculapius (w.263). They show the artist's increasing preoccupation with the theory of proportion, according to the canon of Vitruvius, and his search for the ideal male and female figures. The present study of Apollo, which was based on the recently discovered statue of the Apollo Belvedere, is the most finished of the group, though it was started as a freely drawn sketch, and slowly built up with areas of fine shading. Ruled, indented lines of measurement can be seen in the original on Apollo's head and body, while a curved indented line beneath the knee indicates the use of a pair of compasses. The barely legible inscription refers to the system of proportion.

The development of the drawing into a fully pictorial composition—almost certainly with an engraving in mind, in view of the fact that the word *Apolo* is written in reverse—was probably only an afterthought. Apart from the dramatic sky with sun and clouds, the artist introduced the figure of Diana, thereby providing the female counterpart to the ideal male; but this time no lines of construction are visible. At first she was depicted from the back, with her arm raised against the brilliance of the sun. Only her torso was worked up with shading, before the artist, presumably because of the awkward position of her neck, decided to turn her round and depict her from the front. Her new position, only very lightly sketched in, can be seen to the right of the first figure. Dürer then abandoned the drawing, but not before tracing the design of the figure of Apollo onto another sheet (w.262), this time taking care to give the god his correct attribute of a bow.

Dürer was clearly inspired by Jacopo de' Barbari's engraving of Apollo and Diana (B.16); Apollo, based on a classical prototype, is shown in a similar stance, while Diana, as in Dürer's first version, is depicted from the back (see p. 102). Dürer ultimately produced an engraving of this theme (B.68) but in a totally different arrangement. Both these four studies of the male nude and Dürer's idea of presenting the ideal male and female together came to fruition in 1504 in the engraving of the non-classical subject of *Adam and Eve* (B.1) (see p. 102).

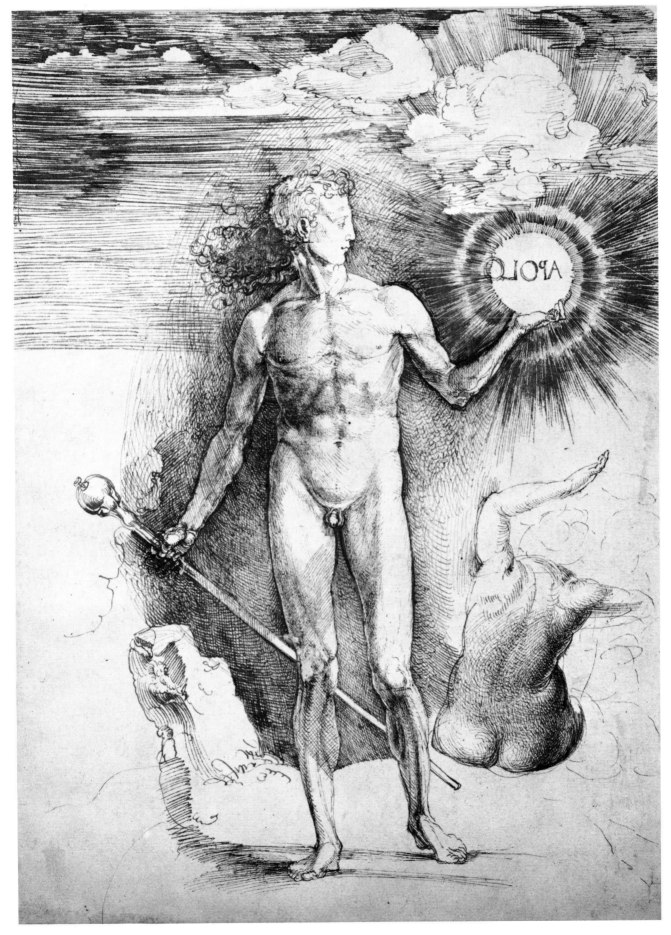

35

Adam and Eve

W.333 L.173 T.257 P.458
Pen and ink with brown wash (see below). 242 × 201mm.
Signed and dated 1504
Provenance: Imhoff; Andreossy; Gsell; Lanna. *New York, Pierpont Morgan Library*

PREPARATORY DRAWING for the engraving of *Adam and Eve* (B.1), dated 1504. In view
of the small but important changes between this drawing and the print—Adam no
longer holds an apple, Eve takes a second one from the serpent—presumably the artist
made another drawing from which he actually worked on the plate. Though the present
drawing is the only existing study of the two figures together, it is in fact made up of
two sheets of paper; the artist carefully cut round the arms before placing them
together, added a strip of paper in the middle, and then gave a unity to his patchwork
of paper by washing in the background. This method indicates that he made drawings
of the figures separately, as, for example, in *Study of Eve* (W.335), and only when he
was satisfied placed them together. The nude figures in this drawing and in all the
other studies either directly or indirectly connected with the print, such as the *Apollo*
(Plate 34), are constructed with ruler and compasses, according to Vitruvian
proportions. The engraving of *Adam and Eve* marks the culmination of the artist's idea

LEFT: Jacopo de' Barbari (died about 1515/16): *Apollo and Diana*. Engraving. 161 × 100mm.
RIGHT: *Adam and Eve*. Engraving, 1504. 252 × 195mm.

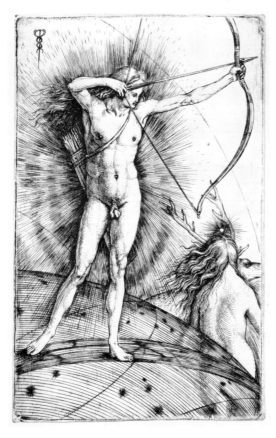
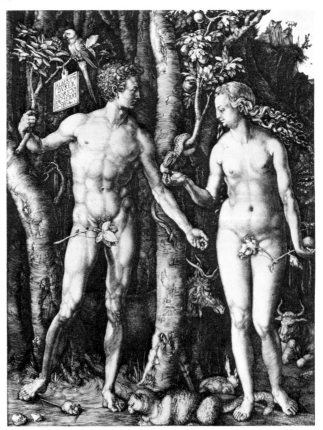

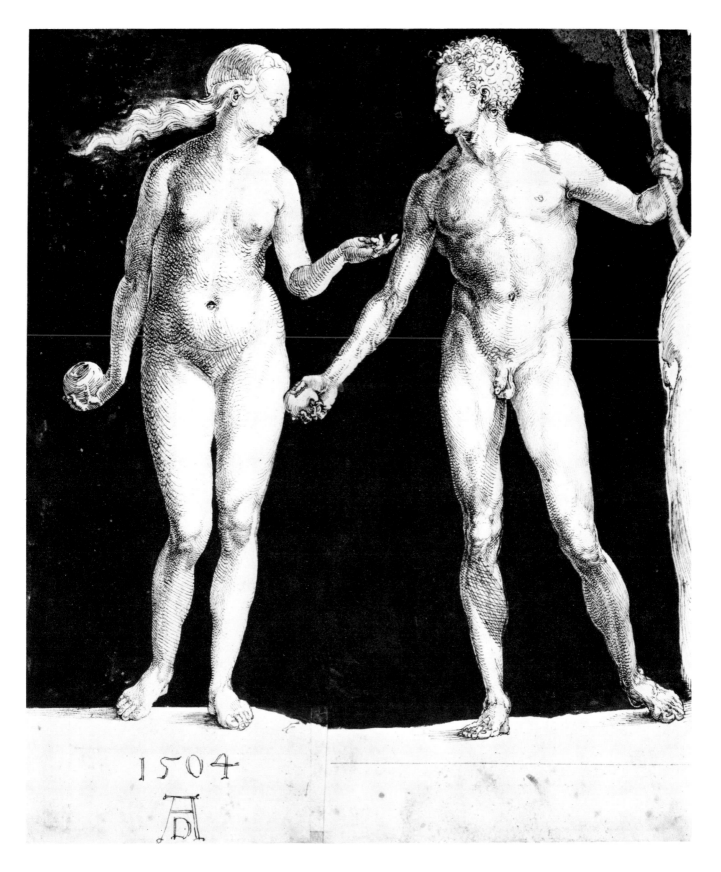

of a representation of the perfect male and female juxtaposed—a search after human beauty, which had begun some years before with the drawings of Apollo.

For the landscape background, Dürer drew on various animal studies he had made previously (see Plates 24 and 32).

The Nailing to the Cross

Literature: E. Schilling, *Berliner Museen*, 1954 (iv) p. 14, repr.
Pen and brown ink. 293 × 206mm.
Signed by another hand
Provenance: Bouverie. *Portinscale, Cumberland, F. Springell collection*

PREPARATORY OUTLINE STUDY for the following drawing, which forms part of the
Green Passion (see note to Plate 37).

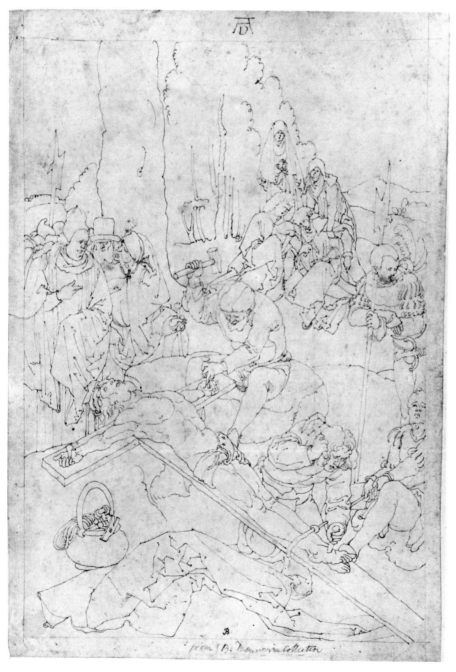

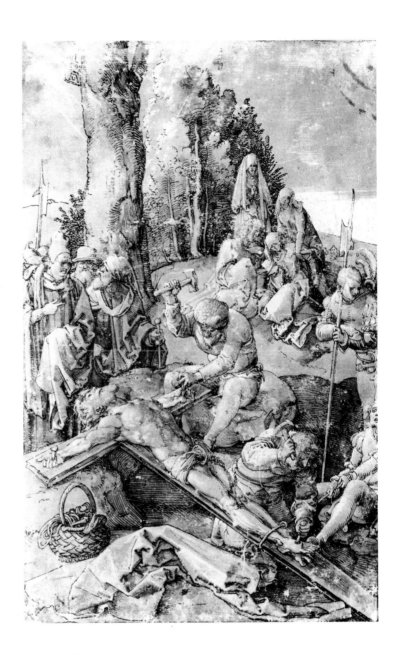

37 *The Nailing to the Cross*

W.311 L.486 T.W45 P.530
Pen and black ink with grey wash, heightened with white, on green prepared paper.
288 × 182mm. Signed and dated 1504. *Vienna, Albertina*

THIS BELONGS to a series of drawings known as the *Green Passion*, on account of the
colour of the prepared paper. Eleven exist today; the twelfth is lost. They are elaborate
and highly finished drawings, and as a result have sometimes been doubted as the work
of Dürer, e.g. by Tietze and Panofsky. (The latter believed that they were models for
painting, and speculated whether they could not have been intended as Stations of the
Cross, commissioned by Frederick the Wise, for the Schlosskirche in Wittenberg.)
They should probably, however, be regarded as finished works in their own right, to be
set beside the two great series of woodcuts of these years, the *Great Passion* and the
Life of the Virgin. Dürer made careful outline drawings in pen before commencing
work, not all of which still exist (see previous drawing).

Death on Horseback

W.377 L.91 T.A133 P.876
Charcoal. 210 × 266mm.
Inscribed: ME(M)ENTO MEI 1505, and signed
Provenance: J. C. Robinson; Malcolm. *London, British Museum*

A POWERFUL AND FRIGHTENING DRAWING, whose subject was probably inspired by
the outbreak of the plague in Nuremberg in the same year, which was one of the
reasons which induced Dürer to travel south again. The artist's acute awareness of
death was never more chillingly portrayed. Death, represented as the King of the
Plague, urges on his flagging, emaciated horse, further weighed down by the cow-bell
hanging round its neck, ringing the death knell as they proceed across the land. The
horse, which is no more than a skeleton, is a savage caricature of the proud Leonardesque
beasts, which are the subject of two engravings of the same year, the *Little Horse* (B.96)
and the *Great Horse* (B.97). So overpowering is the charcoal drawing of death and the
horse, that only afterwards does one notice the lightly drawn *aperçu* of a farm building
on a hill in the top right corner. Beneath the bravura of charcoal strokes on the two
main figures, one can see how the artist sketched in his subject first with a lighter
coloured chalk.

On the verso is the head of an owl, sketched in black chalk.

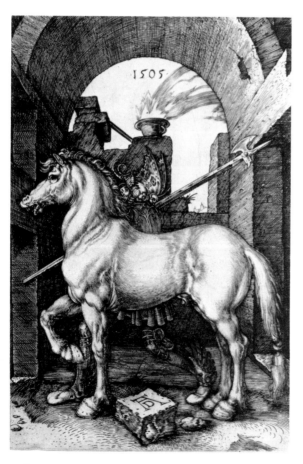

The Little Horse. Engraving, 1505.
165 × 108mm.

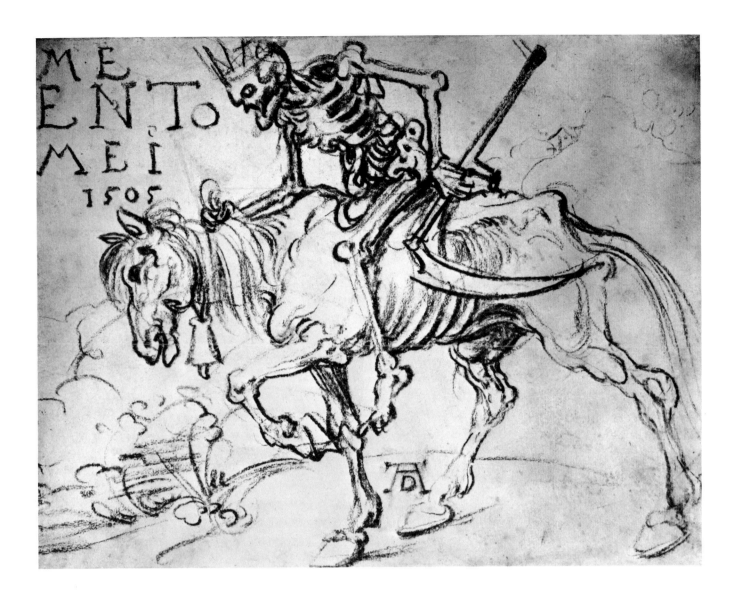

39

Portrait of a Slovenian Peasant Woman

W.375 L.180 T.287 P.1108
Pen and ink with brown wash. 390 × 270mm.
Inscribed *una vilana windisch*, and signed and dated 1505
Provenance: Lagoy; Seymour; ten Cate. *London, British Museum*

ONE OF THE MOST imposing drawings made by the artist during his second visit to
Venice, and clearly one treasured by him, in view of the elaborate monogram and date
bordered by decorative flourishes with the pen. The head itself is built up with areas of
fine hatching, which reflect the style of his recent engravings, but which nevertheless
are marvellously sensitive to the *sfumato* effect of Venetian painting which so coloured
his work when in the city. But it is characteristic of Dürer that, though deeply
influenced by the art around him, he still retained his own brand of personal curiosity
and made an elaborate portrayal of somebody who would not accord with Venetian
ideals of beauty. He remained a supremely detached and direct observer of life.

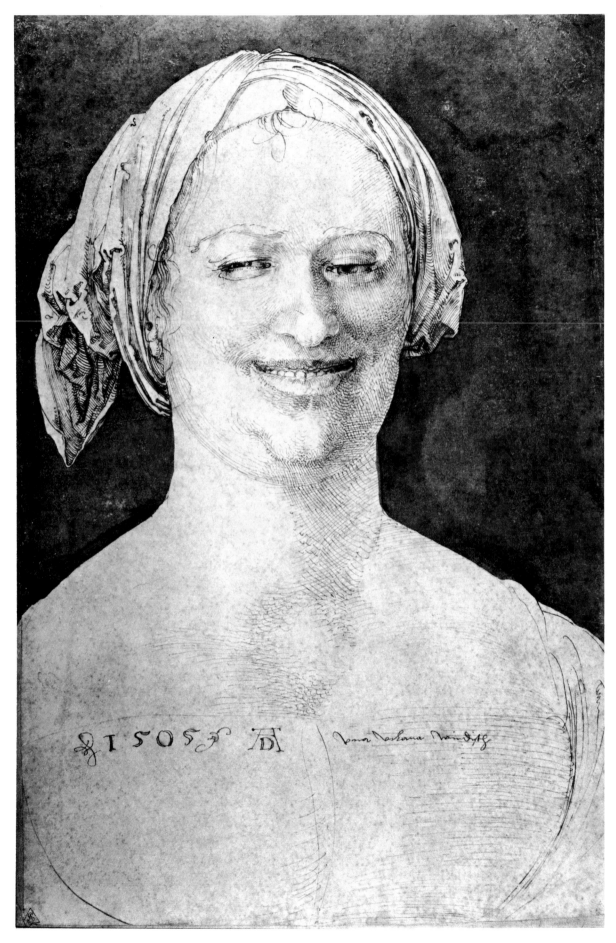

Head of the Young Christ

W.404 L.499 T.303 P.547
Brush drawing in brown ink, heightened with white, on blue Venetian paper.
275 × 211mm.
Originally part of a sheet signed and dated 1506 (see Plate 42)
Vienna, Albertina

PRELIMINARY STUDY for the head of the 12-year-old Christ in the painting of *Christ among the Doctors*, dated 1506, in the Thyssen collection, Lugano. This is probably the painting to which Dürer refers in a letter to Pirckheimer, 'the likes of which I have never painted before'. As well as adding his signature and date, Dürer inscribed the words '*opus quinque dierum*', and so free is the painting that one can readily believe that the actual execution took no longer than five days. But clearly he had meditated the composition for considerably longer since apart from the present drawing he made three elaborately pictorial studies of hands (see Plate 41), all of which were drawn with the brush on blue Venetian paper, similar to the preparatory studies for the painting of the *Feast of the Rose Garlands*.

Christ among the Doctors. Oil on panel, 1506. 650 × 800mm. Lugano, Thyssen collection

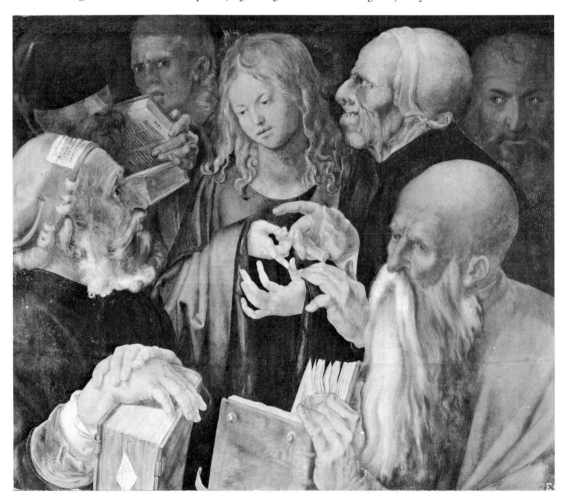

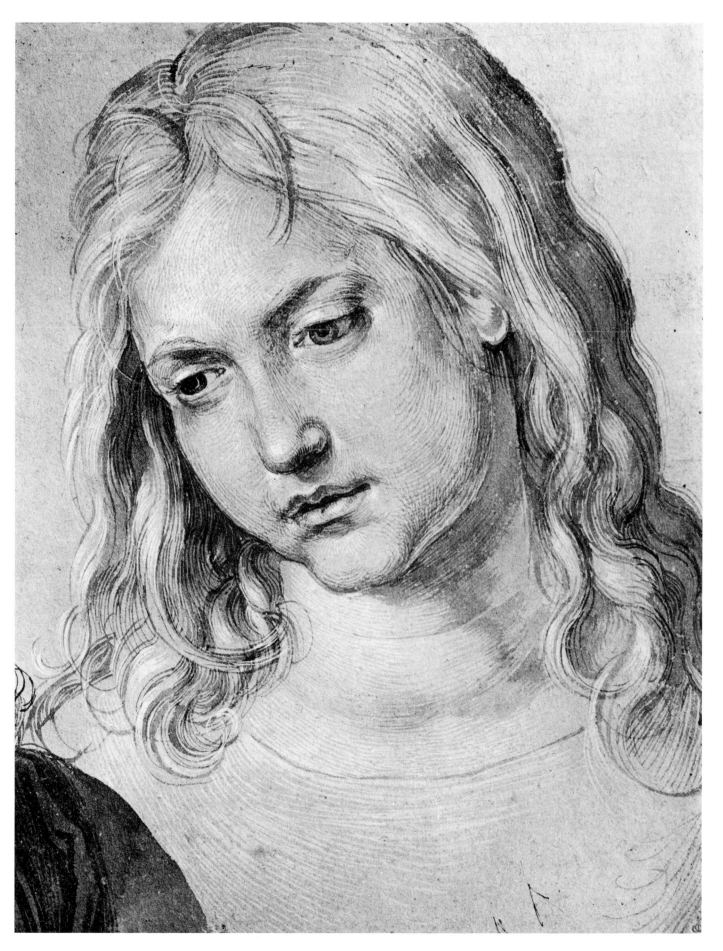

41

Hands of the Young Christ

W.407 L.137 T.319 P.550
Brush drawing in brownish-black ink, heightened with white, on blue Venetian paper.
206 × 185mm. (reproduced original size)
Signed and dated by another hand 1506
Provenance: Crozat; Andreossy; Sir T. Lawrence; Hausmann; Blasius.
Nuremberg, Germanisches Nationalmuseum

STUDY for the hands of Christ in the painting of *Christ among the Doctors*, of 1506
(see note to Plate 40). This and the other two studies of hands (W.405 and 406) show
the importance the artist attached to the gestures of the hands, which in this painting
are nearly as eloquent as the heads in conveying the contrast between age and youth,
between ugliness and beauty. The composition revolves around the motif of the two
pairs of hands. With the index finger touching the thumb of the other hand, Christ
specifically enumerates a point in his argument, while the doctor on the right contradicts
it with a dampening gesture of his hands. The strong element of caricature in this
doctor's appearance suggests that Dürer must have seen 'caricature' drawings by
Leonardo.

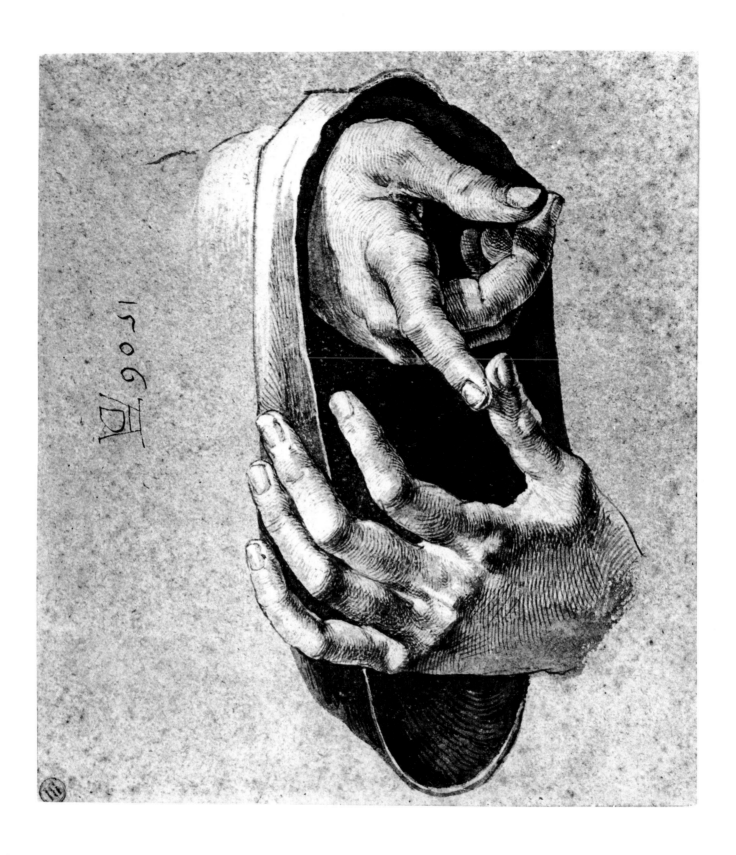

Head of an Angel

W.385 L.496 T.301 P.743
Brush drawing in black ink, heightened with white, on blue Venetian paper.
270 × 208mm.
Signed and dated 1506. *Vienna, Albertina*

PRELIMINARY STUDY for the head of the angel, playing a lute, seated at Mary's feet in the painting of the *Feast of the Rose Garlands*, dated 1506, now in the National Gallery, Prague. The altarpiece was commissioned for the church used by the German community in Venice, S. Bartolomeo, which was near the German merchants' quarter, the Fondaco dei Tedeschi, and presented a great challenge to Dürer in the face of much local hostility and jealousy. The painting was, however, a triumphant success, and on its completion both the Doge and the Patriarch came to admire it. More important to Dürer, 'I have stopped the mouths of all the painters who used to say that I was good at engraving but, as to painting, I did not know how to handle my colours. Now everyone says that better colouring they have never seen.' For the first time he achieved a freedom and looseness of touch which had previously eluded him in his over-laboured handling of oil paint. But the colour and the composition reveal a deep understanding of Venetian painting, in particular that of Giovanni Bellini—the angel playing the lute is a striking example—yet the artist's own individuality is unmistakably present.

This drawing originally formed part of the same sheet of paper as the *Head of the Young Christ* (Plate 40)—part of the angel's left shoulder and a few curls are visible on the lower left of the latter. The study of Christ was done in preparation for another painting, and suggests that Dürer was working on both compositions simultaneously. In this case it was no problem to move from the world of angels to the youthful Christ, and both have the same innocent, serene beauty.

Dürer made at least twenty-two drawings for the *Feast of the Rose Garlands*, in which he studied whole figures, heads, hands, and in one case a watercolour study of the pluvial of the Pope (Plate 43). With the exception of the study of the pluvial, they were drawn with the brush on blue Venetian paper.

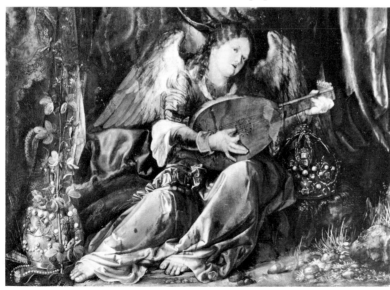

Detail from the *Feast of the Rose Garlands* (see page 116)

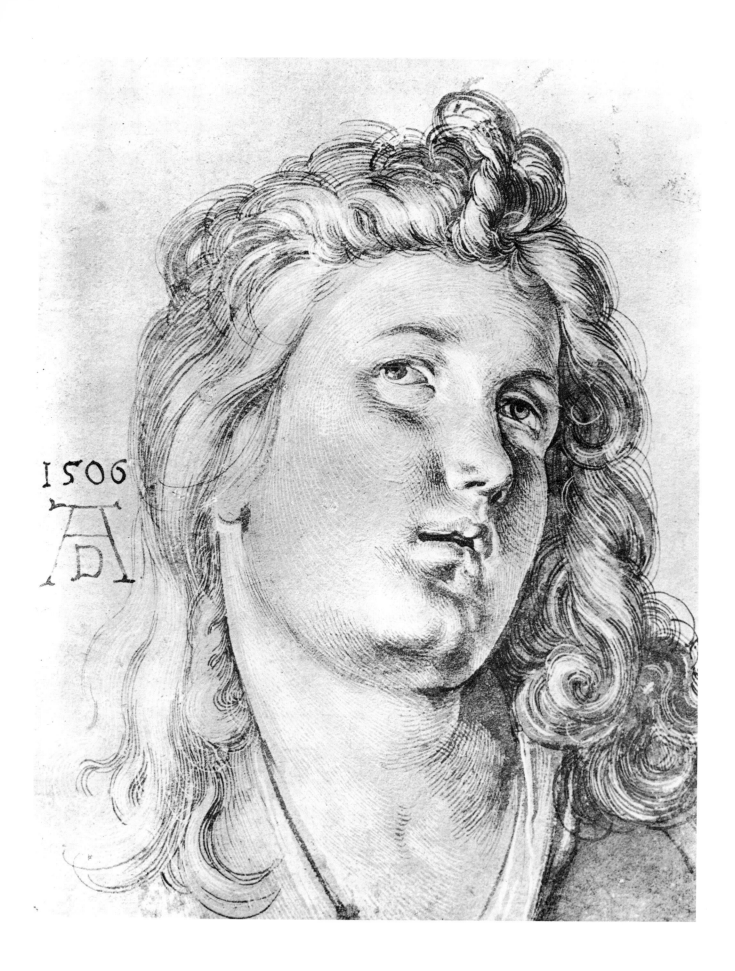

43

Pope's Pluvial

W.401 L.494 T.314 P.759
Watercolour. 427 × 288mm.
Signed and dated 1514 by another hand (Hans von Kulmbach?)
Vienna, Albertina

PREPARATORY STUDY for the pluvial of Pope Julius II in the painting of the *Feast of the Rose Garlands*, commissioned and executed in Venice in 1506 (see note to previous drawing). This is the only one of the twenty-two studies to have been executed in watercolour and is remarkable for the broad 'impressionistic' use of the purple and yellow wash, which gives an effect of light and colour rather than a carefully delineated and objective record of the brocade. Compared with this watercolour, his other costume studies appear documentary.

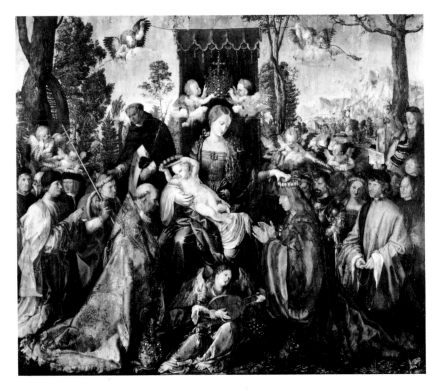

The Feast of the Rose Garlands. Oil on panel, 1506.
1620 × 1945mm.
Prague, National Gallery

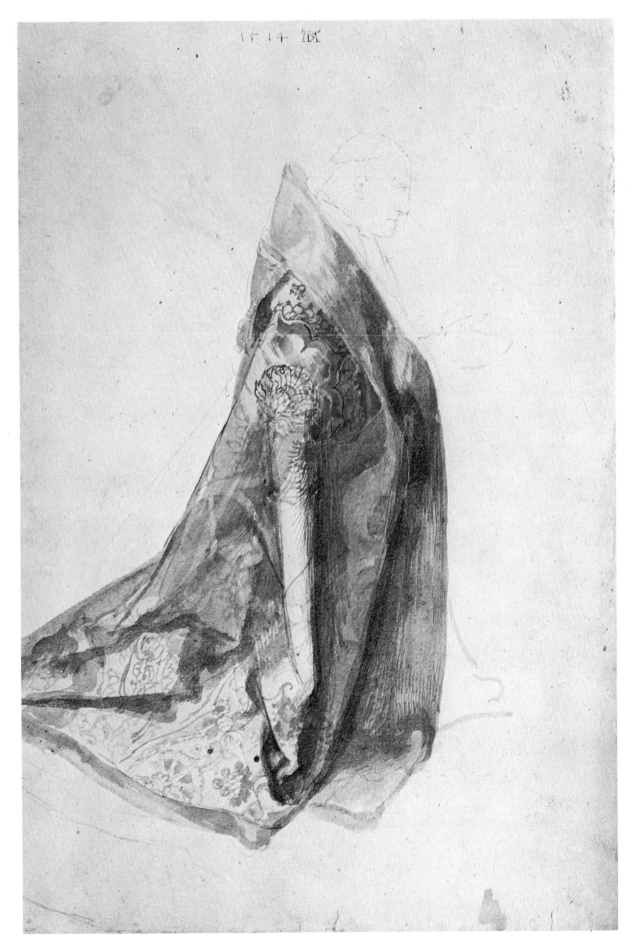

44

Portrait of Girolamo Tedesco (?)

W.382 L.10 T.313 P.738
Brush drawing in black ink, heightened with white, on blue Venetian paper.
386 × 263mm.
Signed and dated 1506
Provenance: Andreossy; Gigoux. *Berlin, Kupferstichkabinett*

PREPARATORY STUDY for the figure of the architect, who appears on the extreme right in the painting of the *Feast of the Rose Garlands* (see note to Plate 42). He is probably to be identified with the Augsburg architect, Girolamo Tedesco or Hieronymus von Augsburg, who was responsible for rebuilding the new Fondaco dei Tedeschi, the centre of the German merchants in Venice, which had been seriously damaged by fire early in 1505. Giorgione and Titian were commissioned to decorate the façade with frescoes, and may have started work while Dürer was still there.

Though this drawing has a degree of perfection which might suggest it was a finished work in its own right, it was nevertheless very much a working drawing. Clearly the artist made a detailed preliminary study of the composition, fixing the exact position of each figure. Hence when he came to the figure of the architect, he confined himself to what would show in the painting—the right arm, for example, is entirely omitted from the drawing.

Detail from the *Feast of the Rose Garlands* (see page 116)

118

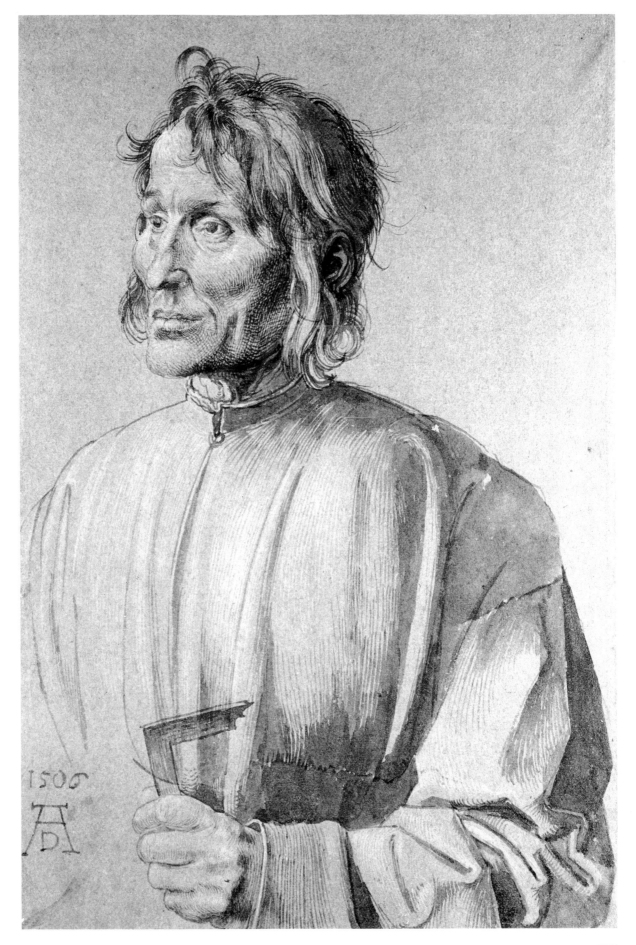

45

Female Nude Seen from the Back

W.402 L.138 T.328 P.1188
Brush drawing in brownish-black ink, heightened with white, on blue Venetian paper.
283 × 224mm.
Signed and dated 1506
Provenance: Imhoff; Böhm; Hausmann; Blasius. *Berlin, Kupferstichkabinett*

ON HIS EARLIER VISIT to Venice, Dürer had made a very similar study of the female
nude (Plate 9), also seen from the back, which had disclosed the influence Venetian
painting had wrought on the German artist. Eleven years later Venetian art had
changed, and the greater luminosity to be seen in the late work of Bellini, as well as in
that of the young Giorgione and Titian, is reflected in Dürer's new exercise. Instead of
starting with the pen and then working up the drawing with the brush, he uses the
brush from the start. There is an absolute consistency of conception and execution
from the moment he started work on the drawing. In the earlier study his ideas
developed during the course of execution. Here, moreover, the range of tone is
extended by the carefully thought-out white highlights, and the curtain of wash against
which the figure is placed, as well as by the use of blue Venetian paper instead of the
usual white paper. The result, both in the type of nude and in the intense awareness of
light and colour, is strongly Giorgionesque.

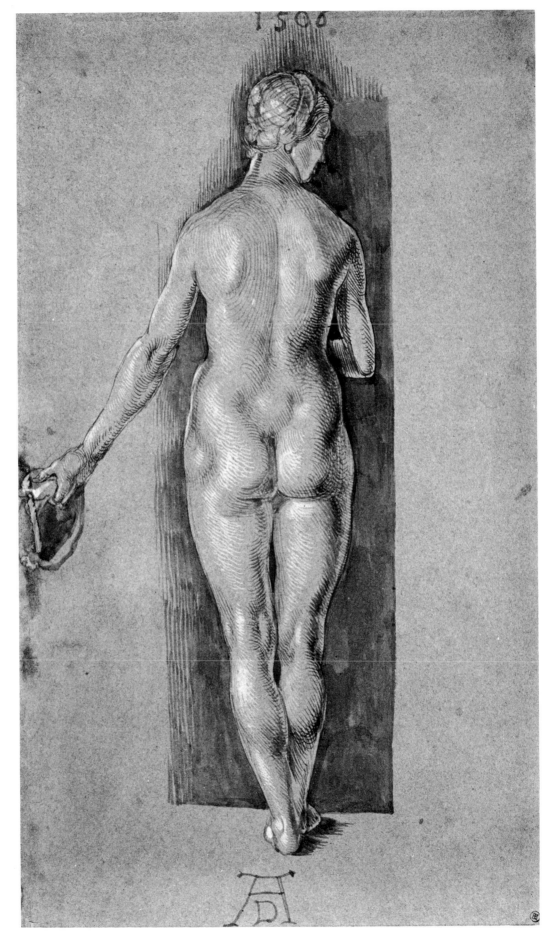

46

Study of Eve (recto)

W.423 L.V,p.7 T.333 P.464
Pen and brown ink. 263 × 165mm.
Provenance: Bianconi; Fries. *Vienna, Albertina*

THIS AND THE FOLLOWING DRAWING, drawn on the other side of the paper, are
characteristic of the type of constructed nude the artist started to make during his
second visit to Italy, when he made a special journey to Bologna (see Introduction,
p. 36). Instead of defining the curves of the body with arcs drawn with the compasses,
Dürer now confined himself to measuring in the axes and main dimensions of the
figures, allowing the contours to flow freely and continuously. Compared with the
figure of Eve for the engraving of 1504 (see Plate 35), she is taller, more slender and
more elegant. The ritual of tempting Adam with the apple becomes a kind of dance,
and it is symptomatic that the artist treats each figure individually and not unified into
one composition. This sheet and two similar studies of *Adam* on both sides of a sheet
(W.421 and 422) were probably drawn with the two panels of 1507, now in the Prado,
in mind.

47

Study of Eve (verso)

W.424 L.476 T.334 P.465
Pen and ink with brown wash. 263 × 165mm.
Provenance: Bianconi; Fries. *Vienna, Albertina*

A FAIR COPY of the preceding drawing, traced through the paper, and then worked up
with wash, a practice which Dürer adopted quite often. It allowed him to develop his
study in two different stages; the first was concerned with mathematical proportion,
while in the tracing he was able to forget about theory and concentrate on the pictorial
aspects.

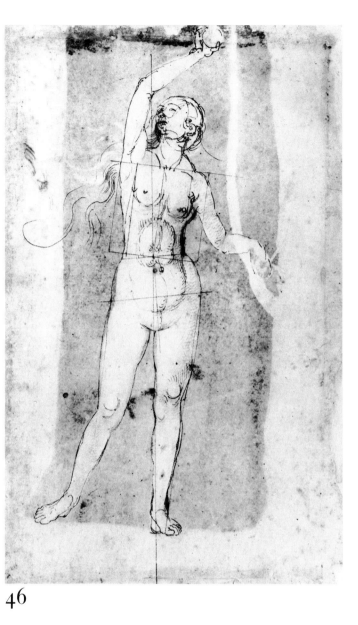

46

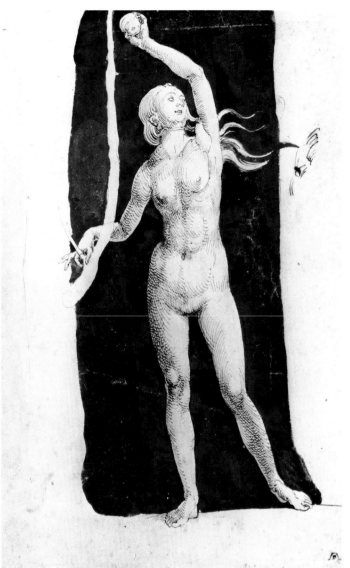

47

48

Study of Feet

W.464 L.165 T.380 P.496
Brush drawing, heightened with white, on green prepared paper. 177 × 217mm.
Signed by another hand
Provenance: Grünling; von Franck; Béhague. *Rotterdam, Museum Boymans–van Beuningen*

A STUDY of remarkable realism for the feet of the kneeling apostle with his back to the spectator in the central panel of the altarpiece commissioned in 1507, shortly after Dürer's return from Venice, by Jacob Heller for the Dominican church in Frankfurt (see p. 126). The central panel, which represents the *Assumption and Coronation of the Virgin*, was the only part to be executed entirely by Dürer. Both in its combination of two different subjects and in its presentation, this panel must reflect some knowledge of Raphael's painting carried out a few years earlier, and now in the Vatican. The panel was burnt in the eighteenth century, and today the composition is known only from a copy. According to Sandrart, four of the wings were painted by Grünewald, and two of these survive in the Städelsches Kunstinstitut, Frankfurt. A series of letters from Dürer to his patron exist, in which one can watch the artist arguing determinedly, over the price to be paid and the date of delivery, with a firm and unimaginative business man, who considered he had every right to expect a contract to be honoured to the letter, without making any allowances for artistic temperament. It is also clear that the actual execution caused the artist much anguish, and he concluded that 'no one shall ever compel me to paint a picture again with so much labour . . . henceforth I shall stick to my engraving, and had I done so before I should today have been a richer man by 1000 florins.'

As in the case of the two paintings executed in Venice, Dürer made numerous preparatory studies—eighteen survive—showing studies of whole figures, heads, hands, feet and drapery. Likewise they were executed in brush on coloured paper, though since the artist had failed to bring back a supply of blue Venetian paper, he had to prepare his paper with colour beforehand, using on this occasion both green and blue. With the exception of the present sheet, which was very freely executed with the brush, the studies for the *Heller Altarpiece*, such as the *Hands of an Apostle* (Plate 49), show a return to a more linear conception compared with his recent Venetian drawings.

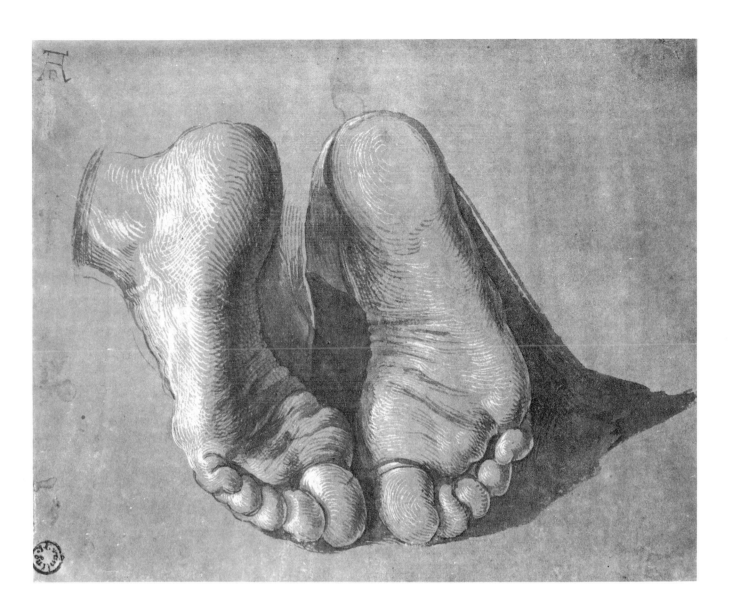

49

Hands of an Apostle

W.461 L.507 T.W57 P.493
Brush drawing in black ink, heightened with white, on blue prepared paper.
290 × 197mm.
Vienna, Albertina

STUDY FOR THE HANDS of the praying apostle on the right of the central panel of the altarpiece of *The Assumption*, commissioned in 1507, shortly after Dürer's return from Venice, by Jacob Heller (see note to Plate 48). It was originally part of a sheet containing a study of the *Head of an Apostle* (w.452): traces of the apostle's shoulder can be seen at the bottom of the present drawing.

LEFT: *The Assumption*. Oil on panel, 1508. 1850 × 1345mm. Copy of the burned original by Jobst Harrich. Frankfurt, Städelsches Kunstinstitut

RIGHT: Detail from *The Assumption*

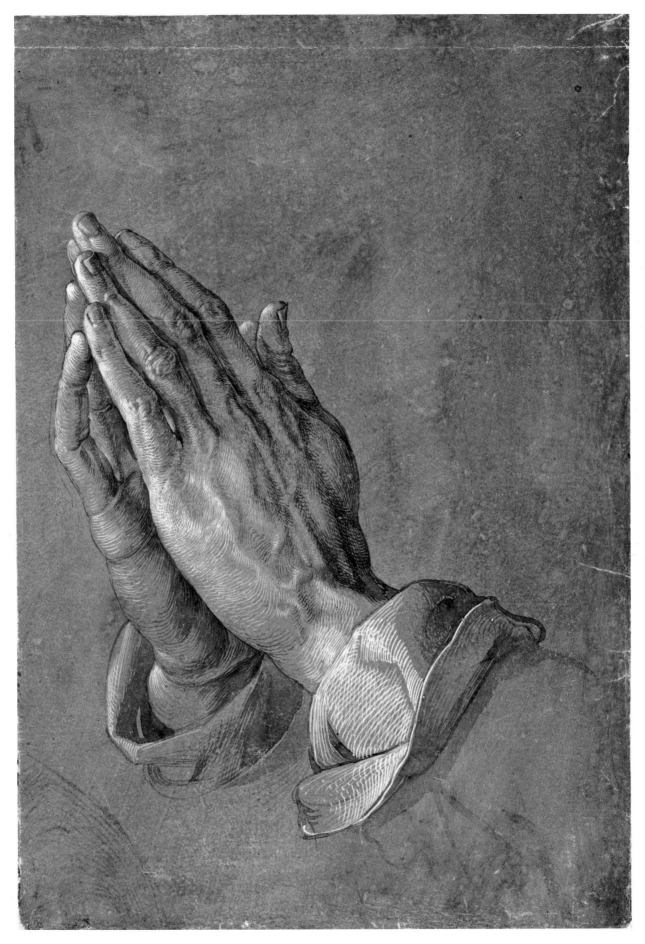

The Adoration of the Trinity

W.455 L.334 T.382 P.644
Pen and brown ink with watercolour. 391 × 263mm.
Dated by the artist: *Anno dom 1508*. Signed by another hand
Provenance: Vivant-Denon; Andreossy; Reiset. *Chantilly, Musée Condé*

PREPARATORY DESIGN for the altarpiece, with its elaborately carved frame and tympanum of the *Adoration of the Trinity*, commissioned by the rich merchant, Matthäus Landauer, who in company with another merchant had founded a home in Nuremberg for twelve old people, known as the *Zwölfbrüderhaus*. The painting was destined for the chapel, which was dedicated to the Trinity and All Saints, and, as well as designing the carved frame, now in the Germanisches Museum, Nuremberg, Dürer was commissioned to make drawings for the stained-glass windows, now in the Schlossmuseum, Berlin. Though the chapel was ready for decoration in 1508, when Dürer made this drawing, the painting was not completed and delivered until 1511, largely owing to his lengthy work on the *Heller Altarpiece*.

There are a number of differences between this *modello* and the final work. Though the basic composition remained the same, the faithful have been increased in number.

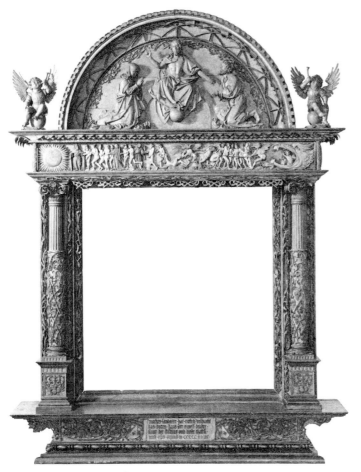

LEFT: Original frame for the *Adoration of the Trinity*. Nuremberg, Germanisches Nationalmuseum

RIGHT: *The Adoration of the Trinity*. Oil on panel, 1511. 1440 × 1310mm. Vienna, Kunsthistorisches Museum

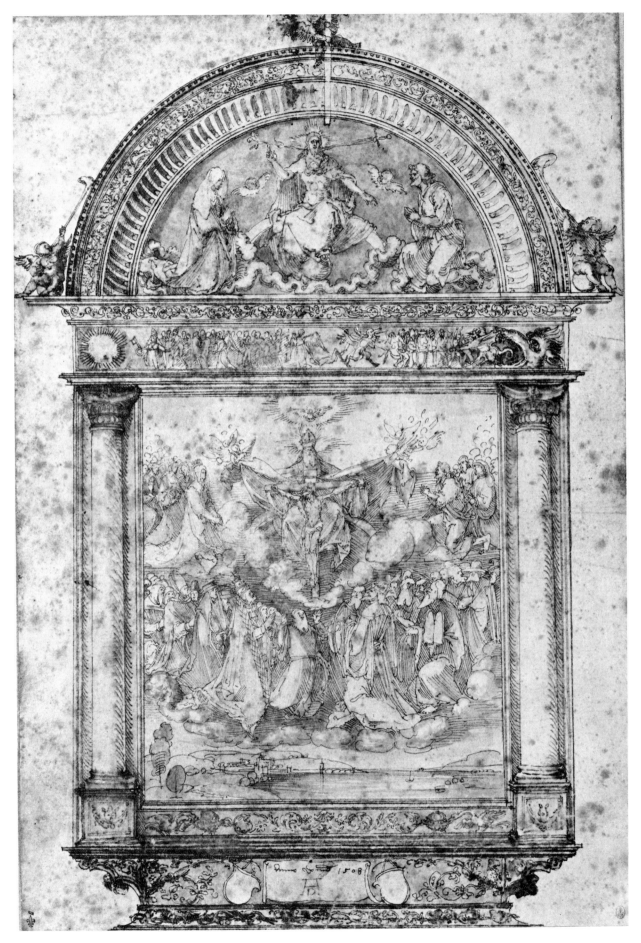

The iconography has also been changed. The area beneath the Cross, occupied in the drawing by 'those who believed in Christ before he came', namely David, Moses, the Prophets and the Patriarchs, is given up to 'the laymen of all ranks' in the painting. Moreover, angels with the Instruments of the Passion have been introduced. The design for the frame was also altered to a less classical pattern. Instead of the severe plain columns, placed immediately beneath the springing of the arched tympanum above, the columns are now fluted, with the lower half covered with entwined decoration, and are placed outside the arch. The painting is arched at the top instead of being rectangular, as in the drawing.

One further difference occurs. In the finished work the figure of the artist appears, standing beside a tablet bearing his signature and the date, in the lower right of the composition, the only inhabitant of the earth. This innovation of including a self-portrait—first seen in the *Feast of the Rose Garlands* (see p. 116), where Dürer is seen standing, holding a scroll, amongst the faithful—was repeated in the three large altarpieces he executed on his return to Nuremberg (see, for example, p. 126) and probably reflects his new notion of himself as a gentleman instead of a mere artist/craftsman. To Pirckheimer, he wrote petulantly from Venice: 'Here I am a gentleman, at home only a parasite.'

51

Heroldsberg

W.481 L.355 T.441 P.1402
Pen and brown ink. 211 × 263mm.
Signed and dated 1510. Inscribed by another hand
Bayonne, Musée Bonnat

HEROLDSBERG, a village situated near Nuremberg, belonged to Andreas and Martin Geuder; the latter was a brother-in-law of Pirckheimer.

For his later studies of landscape, Dürer eschewed the use of colour and confined himself to pen, chalk or silver point. The present magnificent drawing is one of the few drawn with the pen. It was probably not drawn *in situ* but was worked up in the studio from a freer sketch, though there is a noticeable *pentimento* in the drawing of the church spire. The monumental compactness of the buildings and other features of the landscape, arranged with spatial clarity around the pond in the centre, still reveal the impact of his recent visit to Venice.

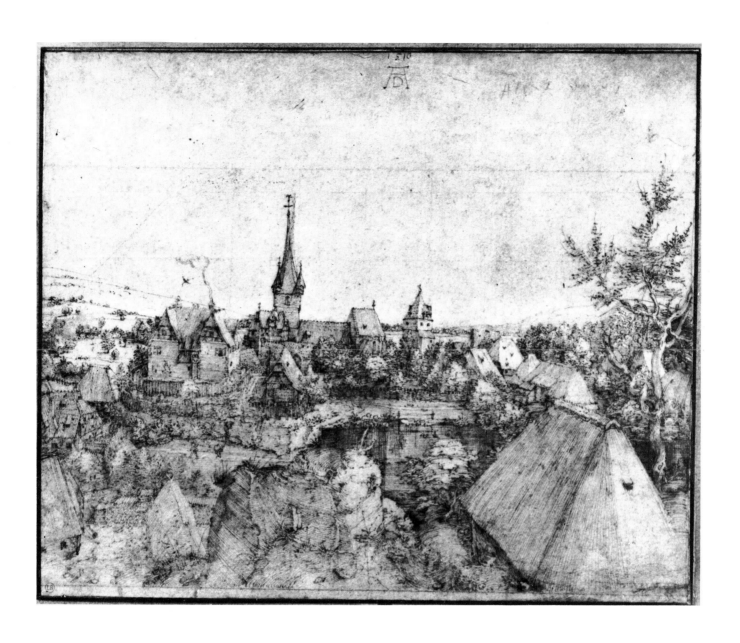

A Knight and his Wife (Study for a Tomb)

W.489 L.762 T.W75 P.1543
Pen and brown ink. 260 × 180mm.
Provenance: Guise. *Oxford, Christ Church*

THE PRESENT DRAWING was made about 1510 as a design for a tomb slab for the Nuremberg foundry of Peter Visscher the Elder, who employed it on two occasions, once for a tomb in Römhild and again for a tomb in Hechingen. Dürer himself, however, used the study of the woman for one of the female companions of Salome in the woodcut of the *Beheading of St John the Baptist* (B.125), dated 1510.

In the same year Dürer produced further designs for tombs, this time for the Fugger family in Augsburg, which were to be executed by the sculptor Adolf Daucher.

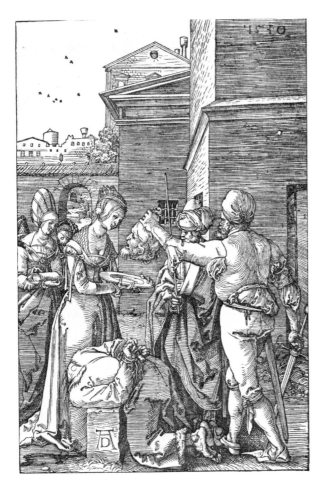

The Beheading of John the Baptist.
Woodcut, 1510. 195 × 131mm.

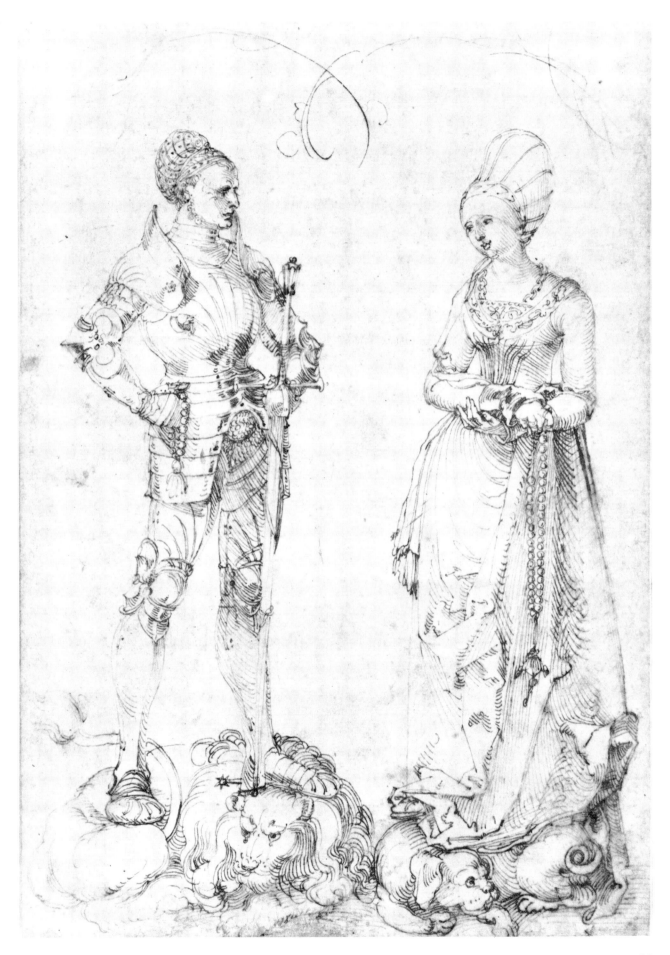

53

The Fall of Man

W.470 L.518 T.404 P.459
Pen and brown ink. 295 × 220mm.
Signed and dated 1510. *Vienna, Albertina*

A DRAWING probably made as an end in itself, but which the artist used almost at the same time on a reduced scale for the woodcut of both the *Fall of Man* (B.17) and the *Expulsion* (B.18) from the *Small Passion* published in 1511. After the elaborate brush drawings on coloured paper, so popular in Venice and during the years afterwards, pen and ink returned to favour about 1510, and it was from such freer, looser drawings, such as the present sheet, that the artist developed his 'classic' woodcut style of the next few years.

Compared with his earlier representations of the theme, both this drawing and the woodcuts are much more pointed in their description of the narrative. The underlying study of proportion is now submerged within the story, and instead of the display of human beauty, the actual act of temptation becomes the focal point. Adam and Eve are clasped together and with their differing emotions concentrate on the apple, which previously had no psychological force. And yet the wish for a perfect representation of the figure was not entirely absent as can be seen from the way the artist has gone over and strengthened the contours of the lower half of Eve's body.

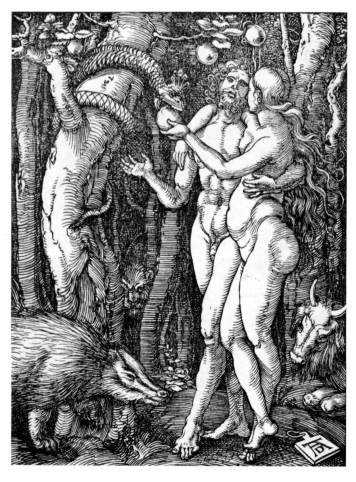

The Fall of Man. Woodcut,
about 1511. 127 × 97mm.

134

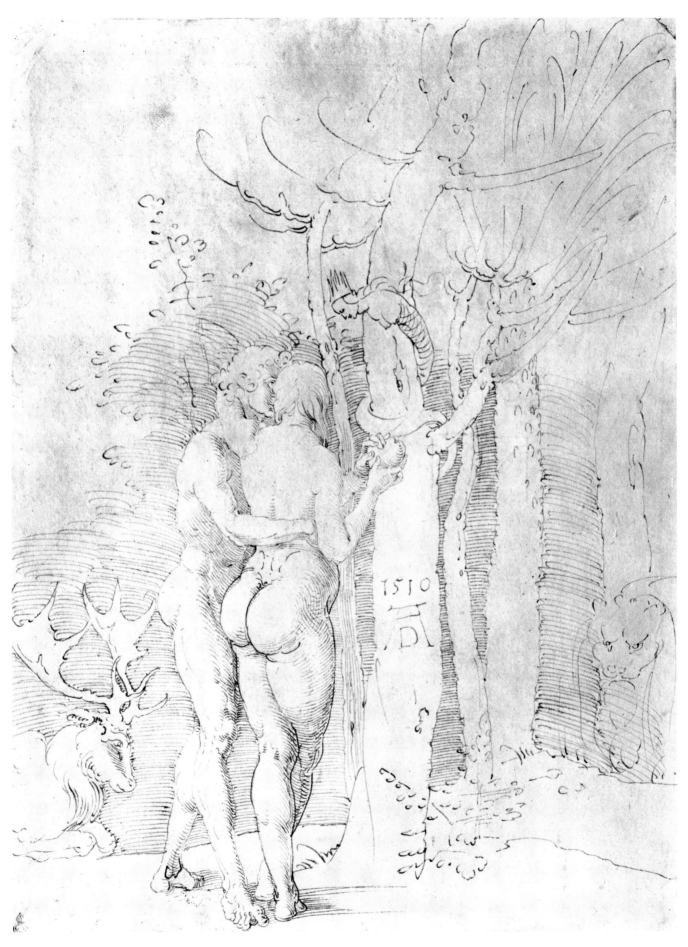

54

St Jerome

W.590 L.777 T.488 P.815
Pen and brownish-black ink. 195 × 151mm. (reproduced original size)
Signed and dated 1511
Milan, Ambrosiana

A PRELIMINARY STUDY for the woodcut of *St Jerome* (B.114), also dated 1511. This
free sketch, very similar in style to the drawing of the *Fall of Man* (Plate 53), represents
an early stage in the composition. In the woodcut the background was altered: a
shallower room, the view of which was further limited by the addition of a large curtain
at one side, serves to project the figure of the saint, deeply absorbed in his reading,
more forcibly. By having his cloak stretched out on the bench beside him, St Jerome
appears a more obtrusive figure than the modest scholar who worked away near the
edge of the drawing. At the cost of losing the intimacy and informality of his preliminary
study, Dürer succeeded in monumentalizing his composition. At the same time he
made numerous small changes of detail, such as placing the lion's tail between its paws,
giving it a more domestic, feline appearance. The setting recalls Venetian painting,
particularly Carpaccio's painting in the Scuola di S. Giorgio degli Schiavoni, which was
completed a few years before Dürer's second visit, and which he would certainly have
seen.

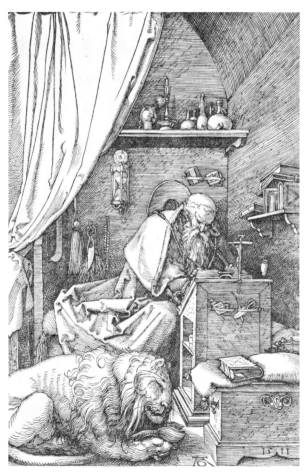

St Jerome. Woodcut, 1511.
235 × 160mm.

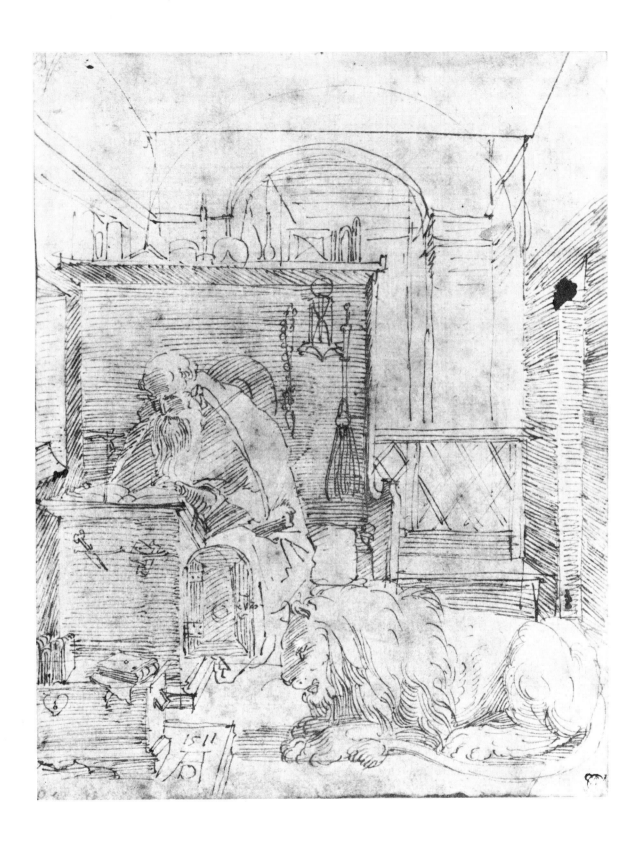

137

Virgin and Child, with a Man on Horseback Playing Bagpipes

W.522 L.786 T.531 P.666
Pen and brown ink. 267 × 190mm.
Signed and dated 1512
Provenance: Imhoff; Vivant-Denon; Dyce. *London, Victoria and Albert Museum*

THE SMALL SKETCH of the Virgin suckling her Child connects with the group of studies made on this theme at this period, which found more complete expression in the following drawing. The main subject of the sheet was the study of the man deeply absorbed in playing his bagpipe, riding on a horse whose stance, with one foreleg raised, is similar to Death's horse in the drawing of seven years earlier (Plate 38). Yet, though old and weary, the beast is devoid of the frightening aspect of the earlier animal. The whole sheet is entirely genial in content.

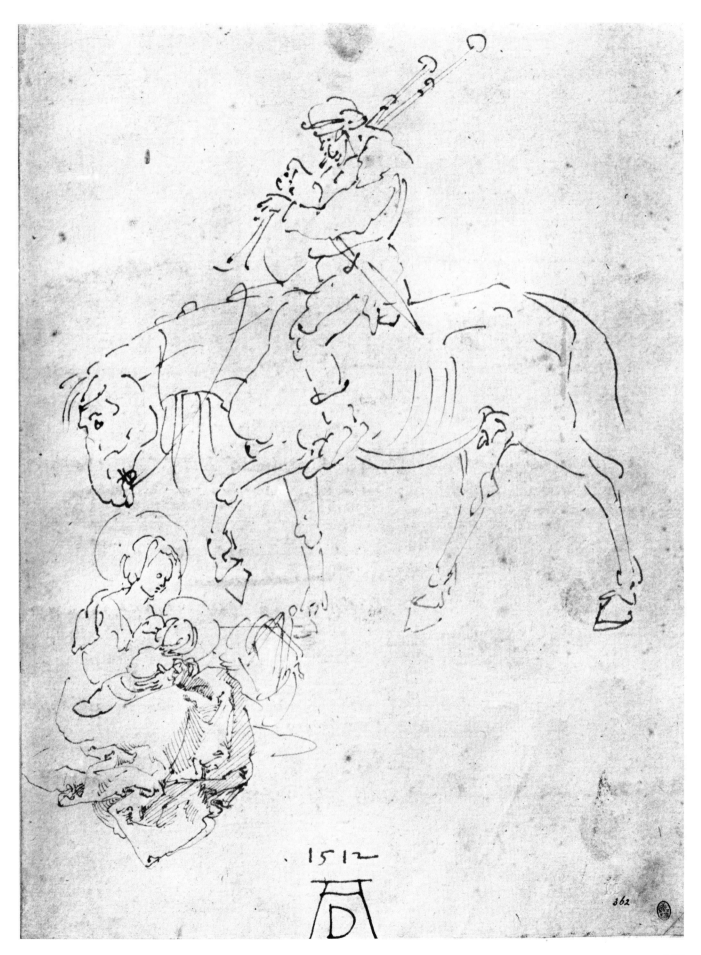

.1512

Virgin and Child

W.512 L.525 T.503 P.665
Charcoal. 418 × 288mm.
Signed and dated 1512
Vienna, Albertina

ALMOST THE ONLY ONE of the large group of drawings devoted to the theme of the
Virgin and Child, either alone or with other members of the Holy Family, made during
the second decade of the century to be executed in charcoal and not in pen and ink. It is
also one of the rare drawings to depict the Virgin and Child half-length, a format
which, however, was more common in his paintings, and which suggests that he may
have had some such work in mind. Whereas the majority of studies of the Virgin and
Child are primarily concerned with the formal arrangement of the two figures, the
present drawing, as well as being one of the most successfully designed, the body of the
Child completing the triangular movement most harmoniously, offers a tender portrayal
of the Virgin suckling her Child, who clutches the mother's wrist, at the same time
exercising his feet and toes.

1512.

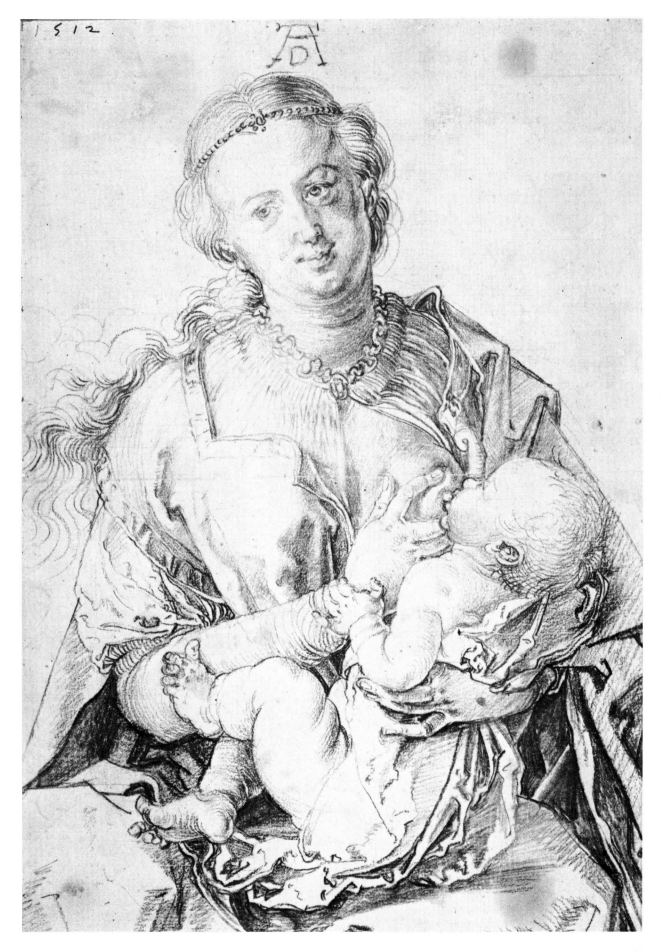

Emblematic Design with a Crane

W.702 L.793 T.W87 P.1535
Pen and brown ink with watercolour. 441 × 319mm.
Dated 1513, and inscribed in the scroll: GI GI GIG
Provenance: Sloane. *London, British Museum*

VARIOUS SUGGESTIONS have been made as to the purpose of this large and unusual
drawing with its mysterious inscription. It would seem unnaturally large to serve as a
design for a book-plate, while the subject would be unusual for representation in
stained glass.

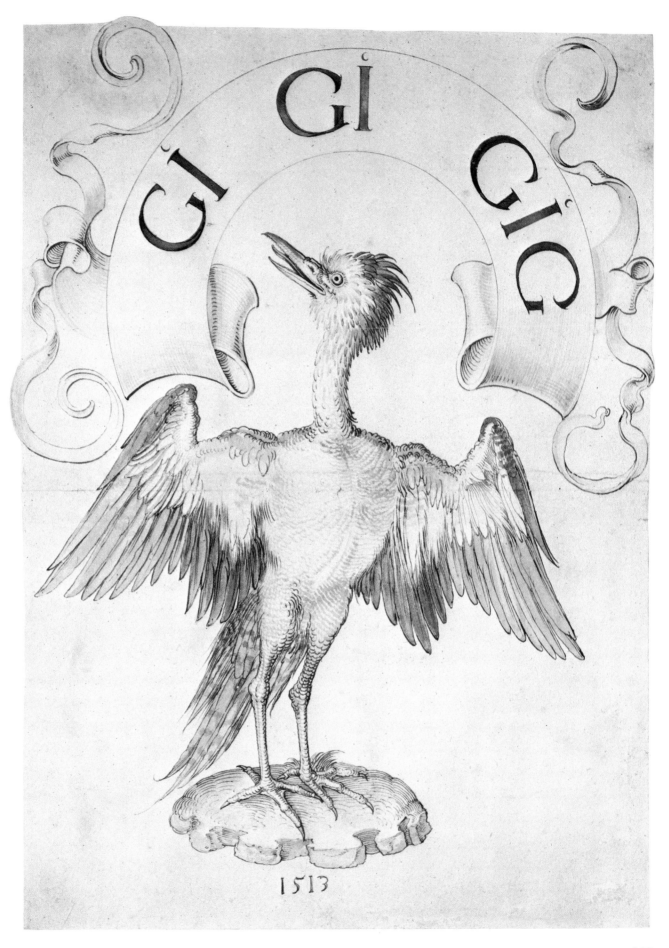

58

Arion

W.662 L.411 T.284 P.901
Pen and brown ink with watercolour. 142 × 234mm.
Inscribed: PISCE SUPER CURVO VECTUS CANTABAT ARION
Vienna, Kunsthistorisches Museum

ONE OF A GROUP of drawings, executed about 1514, done in outline and completed in watercolour (see also w.663–5), which reflect the artist's new 'archaeological' interest in illustrating subjects taken from classical writers. The drawing depicts Arion astride the dolphin which rescued him when he was thrown overboard by pirates. He was returning by ship from Sicily, victor of a musical contest consisting of the most famous musicians, when he was seized by the crew with the intention of murdering and robbing him. Allowed a few moments respite to play for the last time, Arion performed so beautifully that his notes attracted a school of dolphins. One of them saved him from the sea and carried him unharmed to the nearest shore. Though this story is related by several classical writers, Dürer's source was probably Lucian, whom he used for the subject of another drawing of this group of illustrations of classical themes (w.664).

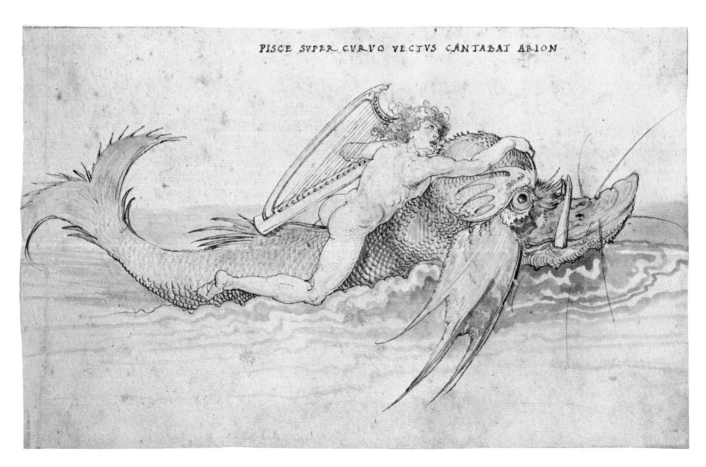

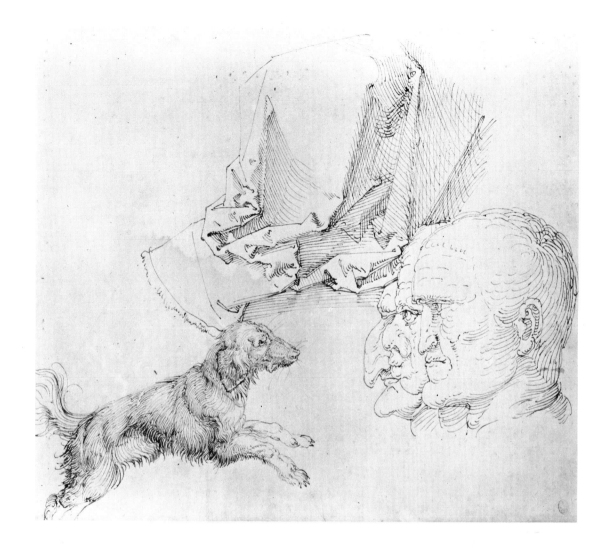

59 *A Sheet of Studies: a Dog, Drapery, and Three Male Caricature Heads in Profile*

Literature: Christopher White in *Burlington Magazine*, 1961 (ciii) p. 20, fig. 33
Pen and brown ink. 182 × 209mm.
Provenance: Vivant-Denon. *London, British Museum*

A DRAWING which has only come to light in recent years, but was partly known from the engraving made by Vivant-Denon when it was in his collection.

The dog, which was probably studied from life, was later used for the engraving of *Knight, Death and the Devil* (B.98) (see p. 148), though his simple *joie de vivre* here was transformed into an expression of serious urgency in the print as befits the subject. Leonardo's influence, which can be seen in the design of the horse in the engraving, is again evident in the three male caricature heads on this sheet. With several other similar studies (for example, W.656 and 657) this drawing marks the beginning of Dürer's interest in the theory of expression.

The drapery study cannot be directly connected with any known work, though it bears a general resemblance to the dress of the Virgin in the drypoint of the *Holy Family* (B.43) of about 1512/3.

60

Knight on Horseback (recto)

W.617 L.790 T.571 P.1675
Pen and brownish-black ink. 239 × 173mm. (reproduced original size)
Milan, Ambrosiana

THIS AND THE FOLLOWING DRAWING, on the other side of the sheet, are preparatory working studies for the engraving of *Knight, Death and the Devil* (B.98) (see p. 148), of 1513. For the representation of the knight on horseback, Dürer turned back to his large watercolour of 1498 (W.176), now in the Albertina (see p. 148). The watercolour, which was in the Imhoff collection and therefore remained in the artist's studio during his lifetime, was essentially a study of German armour, as Dürer's inscription emphasizes. In the print, the knight and his armour are exactly modelled on the watercolour; only the face of the worthy moustached cavalier, the epitome of the obedient soldier awaiting his orders, has been altered to the handsome clean-shaven face of intense seriousness and upright determination fitting for Dürer's 'knight of Christ'.

The harness, bridle and saddle were also based on the watercolour, but where Dürer's new ideas become plainer is in the arrangement of the horse itself. To give a sense of urgency to the knight's quest, it was essential to depict the animal in movement. And here the artist must have been aware of Leonardo's designs for the Sforza Monument, either directly or through some intermediary, where the horse raises a foreleg and hind-leg in a similar fashion. Already in 1503 Dürer had made two drawings of horses with foreleg and hind-leg raised, which were clearly inspired by Leonardo. But, as the construction lines on the present study show, Dürer created the horse according to his own system of proportion. Moreover the bulging muscles of the neck and body of the engraved horse reveal the artist's greater understanding of the anatomy of the animal. Earlier he has been content to observe the horse from the exterior. About this time Dürer was contemplating a treatise on the proportions of the horse, but it got no further than the present studies.

The engraving of *Knight, Death and the Devil* is one of the three major prints produced by Dürer in 1513 and 1514. Though they are all approximately the same size, they have no discernible formal link. Nevertheless they have a spiritual unity and they can be interpreted as symbolizing three ways of life: the moral (*Knight, Death and the Devil*), the theological (*St Jerome*) and the intellectual (*Melancolia*). In his Netherlands Journal of seven years later Dürer referred to the present print simply as *The Rider*, but another passage in the same work, inspired by Luther's rumoured assassination, contains an appeal to Erasmus ('Hark, thou Knight of Christ, ride forth at the side of Christ our Lord, protest the truth, obtain the crown of Martyrs'), which has strong echoes of the print. This suggests that Dürer may have been making a veiled allusion, in the subject of the engraving, to Erasmus, who a decade earlier had published a treatise entitled *The Handbook of the Christian Soldier*. Much abstruse meaning has been read into these three prints (for a full discussion, see Panofsky, pp. 151ff.).

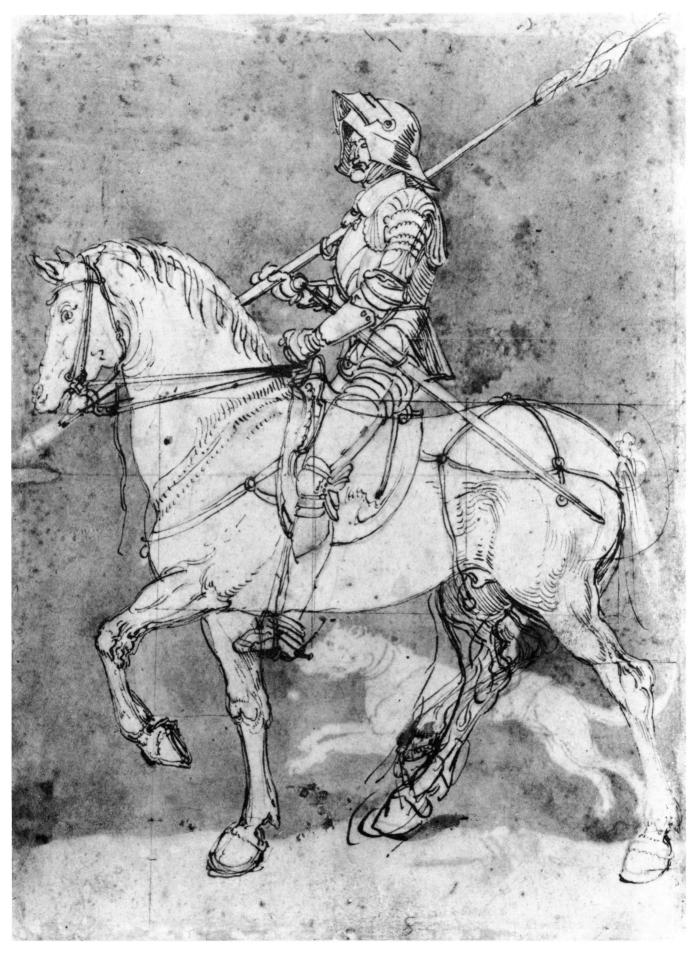

61

Knight on Horseback (verso)

W.618 L 791 T.572 P.1676
Pen and ink with brownish-black wash. 239 × 173mm. (reproduced original size)
Milan, Ambrosiana

THIS REPRESENTS the fair copy, traced through from the other side of the sheet (see note to previous drawing). The reversal of the design had the advantage that it was now in the right direction to act as a guide to working on the copperplate. As well as washing in the background, Dürer added the dog, which appears in the engraving leaping along beside the horse. This additional feature clearly developed from the study of the animal on the *Sheet of Studies* (Plate 59).

LEFT: *Knight, Death and the Devil*. Engraving, 1513. 246 × 190mm.
RIGHT: *Horse and Rider*. Watercolour, 1498. 410 × 324mm. Vienna, Albertina

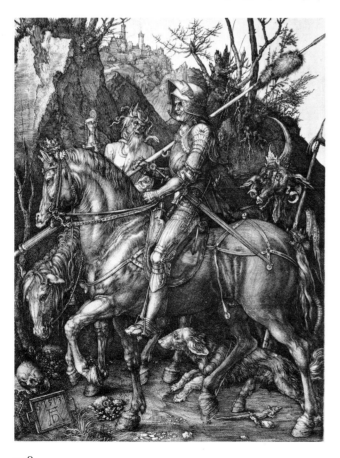

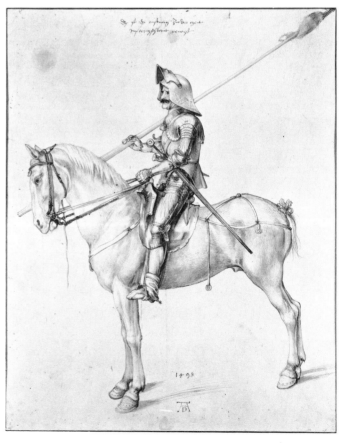

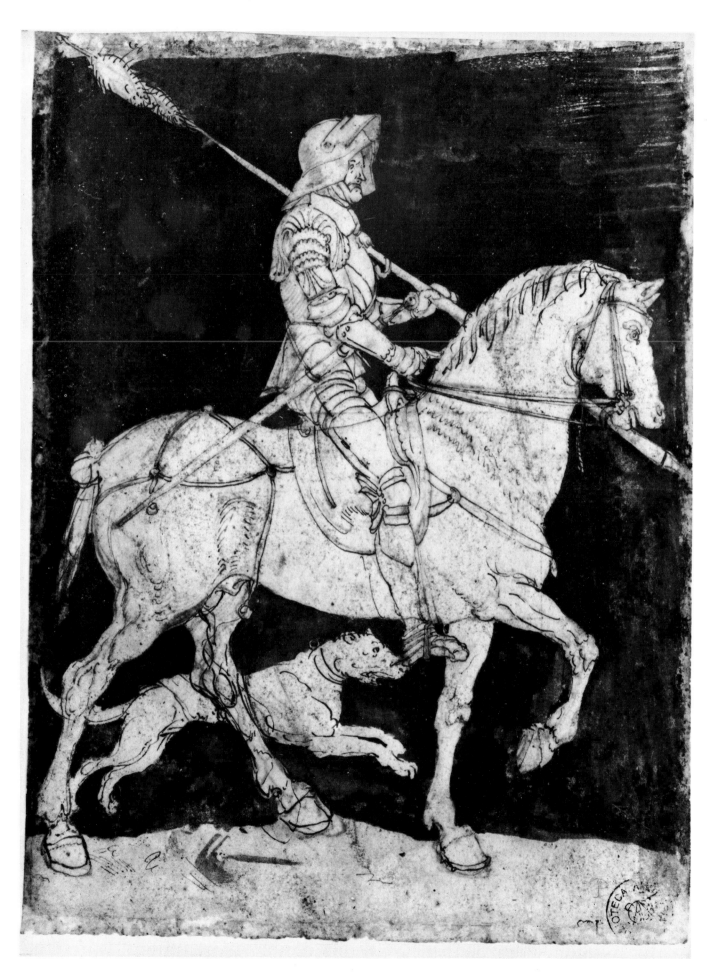

62

Male Nude

w.650 p.1621
Pen and brush drawing in brown and green, with touches of pink. 275 × 200mm.
Signed and dated 1513
Dresden, Sächsische Landesbibliothek

ONE OF THE most finished and most pictorial nude studies of these years, in which the artist has used the brush to imitate the closely hatched backgrounds done with the pen in earlier years. The stature of the model is increased by the area of denser hatching, which represents a greatly enlarged silhouette of the figure. But the other side of the sheet shows that the study was started with a mathematically constructed outline nude on a metrical system, which was then traced through the paper, as in the case of the studies of *Eve* (Plates 46 and 47). The drawing comes from a sketchbook, now in Dresden, containing studies done with a treatise on human proportion in mind, which the artist had planned to publish in 1513. It later formed the basis of the First Book of *The Four Books on Human Proportion*, published in 1528.

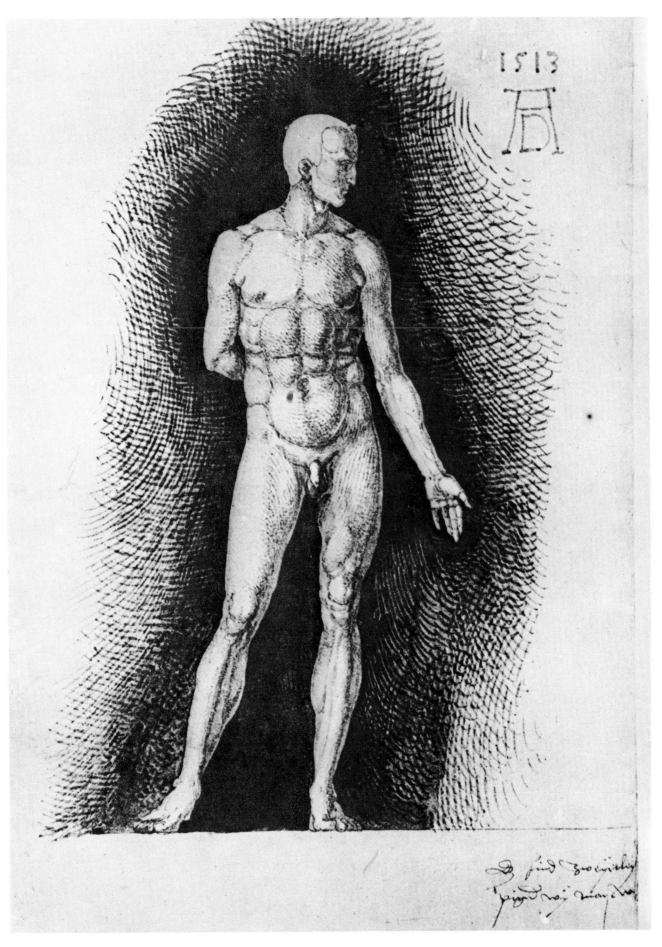

63

The Artist's Mother

W.559 L.40 T.591 P.1052
Charcoal. 421 × 303mm.
Inscribed and dated 1514 by the artist (see below)
Provenance: Imhoff; Andreossy; Firmin-Didot. *Berlin, Kupferstichkabinett*

THIS GAUNT, MOVING PORTRAIT of an old woman, virtually skin and bones, her fixed
squinting stare foretelling the rigor mortis which was so shortly to set in, vividly
illustrates her son's written testimony: 'This my pious Mother bare and brought up
eighteen children [only three were still living when Dürer wrote these words]; she
often had the plague and many other severe and strange illnesses, and she suffered
great poverty, scorn, contempt, mocking words, terrors, and great adversities. Yet she
bore no malice.' When the drawing was made—since the death of her husband she had
lived with her son and daughter-in-law—Dürer inscribed the date and the words:
'From the life. This is Albrecht Dürer's mother when she was 63 years old.' He must
have known that she was approaching death—a year before she 'was one morning
suddenly taken so deadly ill that we broke into her chamber'—and two months later,
he took out his drawing and continued his previous inscription, 'and she died in the
year 1514, on Tuesday before Rogation week, about two hours before nightfall'.

The artist gave a more circumstantial and harrowing account of her last hours in
'the other book', a second Family Chronicle, only known in one fragment: 'She feared
Death much, but she said that to come before God she feared not. Also she died hard,
and I marked that she saw something dreadful, for she asked for the holy-water,
although, for a long time, she had not spoken. Immediately afterwards her eyes closed
over. I saw also how Death smote her two great strokes to the heart, and how she
closed mouth and eyes and departed with pain. I repeated to her the prayers. I felt so
grieved for her that I cannot express it. God be merciful to her.'

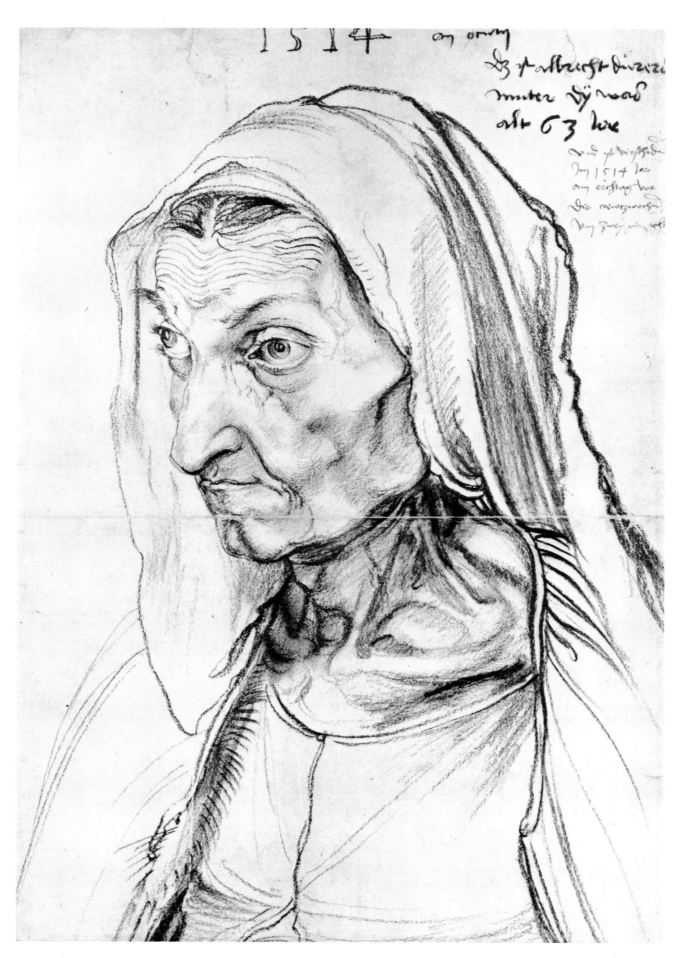

64

Portrait of a Girl

W.562 L.46 T.642 P.1109
Charcoal. 420 × 290mm.
Signed and dated 1515
Provenance: Andreossy; Posonyi. *Berlin, Kupferstichkabinett*

THOUGH VARIOUS SUGGESTIONS have been made, the identity of this touching, round-faced girl remains unknown. It represents the type of large-scale portrait study in charcoal or chalk that the artist was to make with increasing frequency. This sheet is clearly a companion drawing to the portrait of a slightly older girl (w.561), in the Nationalmuseum, Stockholm, a better looking but colder personality, who may be the older sister of the present sitter. But though they share a family likeness, they are as different in character as *The Three Sisters*.

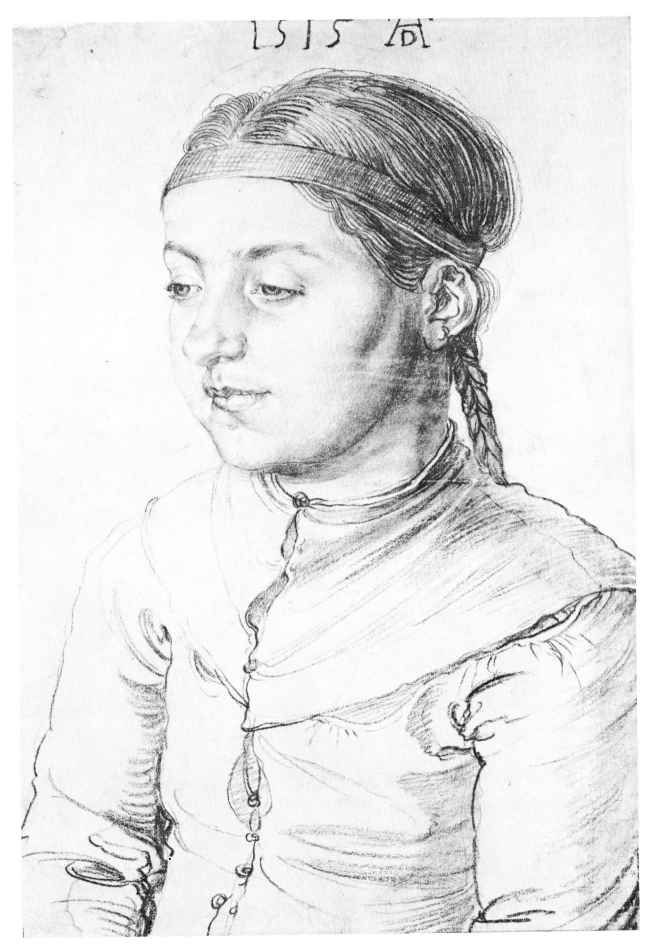

65

Rhinoceros

W.625 L.257 T.639 P.1347
Pen and brown ink. 274 × 420mm.
Inscribed RHINOCERON and dated 1515; for inscription at the bottom, see below
Provenance: Sloane. *London, British Museum*

AT THE BOTTOM of the drawing the artist, clearly copying the letter from his informant in Lisbon, wrote: 'On 8th May, in the year 1513, a live animal, which they call a *rhinocerate*, was brought from India to Lisbon for the King of Portugal, and as it is such a curiosity, I must send you its likeness . . . It is well armed with a thick skin, and is very frolicsome and in good condition. The animal is called *Rhinocero* in Greek and Latin, and in Indian Gomda.' A sketch must have been included in the letter which was the basis of Dürer's drawing. From this the artist made a woodcut (B.136) inscribed with a descriptive text, ending with the words that the animal is 'swift, jolly and amusing'.

The rhinoceros was a present from the King of Cambodia to the King of Portugal. The latter, having matched it in a fight with an elephant, sent it on to Rome as a present to the Pope but it was unfortunately drowned in a shipwreck. It was the first rhinoceros to reach Europe in modern times, and Dürer's woodcut was for many years treated as an accurate zoological representation, achieving immense popularity.

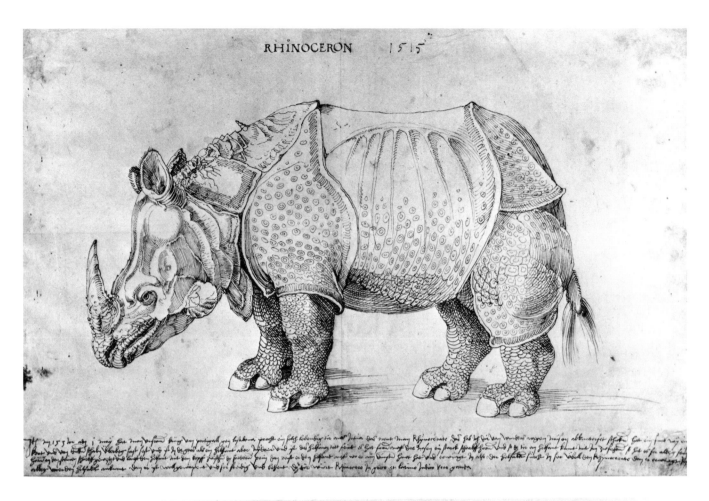

RHINOCERON 1515

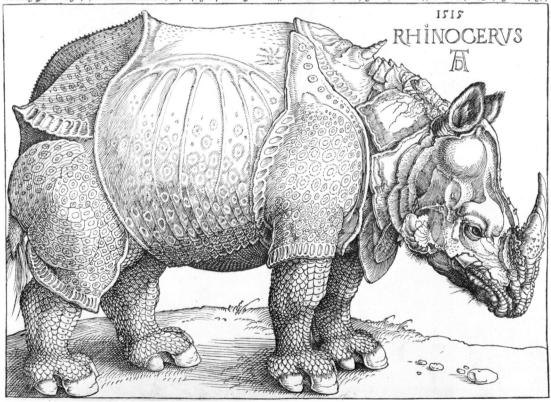

Nach Christus gepurt.1513. Jar. Adi. 1. May. Hat man dem grossmechtigen Kunig von Portugall Emanuell gen Lysabona pracht auß India/ein sollich lebendig Thier. Das nennten sie Rhinocerus. Das ist hye mit aller seiner gestalt Abconterfet. Es hat ein farb wie ein gespreckelte Schildkrot. Vnd ist vō dicken Schalen vberlegt fast fest. Vnd ist in der grōß als der Helfandt Aber nydertrechtiger von paynen/vnd fast werhasstig. Es hat ein scharsff starck Horn vorn auff der nasen/Das begyndt es alßbeg zu wetzen wo es bey staynen ist. Das dosig Thier ist des Helffandt todt feyndt. Der Helffandt furcht es fast vbel/dann wo es Jn ankumbt/so laufft Jm das Thier mit dem kopff zwischen dye fordern payn/vnd reyst den Helffandt vnden am pauch auff vnd erwürgt Jn/des mag er sich nit erwern. Dann das Thier ist also gewapent/das Jm der Helffandt nichts kan thún. Sie sagen auch das der Rhynocerus Schnell/Fraydig vnd Listig sey.

1515
RHINOCERVS

Rhinoceros. Woodcut,
1515. 212 × 300mm.

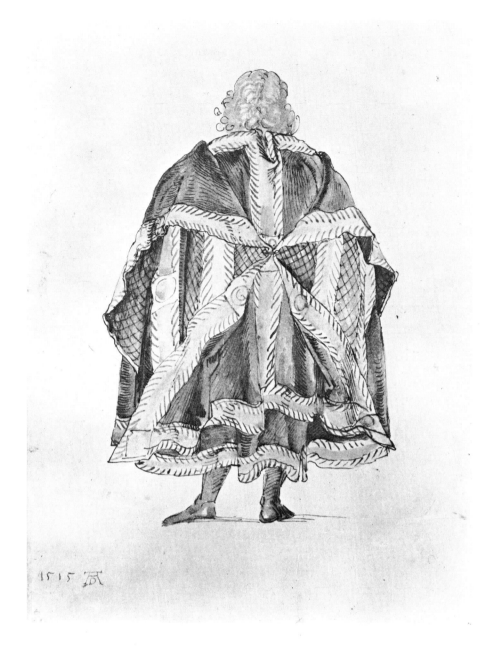

66

Study of Court Costume

W.689 L.543 T.689 P.1289
Pen and ink with watercolour. 283 × 210mm.
Signed and dated 1515 by another hand (Hans von Kulmbach?)
Vienna, Albertina

ONE OF THREE STUDIES of a man in a court costume. The other two (w.686 and 687) were drawn from the front, whereas the present drawing is seen from the back, and becomes almost entirely a drapery study, displaying the elaborate billowing patterns of the costume pinned up in the centre like a ship in full sail. These studies were possibly intended to be included in the woodcut of the *Triumphal Procession of Maximilian I* (B.139), dated 1522, but they were never used.

67

Soldier with Halberd, and a Fox Luring Chickens with Music

68

Sleeping Old Man with a Book, and a Winged Putto with a Dog

T.634 P.965
Pen and violet ink on vellum. 275 × 190mm.
Dated 1515
Munich, Staatsbibliothek

TWO OF THE FIFTY-FIVE marginal illustrations (f.34 *verso* and f.45) made by Dürer in pen and red, violet or green ink in a copy of the Prayer-book of Maximilian. This prayer-book, of which five copies printed on vellum exist today, was written under Maximilian's close supervision, with some passages actually by him, and was probably intended for the Order of St George. The Emperor's revival of the Order with the intention of undertaking a new Crusade represents another of his 'medieval dreams'.

The text of the prayer-book ran continuously so that the artist had to confine himself to marginal illustrations. Many of these have no apparent relevance to the passage they surround, and are little more than inspired doodlings. For some unexplained reason Dürer never finished the illustrations, and a number of other artists such as Cranach and Baldung were commissioned to illustrate the last part of the book (this is now separate from the section illustrated by Dürer and is in Besançon). Dürer used the coloured inks for a purely decorative effect, confining one colour to a page, whereas some of the other artists attempted to introduce a more naturalistic effect by using two colours on the same drawing.

It has often been thought this copy was intended as a specially illustrated one for the Emperor's own use. This, however, is most unlikely since it is both unfinished and incomplete. A number of the drawings, including several by Dürer, clearly require further work; the text lacks initials, and the book contains no liturgical calendar.

The earlier idea that this copy was meant as a working study from which woodcuts would have been made is far more likely, as Panofsky has recently shown. Wood-blocks would have been cut for the illustrations and the capitals, and in imitation of the drawings would have been printed in different colours, a method which was already being practised by printers in Augsburg. Even the type chosen for the text is archaic and resembles the character of handwriting. The prayer-book was intended to give the effect of an illuminated manuscript of a medieval book of hours, but produced by mechanical means. It would have fitted admirably into the Emperor's 'age of chivalry'.

tua Agla Ananizapta te
tragramaton: que sunt laudanda: glorificanda: tremenda: et adoranda: nunc et Per
infinita secula seculorū Amē.
Pater Noster.

O Hiesu vera libertas an
gelorum: mundi fabricator: τ omniū bonoȝ auctor:
via salutis eterne: verus osten
sor. Memento comprehensionis et temptationis tue: quan
do iudei tanquā leones fero
cissimi in templo te circumste

67

Eus noster refugiū et
virtus: adiutor in tribu
latiōibus: que inuenerūt nos
nimis. Propterea non time
bimus dum turbabitur terra:
et transferentur mōtes in cor
maris. Sonuerunt et turba
te sunt aque eorum: conturba
ti sunt montes in fortitudine
eius. Fluminis impetus leti
ficat ciuitatem dei: sanctifica
uit tabernaculum suum al
tissimus. Deus in medio ei
us non commouebitur: ad

69

The Visor of a Helmet, Decorated with a Bagpiper and a Fantastic Bird

W.679 L.544 T.684 P.1448
Pen and brown ink. 194 × 275mm.
Signed and dated 1517 by another hand
Vienna, Albertina

ONE OF A GROUP of five drawings (W.678–682), of about 1515, which were probably
made as designs for a silvered armour commissioned by the Emperor Maximilian from
the Augsburg armourer, Koloman Colman. Both the subjects and style of these
drawings are very close to the illustrations made by Dürer for the Prayer-book of
Maximilian, on which he was working at the same time, and clearly reflect the taste of
the Emperor (see Plates 67 and 68). The collar is decorated with the Order of
Temperance, which occurs prominently in another of the works commissioned by the
Emperor, the *Triumphal Arch* (B.138), of 1515.

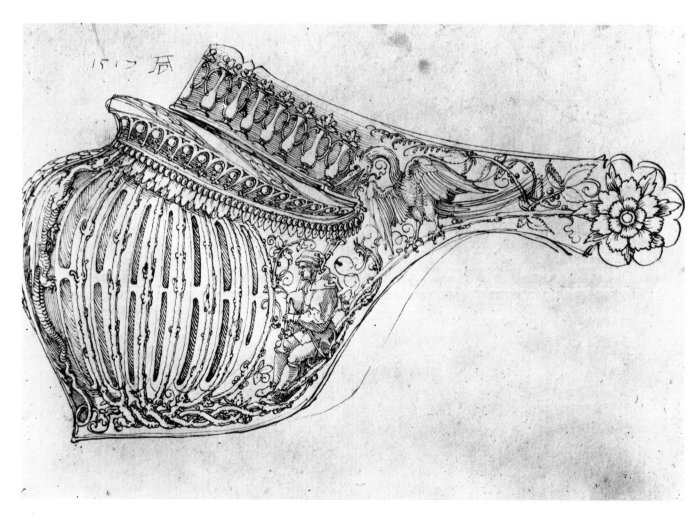

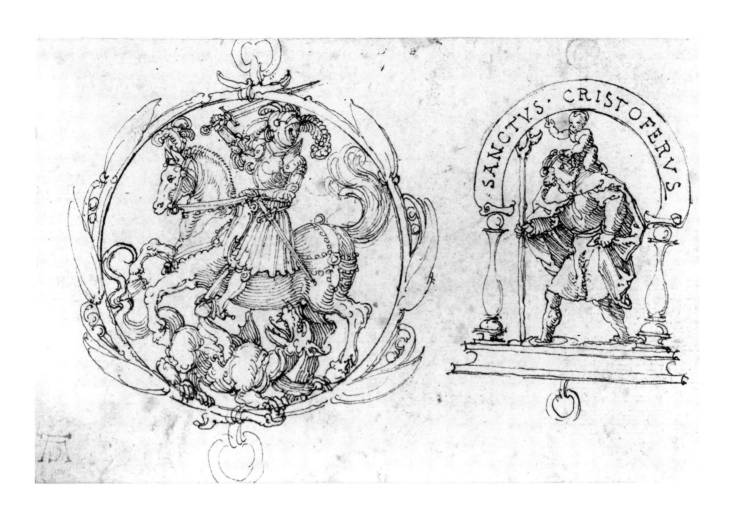

70

Designs for Two Pendants with St George and St Christopher

W.729 L.906 T.686 P.1581
Pen and brown ink. 74 × 116mm. (enlarged)
Signed by another hand
Hamburg, Kunsthalle

ONE OF THE artist's most attractive designs for jewellery, executed about 1515. It was etched by Hollar, which may indicate that in the early part of the seventeenth century it was in the collection of the Earl of Arundel.

The Agony in the Garden

W.585 L.536 T.646 P.558
Pen and brown ink. 296 × 221mm.
Signed and dated 1515
Vienna, Albertina

FINAL PREPARATORY STUDY for the etching of the *Agony in the Garden* (B.19).
Probably as a reaction against his increasingly highly wrought style of engraving, seen
above all in the three major prints of 1513 and 1514, *Knight, Death and the Devil* (B.98),
St Jerome in his Study (B.60), and *Melancolia* (B.74), Dürer took up etching, in which he
was able to use a much more open style of drawing (see Introduction, p. 31). In what
must have been the first idea for the etching of the *Agony in the Garden* (W.584), now
in the Louvre, the foreground was filled with the large figures of two of the sleeping
apostles, while Christ was set back in a relatively unimportant position with his body
turned away from the spectator. In this drawing, however, the apostles have been
banished behind the tree—like animals they have curled themselves up and become
part of the hillside—and Christ takes the centre of the composition, both in scale and
position, so that we witness his agony rather than the faint-heartedness of his followers
as before. Dürer illustrates the passage taken from the gospels, when Christ prays out
loud, 'Father, if thou be willing, remove this cup from me.' In the Louvre drawing, the

LEFT : *The Agony in the Garden*. Etching, 1515. 225 × 160mm.

RIGHT : *The Agony in the Garden*. Pen and brown ink. 1515. 332 × 243mm. Paris, Louvre

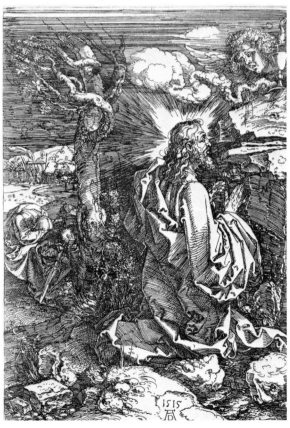

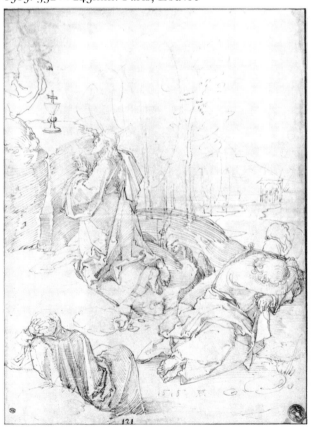

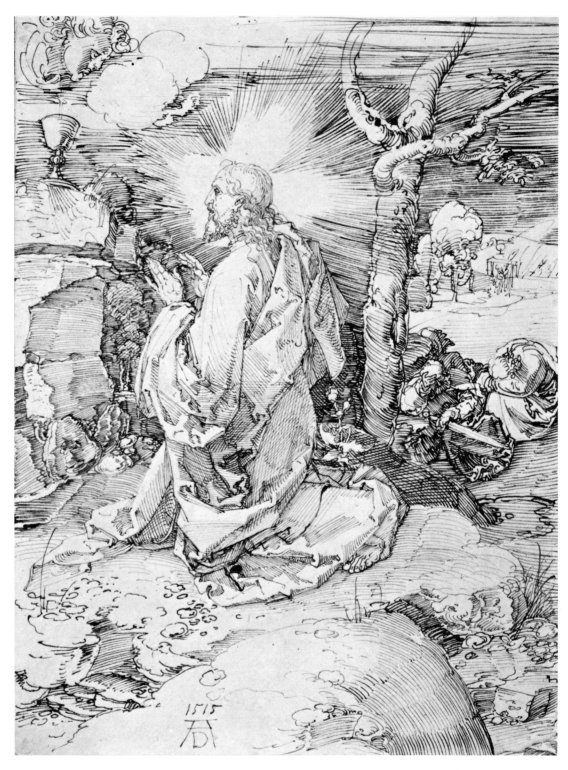

whole figure of the angel appeared, pointing down to the chalice. Now we see only the
head, greatly enlarged, directly above the chalice, looking straight into Christ's eyes.
In the first drawing there was little to distinguish Christ from an ordinary mortal,
but here the radiance of light emanating from his head imbues him with a mystical
appearance. Apart from a number of refinements of detail, the etching followed both
the arrangement and the brilliant open pen drawing of the second study. It was a
theme which preoccupied the artist, and in 1518, in another drawing in the Louvre
(w.586), he returned to the arrangement of his first sketch, by introducing the sleeping
apostle into the foreground but without losing Christ's dominance of the scene.

A Woman Carried Off by a Man on Horseback

W.669 L.817 T.669 P.898
Pen and brown ink. 251 × 203mm.
Provenance: Lanna. *New York, Pierpont Morgan Library*

PREPARATORY STUDY for the etching of the *Rape of Proserpine* (B.72), dated 1516.
Though Dürer followed the design of the two main figures on the etching plate, there
are nevertheless a number of differences between the two works, which indicate that he
originally had another subject in mind, as yet unidentified, when he made this drawing.
Here corpses are strewn on the ground beneath the horse, whereas in the print the
horse has been changed into a unicorn and the corpses omitted. At the same time an
extensive landscape was added in the background. As in the preparatory drawing
(Plate 71) for the etching of the *Agony in the Garden* (B.19) of the previous year, the
more open, looser hatching in the present sheet reflects the style of his woodcuts rather
than his recent engravings. The stance of the rearing horse contains strong echoes of
Leonardo's designs for the Sforza and Trivulzio Monuments.

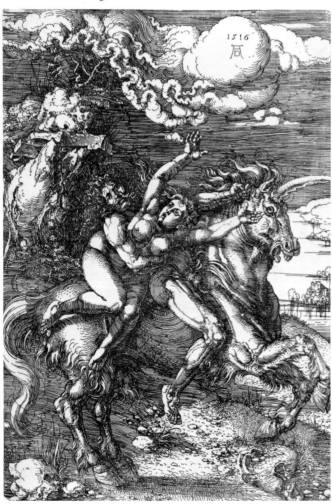

The Rape of Proserpine. Etching,
1516. 310 × 215mm.

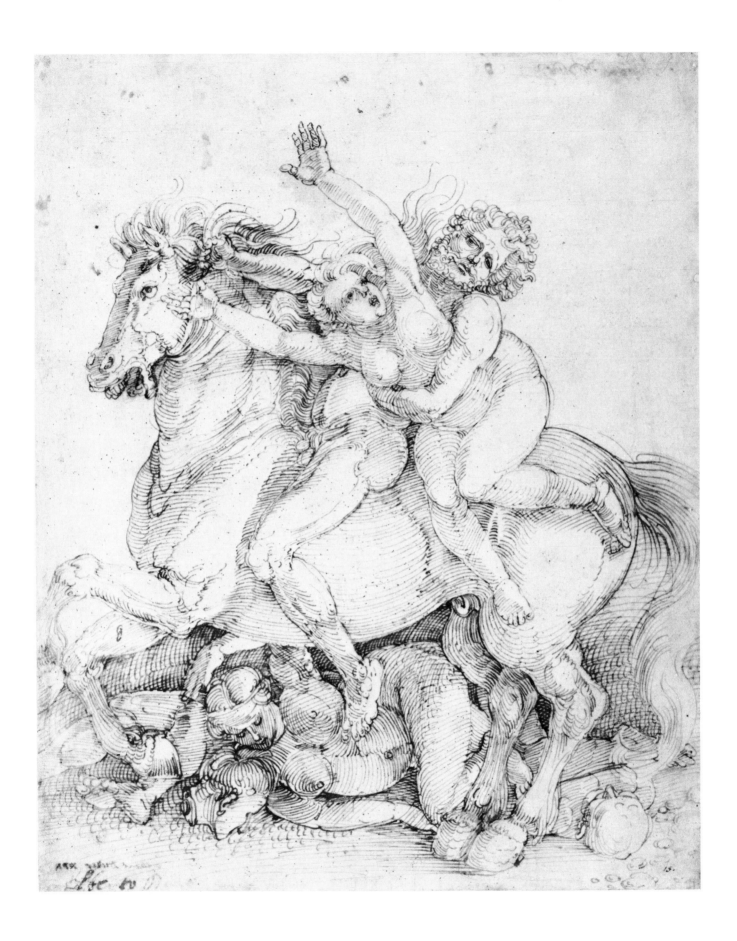

Emperor Maximilian

w.567 l.546 t.708 p.1030
Charcoal; at a later date (? by Dürer) touches of red and yellow wash and white
body-colour added. 381 × 319mm.
Inscribed by the artist (see below). Signed by another hand
Provenance: Imhoff. *Vienna, Albertina*

AFTER MAKING this charcoal portrait from the life, Dürer wrote in pen and ink in the
top right-hand corner: 'This is the Emperor Maximilian, who I, Albrecht Dürer,
portrayed at Augsburg in his little cabinet, high up in the palace, in the year reckoned
1518 on Monday after John Baptist's.' The occasion was the Diet of Augsburg (see p. 25).

Compared with earlier portrait drawings, this study is much looser and more freely
sketched. Nevertheless the character of the Emperor—distinguished, aloof and
disillusioned—is powerfully expressed. The drawing served as the basis for two painted
portraits, now in Vienna and Nuremberg, as well as the famous and frequently copied
woodcut (B.154), which was responsible for spreading the image of the much loved
Emperor throughout Europe. Both paintings and the woodcut were probably executed
only after Maximilian's death in 1519. The woodcut kept to the bust-length of the
drawing, whereas both paintings were enlarged to half-length to show the hands
holding a pomegranate. For the painting in Nuremberg, the artist made a charcoal
study of hands grasping the pomegranate (w.635). But all three works lost the humanity

LEFT: *The Emperor Maximilian.* Oil on canvas, 1519. 830 × 650mm. Nuremberg, Germanisches
Nationalmuseum

RIGHT: *Hands with Pomegranate.* Charcoal, 1519. 152 × 149mm. Vienna, Albertina

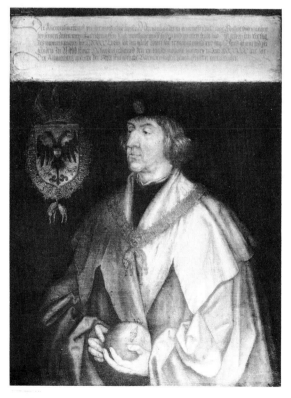

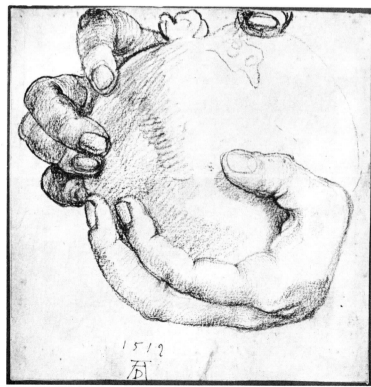

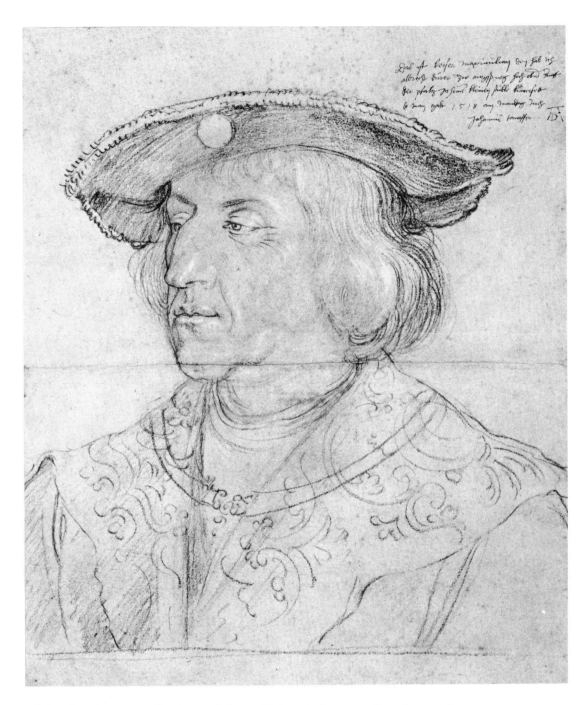

of the drawing and offer instead formal hieratic images of a ruler, without any
suggestions of his character.

Dürer had probably met Maximilian for the first time on his visit to Nuremberg in
1512, and three years later he was granted an annual pension of a hundred florins.
Though their meeting led to a number of commissions—the gigantic woodcut of the
Triumphal Arch of the Emperor Maximilian (B.138), composed of nearly two hundred
different blocks, the woodcut of the *Triumphal Procession of the Emperor Maximilian*
(B.139), and the unfinished illustrations to the *Prayer-book* (Plates 67 and 68)—Dürer
never succeeded in producing his most significant work for his imperial patron, who
still lived in his imagination in the 'age of chivalry' and never tired of constructing a
web of medieval allegory around the events of his life. In each case Dürer was defeated
by the allegorical subject-matter, and there was no more ill-conceived venture in his
career than the *Triumphal Arch*, with its elaborate imagery drawn up by Pirckheimer.

Virgin and Child with an Angel Playing the Violin before a Landscape

W.536 L.391 T.740 P.680
Pen and black ink. 305 × 210mm.
Signed and dated 1519
Windsor, Royal Collection

THE MOST monumental and perfect of the studies of the Virgin and Child made by the artist during the second decade of the century. It represents the culmination of his search for a satisfactory formal and psychological representation of this particular theme, which had occupied him since his return from Venice and stands as one of the most perfect blendings of Dürer and Venetian art. The music-playing angel, recalling that in the *Feast of the Rose Garlands*, the Virgin and Child enthroned before a curtain with extensive vistas of landscape on either side, all show the artist's debt to Venetian art; yet the types, the yearning look of the angel, the self-conscious composure of the Virgin, are unmistakably Dürer. In spite of the masterly fluency and certainty of the pen strokes, the artist prepared his way with 'construction' lines, which can be seen, for example, on the Virgin's face.

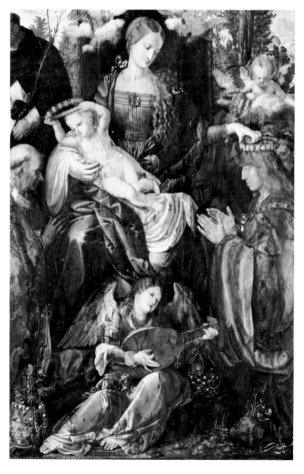

Detail from the *Feast of the Rose Garlands* (see page 116)

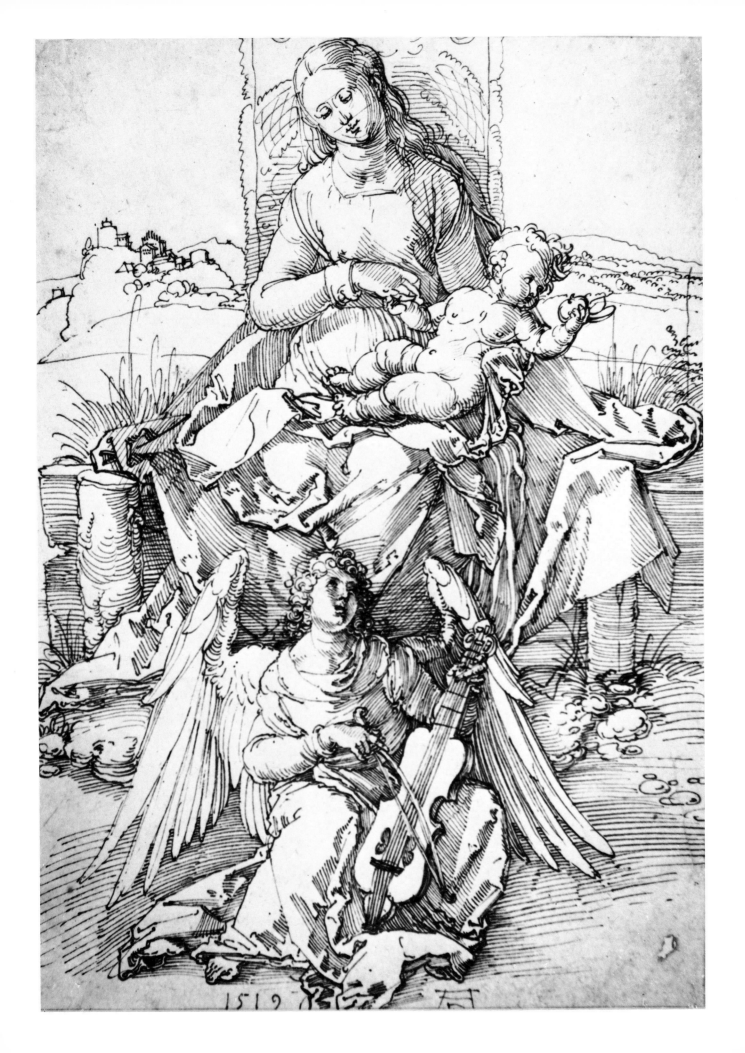

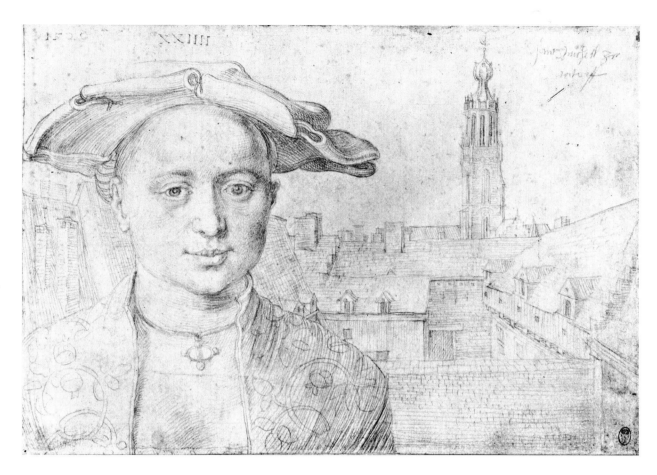

75

Man of Twenty-four
with View of St Michael's, Antwerp

W.769 L.338 T.775 P.1490
Silver point on pinkish prepared paper. 133 × 194mm.
Dated upper left 1520. Inscribed above the man: XXIIII, and upper right: *sant michell
zwantorff*
Provenance: Vivant-Denon; Reiset. *Chantilly, Musée Condé*

A LEAF from the sketchbook ('*mein Büchlein*'), which Dürer took with him on his
journey to the Netherlands, and filled with drawings in silver point. Fifteen leaves exist
today, most of them with drawings on both sides, containing portraits, views of
landscape and buildings, and a variety of other objects which caught his interest. The
artist did not proceed consecutively through the book, but often only returned to draw
on the verso at a later date. Moreover, where the oblong format did not suit a subject,
such as a portrait, he only used half the sheet, and only later on returned to complete it
with another study, subconsciously fitting them together in a harmonious composition.

 Dürer also took with him another small book, in which he noted down his expenses,
the people he met and drew, the places he visited, and other miscellaneous impressions.
When his interest was fully engaged, such as on his visit to Zeeland to see a whale, he
was moved to write long and vivid descriptions.

 The identity of the 24-year-old man on the present leaf is not known. Dürer spent

much of his time in Antwerp, going off to visit other places and then returning. He makes no mention in his Journal, however, of drawing the church of St Michael. It was clearly done after the portrait of the man, and the view skilfully arranged around him. It could have been executed as late as July, 1521, since the date of 1520 presumably refers to the portrait.

76 *Town Hall, Aachen*

W.764 L.339 T.764 P.1483
Silver point on pinkish prepared paper. 127 × 189mm.
Inscribed by the artist: *dz rathaws zw ach*
Provenance: Vivant-Denon; Reiset. *Chantilly, Musée Condé*

A LEAF from the Netherlands sketchbook (see note to Plate 75). Dürer made a special visit to Aachen from Antwerp, where he spent the whole of October 1520. He does not record in his Journal making a drawing of the Town Hall, though it was possibly done on the occasion when he notes that 'I gave the town-servant who took me up into the hall 2 white pf.' One of the main purposes of the artist's journey to the Netherlands was to attend the coronation of Charles V at Aachen, in the hope of meeting him and getting a renewal of his pension, which had lapsed since the death of Maximilian. Given what must have been the splendour of the scene, the coronation receives short shrift in the Journal. If he was preoccupied with the question of his pension, he was put out of his anxiety the following month, when it was ratified by the new Emperor.

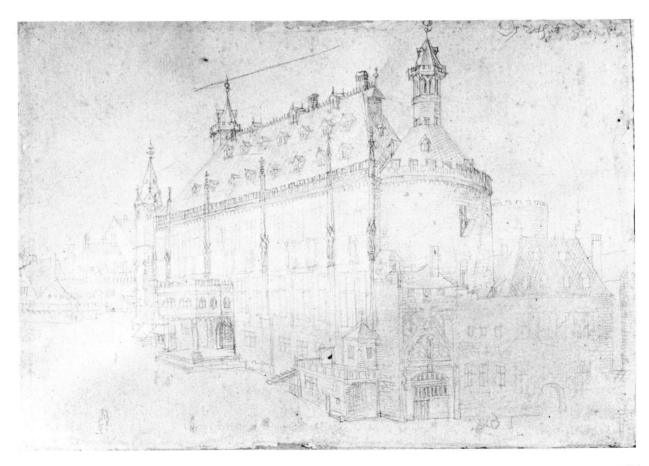

Two Studies of a Lion

W.779 L.60 T.815 P.1497
Silver point on pinkish prepared paper. 122 × 171mm.
Provenance: Firmin-Didot. *Berlin, Kupferstichkabinett*

A LEAF from the Netherlands sketchbook (see note to Plate 75). On 10 April 1521, Dürer was in Ghent. After admiring the Ghent altarpiece ('it is a most precious painting, full of thought'), he records that 'next I saw the lions and drew one with the metal point.' And a study of a lion, inscribed *zu gent*, occurs on one leaf of the sketchbook (W.781). These two studies were probably made on the same occasion and probably show the same animal, seen in different positions.

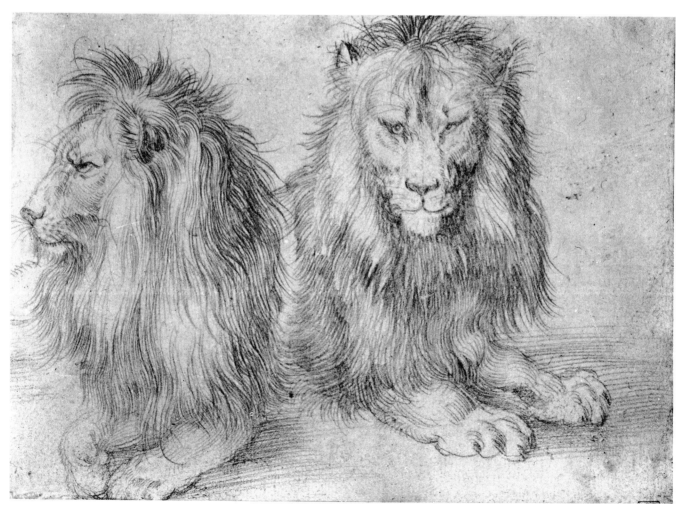

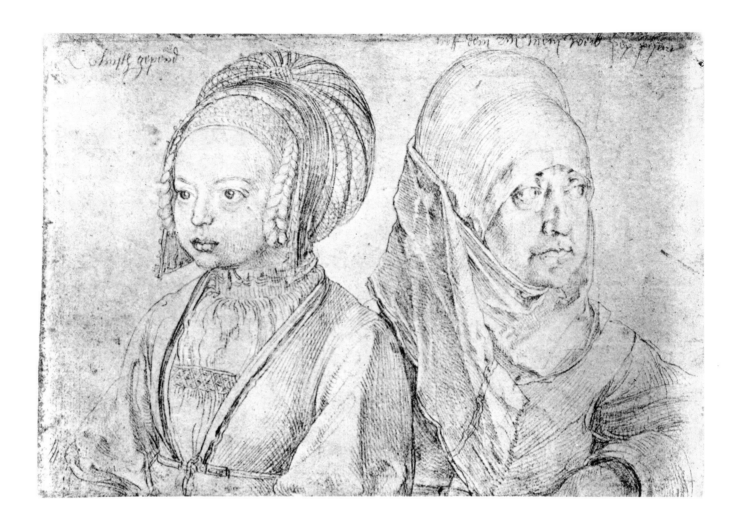

78 *A Woman from Cologne and Dürer's Wife*

W.780 L.424 T.813 P.1499
Silver point on pinkish prepared paper. 129 × 190mm.
Inscribed: (above the woman) *Cölnisch gepend* and (above his wife) *awff dem rin mein weib pey popart*
Vienna, Albertina

A LEAF from the Netherlands sketchbook (see note to Plate 75). These two studies are drawn on the verso of the study of a lion (w.781) made in Ghent on 10 April 1521. This side was, however, made nearly three months later on the return journey to Nuremberg, and is among the last drawings Dürer made in the sketchbook. He arrived in Cologne in the second half of July 1521, when he must have drawn the portrait of the girl dressed in local costume, and then some days later when he reached Boppard, according to the inscription, he added the portrait of his wife. Though she was allowed to accompany him for the first time on a journey, Dürer had not paid her much attention. As the sheet stands, it provides a telling contrast between age and youth, and some such idea may have prompted Dürer to complete the page with a portrait of his wife. (While in the Netherlands, he had made a large portrait of her in Netherlandish costume in metal point (w.814), which he carefully inscribed.)

175

79

Antwerp Harbour with the Scheldt Gate

W.821 L.566 T.753 P.1408
Pen and brown ink. 213 × 283mm.
Dated 1520 and inscribed *Antorff*
Vienna, Albertina

DÜRER took the view of the Scheldt Gate with the river on the left from above ground
level, presumably from the window of a building. It is the most 'impressionistic' of all
his landscape studies. Unlike his earlier drawings, which attempt to give a detailed
rendering of the myriad forms of nature, here with marvellous economy he catches the
essence of the view in a very few strokes of the pen. From a technical point of view this
sheet is unfinished, since the buildings in the foreground are only lightly blocked in.
The artist must have decided that further elaboration would have muted the sweep of
the eye diagonally along the quay and on down the river towards the sea.

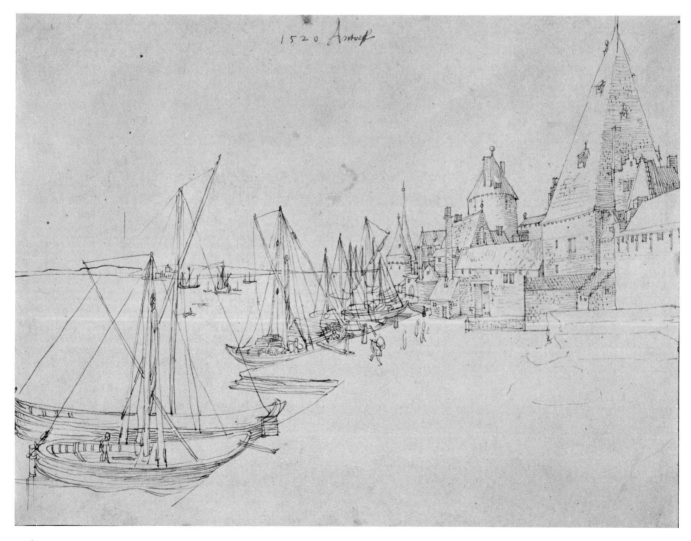

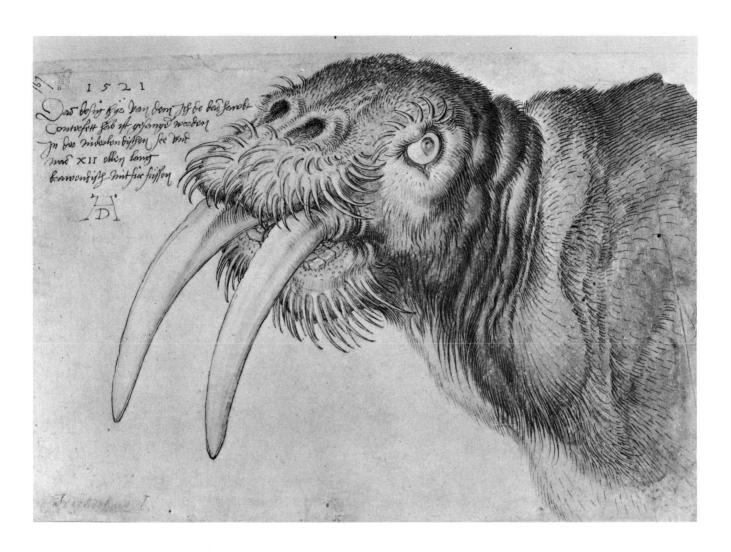

80

Head of a Walrus

W.823 L.290 T.850 P.1365
Pen and brown ink with watercolour. 206 × 315mm.
Signed and dated 1521, and inscribed (see below)
Provenance: Sloane. *London, British Museum*

IN THE UPPER LEFT CORNER of the sheet, Dürer wrote: 'The animal whose head I have
drawn here was taken in the Netherlandish sea and was 12 Brabant ells long and had
four feet.' He must have seen this walrus on his journey to Zeeland in December 1520,
when he had hoped to catch sight of the stranded whale, which had, however, been
floated off by the tide before the artist could get there.

On his return to Germany, he used this study for the head of St Margaret's dragon
in one of the 'upright' versions of the *Sacra Conversazione* (W.855), now in Bayonne.

Erasmus

W.805 L.361 T.760 P.1020
Charcoal. 373 × 271mm.
Dated 1520, and inscribed by another hand: *Erasmus fon rottertam*
Provenance: Andreossv; Gigoux; Bonnat. *Paris, Louvre*

ON HIS VISIT TO BRUSSELS at the end of August 1520, Dürer records that 'I have also given Erasmus of Rotterdam a *Passion* engraved in copper', and then a little later on, 'I have once more taken Erasmus of Rotterdam's portrait'. Today only this drawing exists, but it must clearly be the portrait to which Erasmus refers in a letter to Pirckheimer of 1525, when he writes: 'I should like to be depicted by Dürer; why not by such a great artist? But how is it possible? He had started at Brussels with charcoal, but now, I am afraid, I am long forgotten.' In another letter of a few months later, he explained that the drawing was unfinished because they were interrupted by the arrival of 'courtly ambassadors'. This drawing is far less modelled than other charcoal portraits made in the Netherlands, and lacks the shading in the background.

When Dürer came to make his engraving (B.107) six years later, he was unable to refresh his knowledge of the sitter from the life, and had to turn to this drawing for help. He did not however base the engraving directly on the drawing, and though keeping the same cap he portrayed Erasmus nearly in profile, standing at his desk

LEFT: Quentin Massys (1465/6–1530): *Erasmus of Rotterdam*. Oil, 1517. 590 × 465mm. Rome, Galleria Nazionale RIGHT: *Erasmus*. Engraving, 1526. 249 × 193mm.

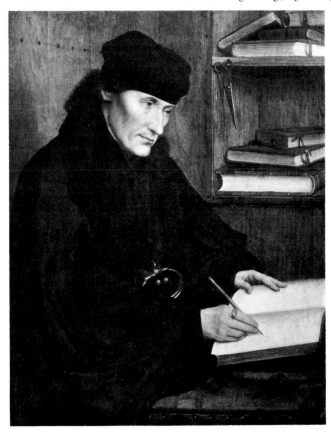
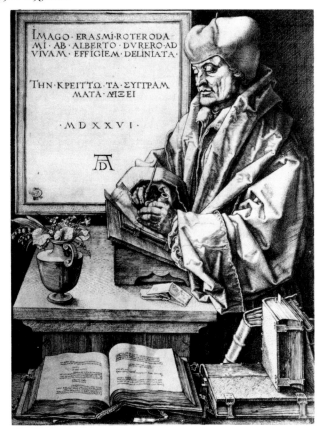

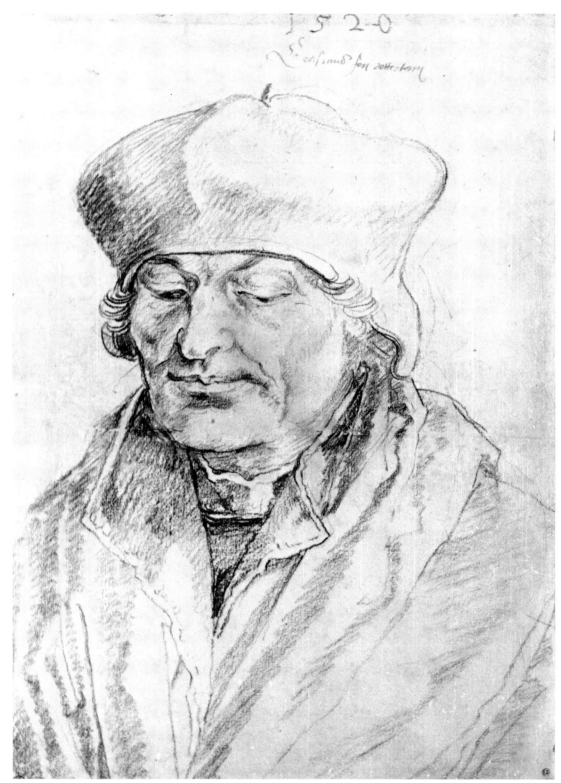

writing, a *mise en scène* inspired by Quentin Massys's portrait of the humanist. The print, though offering the image of a scholar surrounded by his books, was not a success as a portrait of a human being, a failing which Erasmus himself felt when writing to Pirckheimer: 'That the portrait is not an altogether striking likeness is no wonder. I am no longer the person I was five years ago.' Perhaps Dürer was himself dissatisfied, and the Greek inscription stating that the writings of Erasmus will give a better portrait of him than the print was not entirely well-meant flattery of the man he so strongly admired.

82

Portrait of a Young Man

W.807 L.287 T.833 P.1078
Charcoal. 378 × 273mm.
Dated 1521 (cut at top) by Dürer and signed by another hand
Provenance: Sloane. *London, British Museum*

ONE OF THE MOST imposing charcoal portraits drawn by Dürer on his Netherlands journey, but no convincing identification of the sitter has been made. These large charcoal portraits were clearly made as finished works of art, either as commissions or gifts, and with their shaded backgrounds produce the effect of a grisaille.

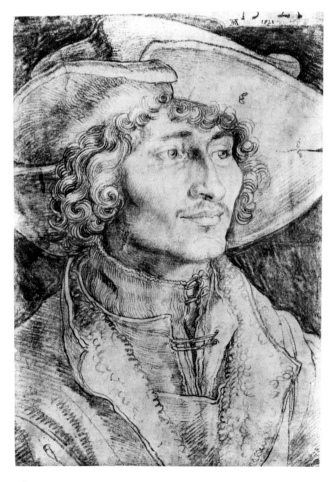

Portrait of a Young Man

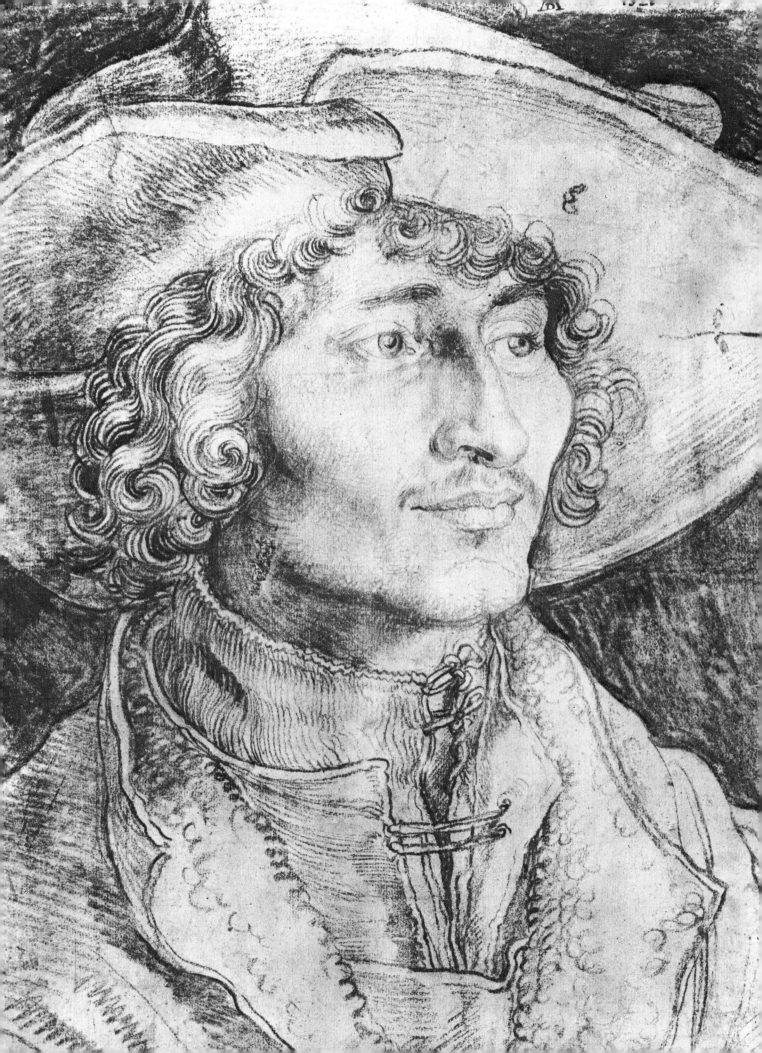

83

Moorish Woman (The Negress Catharine)

W.818 L.851 T.811 P.1044
Silver point. 200 × 140mm. (reproduced original size)
Dated 1521, and inscribed *Katherina allt 20 jar*; signed by another hand
Florence, Uffizi

WHILE IN ANTWERP at the very beginning of April 1521, Dürer records in his journal,
'I drew with the metal point a portrait of his Moorish woman', which can be identified
with the study of '20-year-old Katherina' portrayed here. She was servant to Joano
Brandano, the business representative and consul of the King of Portugal. Brandano,
with whom Dürer had frequent dealings during his stay, made the artist numerous
presents, including a set of porcelain and some Portuguese and French wine. He was
typical of the kind of person who patronized Dürer during his time in Antwerp. These
were mainly foreign merchants, such as Fernandez, another rich Portuguese merchant,
who succeeded Brandano as consul, or Tommaso Bombelli, a Genoese merchant.

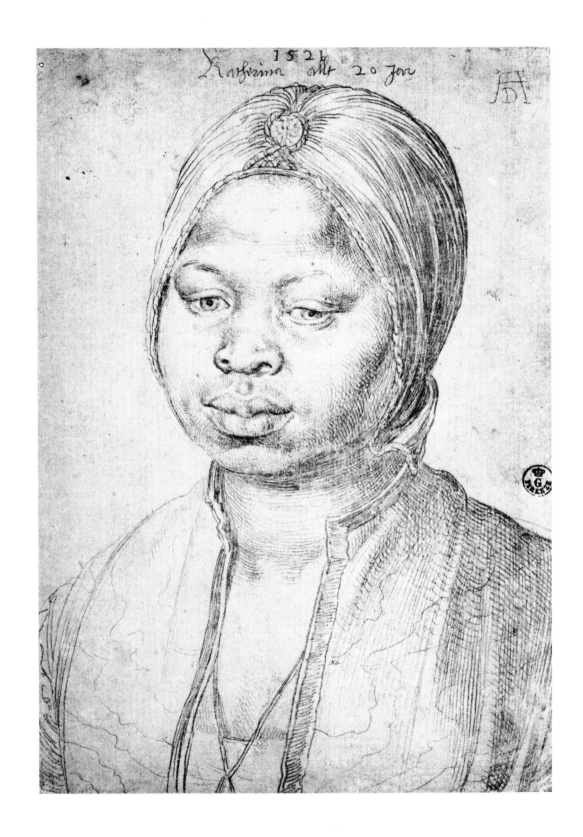

183

84

Lucas van Leyden

w.816 l.847 t.830 p.1029
Silver point. 244 × 171mm. (reproduced original size)
The artist's monogram and name inscribed by another hand
Lille, Musée Wicar

ARTISTICALLY one of the most important encounters in the Netherlands was Dürer's meeting with Lucas van Leyden, whose work had increasingly come under the influence of the German artist. In the year of Dürer's arrival in the Netherlands, Lucas had produced both a drawing and a print, done in a combination of etching and engraving, based very closely on the former's woodcut portrait of the Emperor Maximilian (B.154). While in Antwerp at the beginning of June 1521, Dürer writes: 'Master Lukas who engraves in copper asked me as his guest. He is a little man, born at Leyden in Holland.' And in the next paragraph Dürer adds, 'I have drawn with the metal point the portrait of Master Lukas van Leyden.' This portrait, engraved by Wierix, was included, later in the century, in H. Cock's *Pictorium aliquot Celebrium Germaniae inferioris effigies.*

In the top left-hand corner, a number of trial strokes have been made with the silver point.

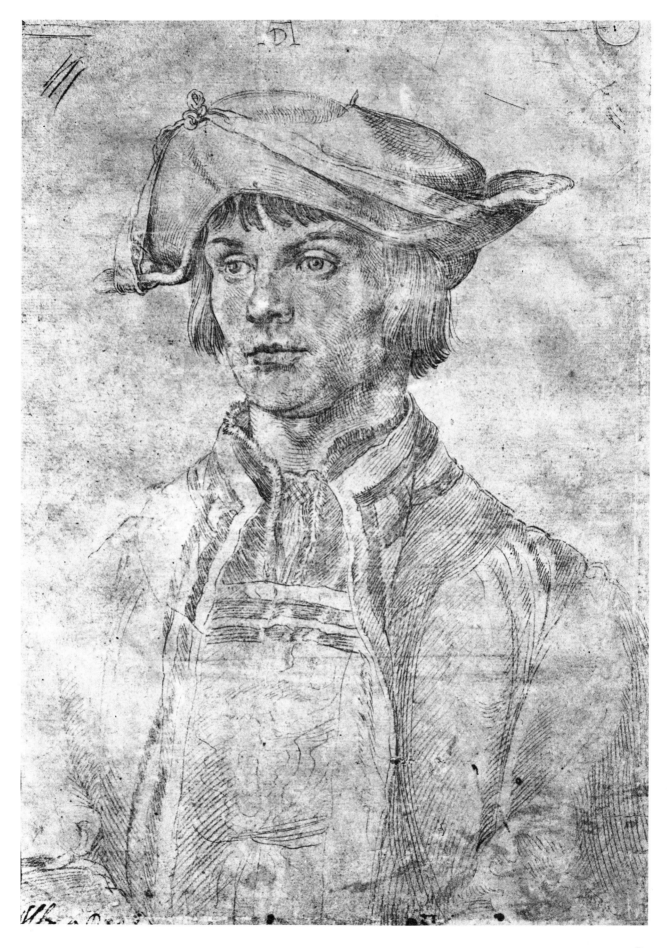

Portrait of an Old Man of Ninety-three

W.788 L.568 T.804 P.817

Brush and black ink, heightened with white, on dark-purple prepared paper. 420 × 282mm.
Signed and dated 1521, and inscribed: *Der man was alt 93 jor und noch gesunt und*
vermuglich zw antorff
Provenance: Imhoff. *Vienna, Albertina*

DÜRER made this study of 'a hale and hearty 93-year-old' in Antwerp from a model. It
was probably this man who was the recipient of three stuivers for his services noted by
Dürer in his journal. At the same time Dürer decided to use the drawing for a painting
of *St Jerome in Meditation*, now in the National Gallery, Lisbon, which he already
describes as being finished in March 1521. Since Dürer wished the saint to look out at
the spectator, and not downwards as in his drawing of the old man, he made another
study of the head (W.789), in the same medium as the present sheet, to guide him when
he started work on the panel. For three other preparatory drawings see Plates 86–8.

 The painting also was executed in Antwerp, and in his Journal for March 1521
Dürer writes, 'I painted a *Jerome* carefully in oils and gave it to Rodrigo of Portugal.'
Rodrigo Fernandez, later Portuguese consul, became a good friend of the artist, and
gave him numerous presents. The painting was clearly inspired by Flemish art,
particularly the work of Quentin Massys, but in its turn it exerted enormous influence
in Flanders, which varied from outright copies, with a few details altered, to less
blatant adaptations, such as the pointing finger and the shell in Lucas van Leyden's
engraving of *St Jerome in his Study* (B.114), of 1521.

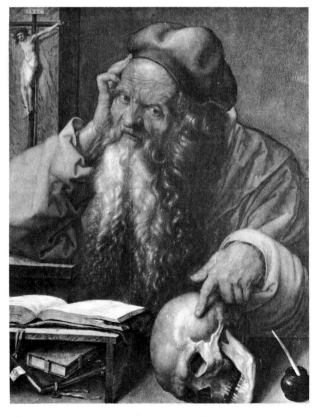

St Jerome in Meditation. Oil on panel,
1521. 600 × 480mm. Lisbon, National
Gallery

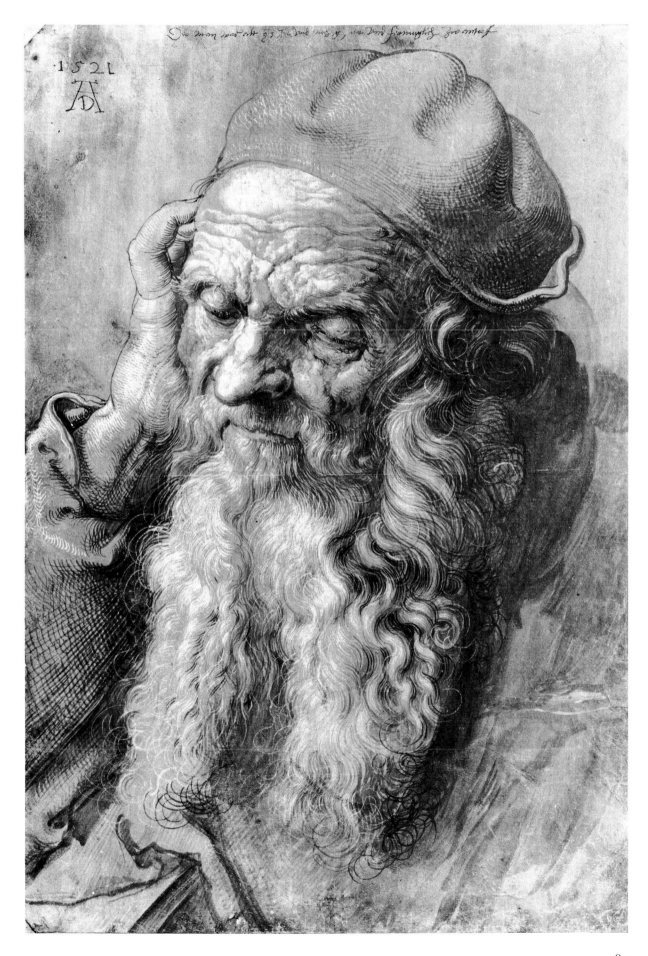

Bust of an Old Man, and his Left Forearm

W.790 L.569 T.806 P.818
Brush drawing in black ink, heightened with white, on dark-purple prepared paper.
395 × 286mm.
Signed and dated 1521
Vienna, Albertina

STUDIES made of the '93-year-old man' (see previous plate) and used as preparatory studies for the painting of *St Jerome in Meditation* (see p. 186) in Lisbon. The arrangement of the saint—here he looks down apparently asleep—was changed in the painting. The arm was also differently arranged, bent at the wrist instead of straight. Only the detail of the hand was transferred unaltered to the painting.

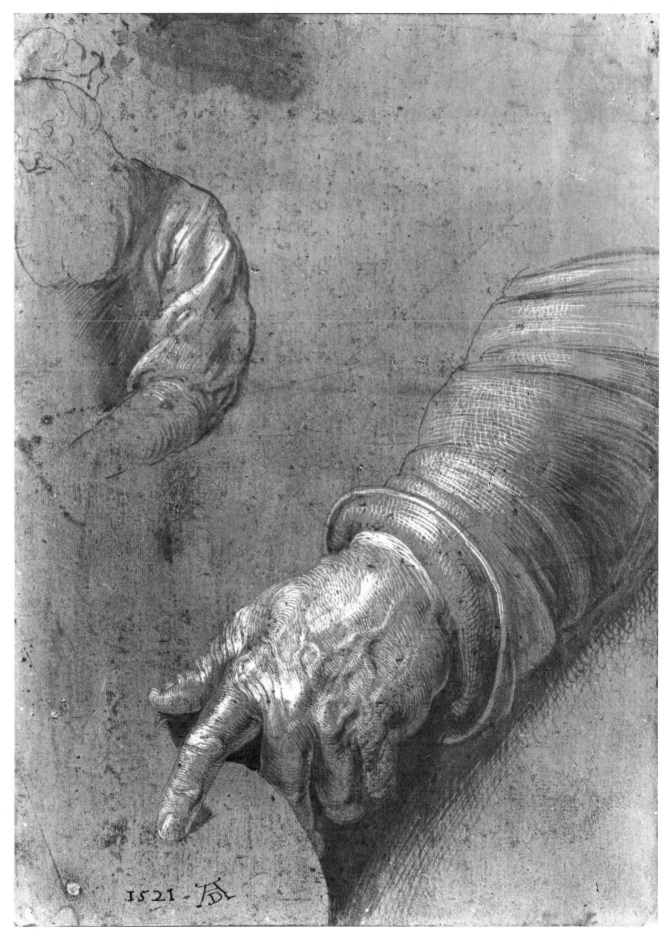

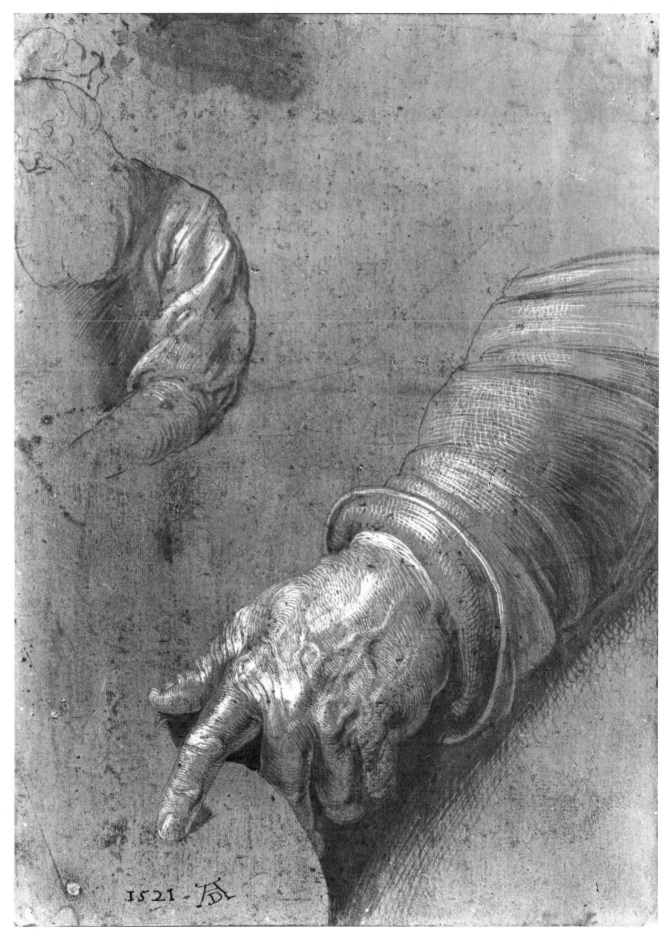1521 · AD

Writing-desk with Books and an Oval Box

W.791 L.571 T.807 P.821
Brush drawing in black ink, heightened with white, on dark-purple prepared paper.
198 × 280mm.
Signed and dated 1521
Vienna, Albertina

PREPARATORY DRAWING for the painting of *St Jerome in Meditation* (see p. 186), in
Lisbon (see note to Plate 85). In the painting, the left half of the desk and the oval box
were omitted.

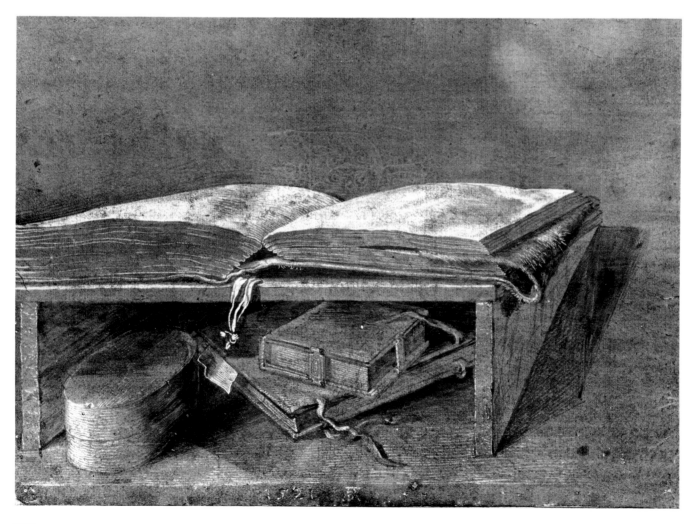

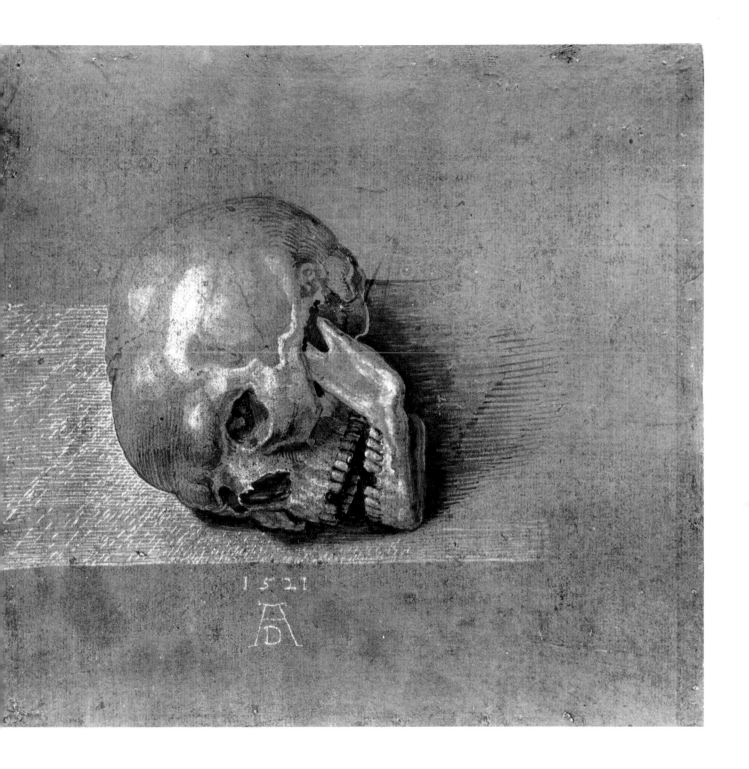

88 *Death's Head*

W.792 L.570 T.808 P.820
Brush drawing in black ink, heightened with white, on dark-purple prepared paper.
180 × 192mm. (reproduced original size)
Signed and dated 1521
Vienna, Albertina

PREPARATORY DRAWING for the painting of *St Jerome in Meditation* (see p. 186), in
Lisbon (see note to Plate 85).

89, 90

Christ Carrying the Cross

W.793/4 L.842/3 T.787/8 P.579/81
Both pen and black ink. 210 × 285mm.
Both signed and dated 1520
Florence, Uffizi

AT THE END of May 1521 Dürer wrote in his Netherlands Journal, 'I drew 3
Leadings-forth and 2 *Mounts of Olives* on 5 half-sheets.' Though there is a discrepancy
of one year in the date inscribed on three of the drawings—the third 'Leading-forth' no
longer exists—this remark is generally assumed to refer to these two sheets and the
following two (Plates 91 and 92). Also drawn on 'half-sheets' but unmentioned in the
Journal are three studies of the *Entombment* (W.795, 796 and 799), all dated 1521. The
existence of these drawings suggests that Dürer had a new Passion series in mind,
which, judging from their style and size, were to be executed in woodcuts. Two years
later, in 1523, Dürer produced a drawing of the *Last Supper* (W.889), in the same style
and format, which was cut in a somewhat rearranged form on a wood-block (B.53). The

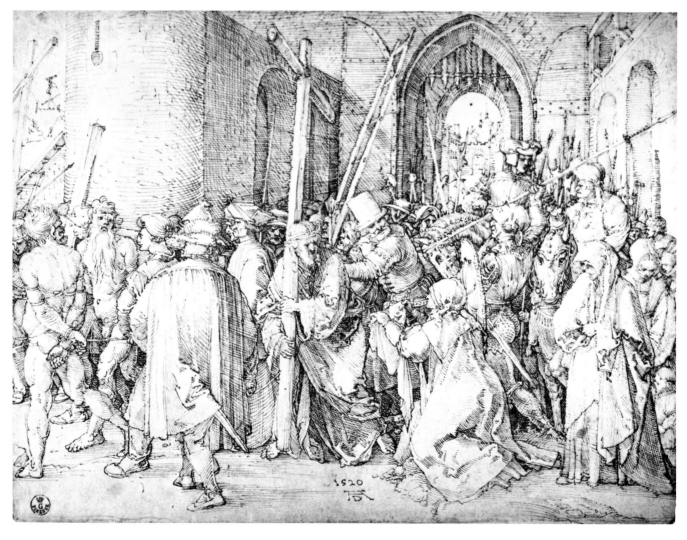

89

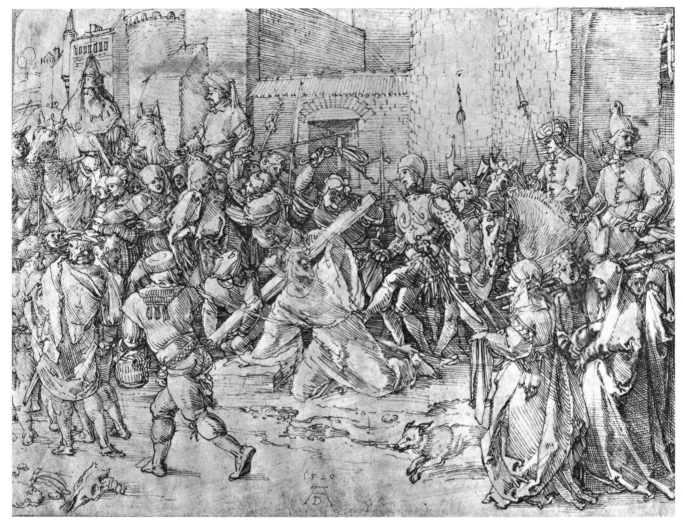

following year he drew another oblong *Christ on the Mount of Olives* (w.891) and an
Adoration of the Kings (w.892).

The most immediately notable feature about these drawings is that the composition,
although the same size as the woodcut series of the *Life of the Virgin*, is horizontal
instead of vertical. Previously, with very few exceptions, Dürer had kept strictly to an
upright format in his prints and drawings. This new style encouraged him to produce a
procession of figures across the page instead of concentrating on the central point of the
composition. The existence of more than one representation of each of the subjects
suggests that the artist was in an unusual dilemma. In this case there was no question
of his merely improving his design from one drawing to another. Each drawing is quite
complete and perfect in itself, and offers an essentially different interpretation of the
story in hand. It seems more likely that he was fundamentally uncertain how to
illustrate the theme of the Passion within his new format.

The two interpretations of *Christ Carrying the Cross* show a basic contrast. The
composition of Plate 89 is more static. Christ, picked out by the massive, nearly
vertical cross as well as by the accents of the ladder and a raised spear, has stopped and
turned back to St Veronica, who proffers the veil on her knees. In spite of the man
shoving him, Christ and Veronica have time to look into one another's eyes. Though
the soldiers make determined efforts to get the procession moving again, the pace is
slow. The vast, huddled crowd is moving out of the courtyard, only then able to turn to
their right and proceed across the foreground. The massive architecture, whose depth

is emphasized by the vista through two courtyards, further serves to arrest the eye. And at the head of the procession one can see the two thieves, naked and with their hands bound, turning back to discover what has happened to their companion.

The scene in Plate 90 is intensely dramatic and *mouvementé*. The figure of Christ, who now falls to his knees instead of stopping in his steps, provides a vigorous contrast to the movement of the soldiers and the crowd who point the way unmistakably with their arms. The juxtaposition of diagonal accents creates a sense of intense restlessness. There is no time for St Veronica to fall to her knees; the Holy Women, accompanied by St John, follow helplessly behind. One soldier tugs at Christ; another whips him; a third kicks him. In this drawing one is far less conscious of the buildings behind. Without any arresting vistas they merely provide a backdrop to the figures lining the route.

Dürer's earlier interpretations in the three Passion series in woodcut and engraving had been quite different. While in the Netherlands, he probably saw an Eyckian composition, now known in a painting in Budapest, which has a number of similarities in format and detail with Plate 89; Christ for example, stands, and does not fall to his knees as in Dürer's previous representations. Dürer must also have looked at Schongauer's large engraving of the same subject (B.21), which in general movement and several details, such as the high priest in the conical hat and the turbaned figure beside him both on horseback, and the dog running beside the procession, has affinities with the second version (Plate 90).

91, 92

Christ on the Mount of Olives

W.797 L.844 T.789 P.560
Pen and brown ink. 206 × 274mm.
Signed and dated 1520
Provenance: P. Lely; Lord Hampton. *Basle, R. von Hirsch collection*

W.798 L.199 T.820 P.562
Pen and brown ink. 208 × 294mm.
Signed and dated 1521 on left; also monogram on right
Provenance: Vivant-Denon(?); Reinhold; F. W. Fink. *Frankfurt, Städelsches Kunstinstitut*

PROBABLY the '2 *Mounts of Olives*' mentioned by Dürer in his Netherlands Journal in May 1521 (see note to Plates 89 and 90).

Like *Christ Carrying the Cross*, Dürer here offers two different interpretations of the subject. But the basic difference between the two renderings—whether to emphasize the weakness of the sleeping Apostles, or to concentrate on Christ's spiritual torment—was one that he had pondered at an earlier date when working on the etching of 1515 (see note to Plate 71). As in the drawing of 1515 in the Louvre (see p. 164), Plate 91 portrays the large slumbering figures of the Apostles in the foreground, while Christ, a little way back, kneels on the rock. In the earlier representation the act of prayer had been expressed by joined hands. But now Christ raises his arms to Heaven in a

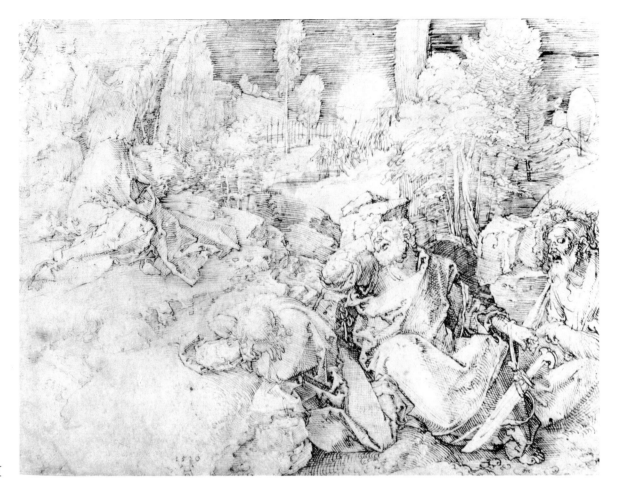

91

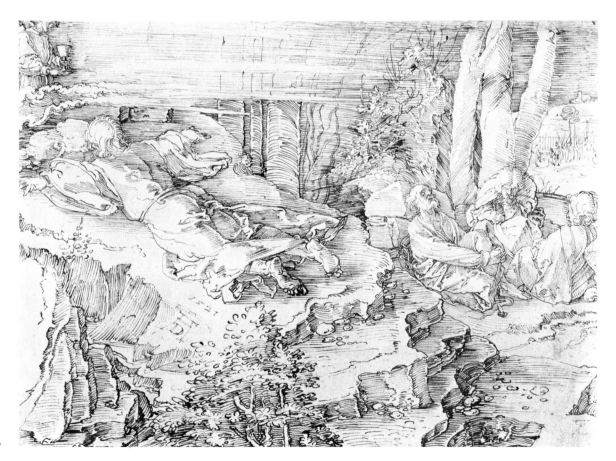

92

beseeching gesture. His face is a white silhouette; no features are required to convey his emotions.

Plate 92, on the other hand, gives the centre of the composition to Christ, and the Apostles are placed further back, as in the etching (see p. 164) of 1515 and its preparatory drawing (Plate 71). But like Plate 91, the new interpretation is more emotionally intense. No longer does Christ kneel; he is now flat on his face on the ground, his arms stretched out sideways, foreshadowing his position on the Cross. Dürer illustrates, literally, the words of St Matthew: 'He . . . fell on his face, and prayed.' A mist descends with the Angel, covering the upper part of the trees. While the Apostles sleep and Judas and the soldiers make their way through the garden, we are made aware of the miraculous presence of another more spiritual world. Dürer the rationalist achieves a mystic and poetic quality that he never surpassed in any other work.

The representation of Christ prostrate on the ground had occurred very occasionally before in German art, and also in a woodcut (B.54) by Dürer himself, which was probably intended for the *Small Passion* but never used. Even closer in pose is the figure of one of the sleeping Apostles in the *predella* panel to Mantegna's *San Zeno Altarpiece*, which Dürer may well have seen when in Italy. The rocky terrain and the chiselled, clinging drapery, as if the force of gravity had trebled in strength, are also reminiscent of Mantegna, whose method of drawing with the burin is very strongly felt in this group of drawings of the Passion. Dürer achieves the same rock-like structure in his figures and landscape by a far greater economy of hatching than he had previously used. Shading tends to be drawn in a number of basic directions, emphasizing the unity of the scene.

There is another drawing portraying Christ stretched out on the ground (w.803), in Berlin, limited to the figures of Christ and the Angel, which if genuine is probably connected with Plate 92. In 1524 Dürer produced yet another version of the subject (w.891), now in Frankfurt, which in essence derives from Plate 91 but reveals an increasingly austere spirit matching the representation of the *Last Supper* (w.889).

93, 94

Virgin and Child with Three Saints and Angels

W.837 L.343 T.846 P.760
Pen and black ink. 252 × 387mm.
Dated 1521 by Dürer and signed by another hand
Provenance: Vivant-Denon; Révil; Reiset. *Chantilly, Musée Condé*

Virgin and Child with Ten Saints and Angels

W.839 L.364 T.851 P.763
Pen and brown ink. 315 × 444mm.
Provenance: Vivant-Denon. *Bayonne, Musée Bonnat*

ON HIS RETURN from the Netherlands in 1521 Dürer was clearly commissioned to execute an altarpiece of the *Virgin and Child with Saints and Music-making Angels* or *Sacra Conversazione*, but the work was never carried out and nothing is known about the external circumstances of the commission. Six compositional sketches and a number

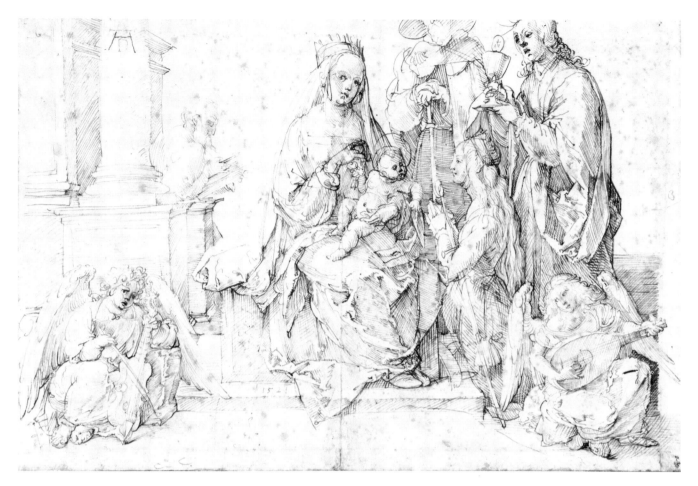

93

of chalk studies of details show that the artist gave very considerable thought to this work, and that it would undoubtedly have been the greatest painting of his whole career. The subject was inspired by his recollections of Venetian painting, particularly that of Giovanni Bellini, and his own altarpiece of the *Feast of the Rose Garlands* (see p. 116), executed in Venice.

The earliest version of the subject (Plate 93) shows a horizontal composition with the Virgin and Child enthroned, three saints including St Catherine to their left, a music-making angel at each corner, and St Joseph reading behind heavy architecture in the background. The unbalanced composition draws attention to the fact that this arrangement was a combination of two themes, the Holy Family and the Mystical Marriage of St Catherine. Dürer quickly solved this dichotomy in a second drawing (w. vol. IV, pl. VI) by eliminating St Joseph and removing St Catherine from her prominent position at the Virgin's feet. The Virgin and Child are now enthroned high up above the saints and angels, who, greatly increased in number, are arranged symetrically on either side, in the manner of the *Feast of the Rose Garlands*.

Both these drawings, which may have been intended as *modelli* rather than compositional exercises, were carefully elaborated with shading, but in his studies thereafter Dürer confined himself to spirited outline sketches, which nevertheless contain a remarkable degree of characterization of each participant, so much so that where a chalk study of a head exists it becomes easy to identify it with the appropriate figure in the composition. The individuality of each participant was of great concern to the artist, and in the next version of the subject (w.838), he wrote in the names of the Old Testament figures (see p. 198). Both this drawing and the following study (Plate 94) are variations on the theme of the *Feast of the Rose Garlands*, with the saints and angels

arranged in a semicircular group around the enthroned Virgin and Child. In the second of these two studies (Plate 94) Dürer creates a greater sense of space by placing the throne further back and filling the foreground with animals and music-making angels. He still showed great uncertainty, however, in deciding which saints should be depicted. In both these sketches he included representatives of the ancestors and kinsmen of Christ, but in the earlier version (see p. 198) he increased the number of saints to fifteen, while the later one (Plate 94) shows a reduction to ten.

Unlike the two very first drawings of this theme, both of which remained unfinished, these two compositional sketches show the introduction of a donatrix, who kneels at the Virgin's feet on the lowest step of the throne. It has been plausibly suggested that this figure might be Pirckheimer's sister, who was a friend of the artist's, and that the painting might have been intended for her convent in Nuremberg, of which she was abbess.

Dürer was not, however, satisfied with this solution, and in two further studies (w.855 and 856) (see p. 199), one of which is dated 1522, he radically altered the composition by changing the 'horizontal' format into a vertical one. The donatrix was omitted, and the saints, now arranged in a circular group around the Virgin and Child, were reduced in number from ten to eight. On these two drawings the inscriptions refer to the colours of the drapery and not, as previously, to the identity of the Saints. At this stage the project was abandoned, possibly because the rapidly changing religious situation in Germany would have frowned heavily on such a Catholic altarpiece. But there is good reason to believe that the two large panels of the *Four Apostles*, which would have been in scale with the later, upright version of the composition, were originally intended as the wings of the altarpiece (see note to Plate 101).

LEFT: *Virgin and Child with Fifteen Saints and Angels* (w.838). Pen and brown ink, about 1521. 312 × 445mm. Paris, Louvre

RIGHT: *Virgin and Child with Eight Saints and Angels* (w.855). Pen and brown ink, 1522. 402 × 308mm. Bayonne, Musée Bonnat

FAR RIGHT: *Virgin and Child with Eight Saints and Angels* (w.856). Pen and brown ink, about 1522. 262 × 228mm. Bayonne, Musée Bonnat

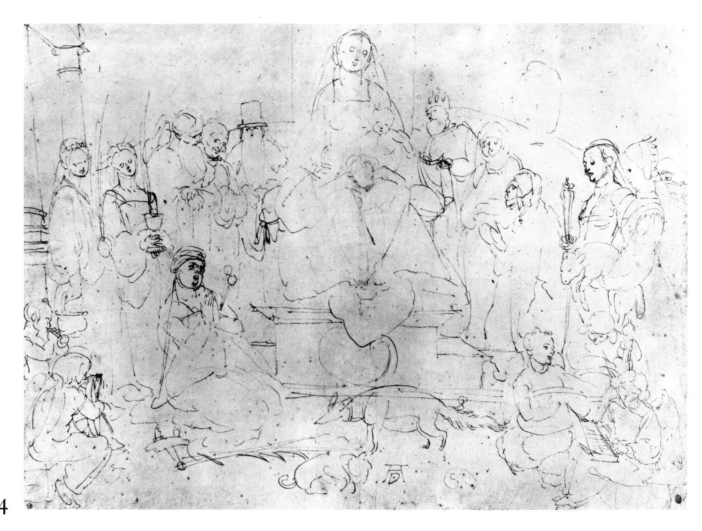

94

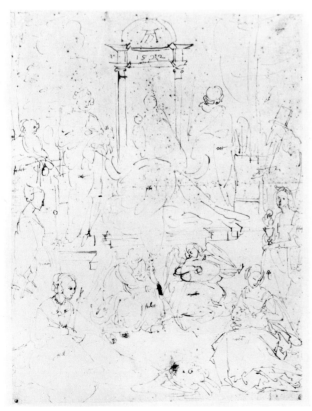

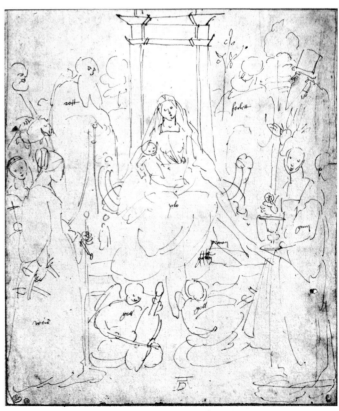

95

St Apollonia

w.846 l.65 t.853 p.768
Black chalk on green prepared paper. 414 × 288mm.
Signed and dated 1521
Provenance: J. C. Robinson. *Berlin, Kupferstichkabinett*

THIS DRAWING is a preparatory study for the figure of *St Apollonia* in the never-executed *Sacra Conversazione*, on which Dürer was carrying out the preliminary work in 1521 (see notes to Plates 93 and 94). The figure of the saint as shown in this drawing can be recognized in two of the 'horizontal' compositional studies (Plates 94 and drawing on p. 198), just behind St Agnes on the extreme right hand side. (She was omitted from the later, upright versions.) Even though the artist had not settled the arrangement of his composition at this stage, he was already studying some of the details, such as the heads of various saints (w.845–848) and the fall of the drapery over the knees (w.840–844), in a number of large-scale chalk drawings on prepared paper, similar to the present sheet, which was probably drawn from the life. In the last 'horizontal' compositional sketch (Plate 94), Dürer afterwards worked over three of the heads of saints, including that of St Apollonia, giving them greater characterization, obviously with these life studies beside him.

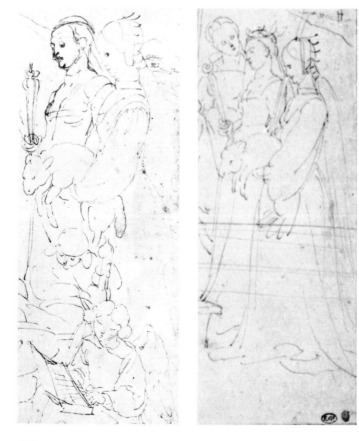

LEFT: Detail of *Virgin and Child with Ten Saints and Angels* (see Plate 94)

RIGHT: Detail of *Virgin and Child with Fifteen Saints and Angels* (see page 198)

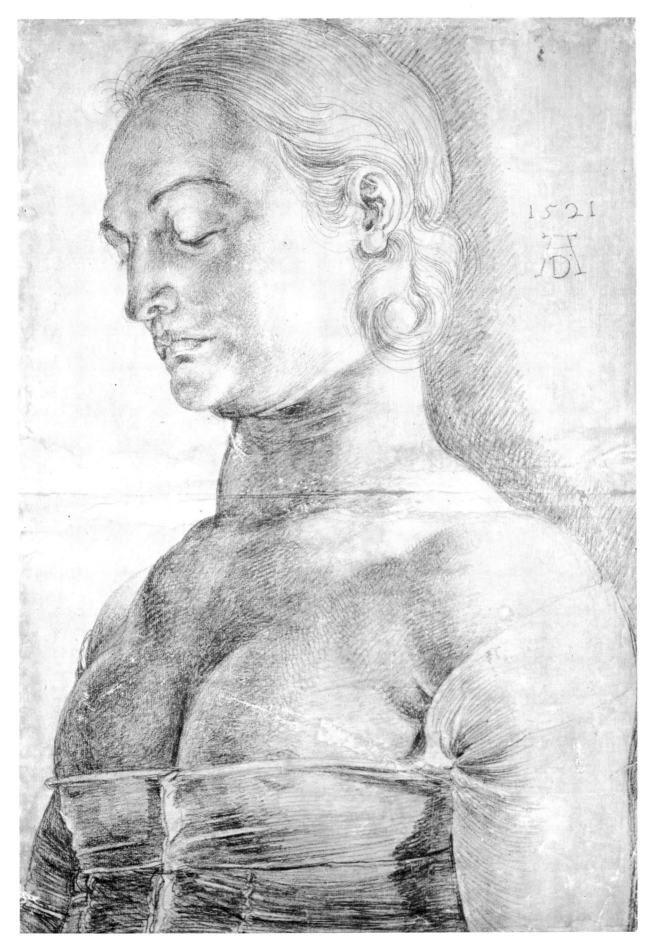

Design for a Throne for Cardinal Lang von Wellenburg, Archbishop of Salzburg

W.920 L.859 T.874 P.1560
Pen and ink with brown and pink wash. 287 × 170mm.
Inscribed: *Ann meinen genegdigsten hern von salburg*; signed and dated 1521
Brunswick, Herzog Anton Ulrich Museum

DÜRER would have had the opportunity of meeting Cardinal Lang, who came from a distinguished Augsburg family, for the first time at the Diet in Augsburg in 1518. Lang later visited Nuremberg on two occasions, at the end of 1521, and a year later. Probably at the same time as the present drawing, or during the Diet of 1518, Dürer made a portrait drawing of the Cardinal (W.911), now in the Albertina, in a style suggesting he had a woodcut in mind. The present drawing was made on the Cardinal's first visit to Nuremberg. Such a decorative design was out of character with Dürer's work after his return from the Netherlands and was probably the result of a wish to please the Cardinal, who had been private secretary to Maximilian and to Frederick III before him and was one of the keenest patrons of the arts at the Emperor's court. The same spirit can be seen in the woodcut of the *Triumphal Procession of the Emperor Maximilian* (B.139), executed in the following year, and when designing the *baldacchino* in this work Dürer must have recalled his drawing for Cardinal Lang's throne, with which it bears a close similarity.

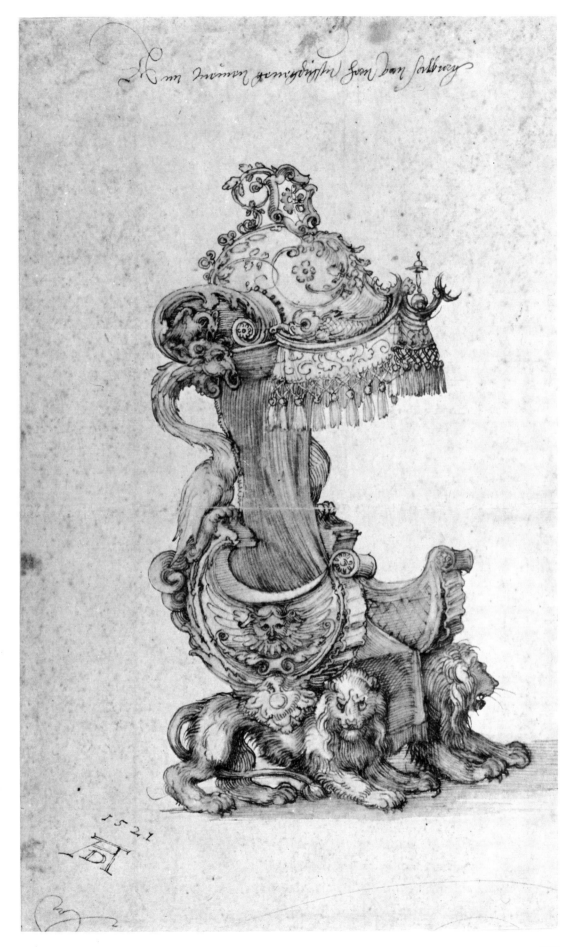

The Elector Frederick the Wise

W.897 L.387 T.926 P.1021
Silver point over charcoal. 177 × 138mm. (reproduced original size)
Provenance: Sir T. Lawrence; Armand; Valton. *Paris, École des Beaux-Arts*

THE ELECTOR visited Nuremberg in the winter of 1522/3, when Dürer presumably
made this drawing from the life. The unusual combination of silver point over charcoal
suggests that Dürer used charcoal to sketch the sitter, and then completed the drawing
in silver point with a high degree of refinement and detail in the studio afterwards. The
drawing was made as a preparatory study for the engraved portrait (B.104) finished in
the following year. But in transferring the design on to the copperplate, Dürer made a
number of subtle changes. In the drawing the Elector exhibits considerable liveliness of
spirit, even though he has a large fleshy face. The print, however, shows a heavier face;
the jaw juts out further, giving the sitter a stubborn, sensual appearance, and the
mouth is harder, while the casual wisp of hair which fell below the cap in the drawing
is banished. Carried away by his virtuoso handling of the burin, Dürer has developed
the curls of the beard into an elaborate pattern reminiscent of Leonardo's drawings of
waves. For the warmth of direct contact in the drawing, he has substituted an image of
cold power.

The Elector Frederick the Wise.
Engraving, 1524. 193 × 127mm.

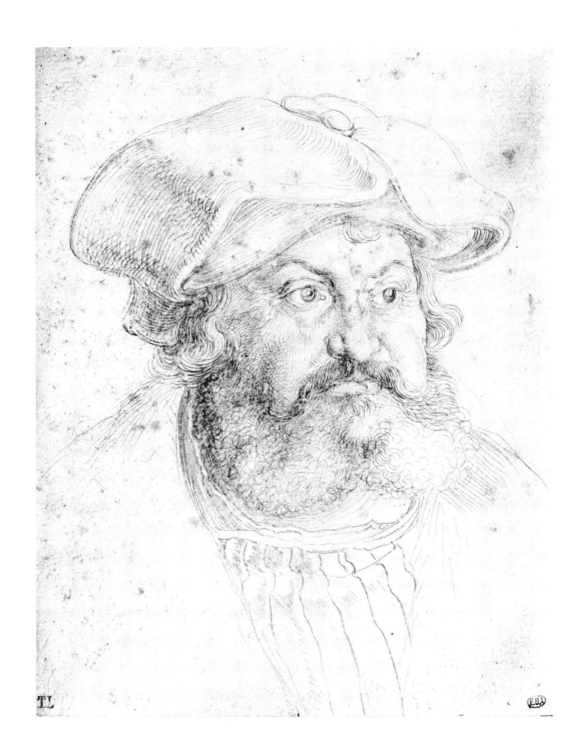

Self-portrait as the Man of Sorrows

W.886 L.131 T.894 P.635
Metal point with some white body-colour on green prepared paper. 408 × 290mm.
Signed and dated 1522
Provenance: Lefevre; Grünling. *Formerly Bremen, Kunsthalle*

EXECUTED a year after his return from the Netherlands, his health already impaired by
the fever he caught on his visit to Zeeland, Dürer represented himself in this highly
finished drawing as Christ as the Man of Sorrows, holding a whip and a scourge. His
face bears an expression of deep spiritual anguish and his body is in a state of physical
emaciation. Though the emotion was undoubtedly heightened on this occasion by his
self-identification with Christ's sufferings, the mood of this drawing reflects the
increasingly spiritual and withdrawn existence which he led during his last years. The
drawing was used for the painting, probably executed in the following year, now at
Weissenstein Castle, Pommersfelden.

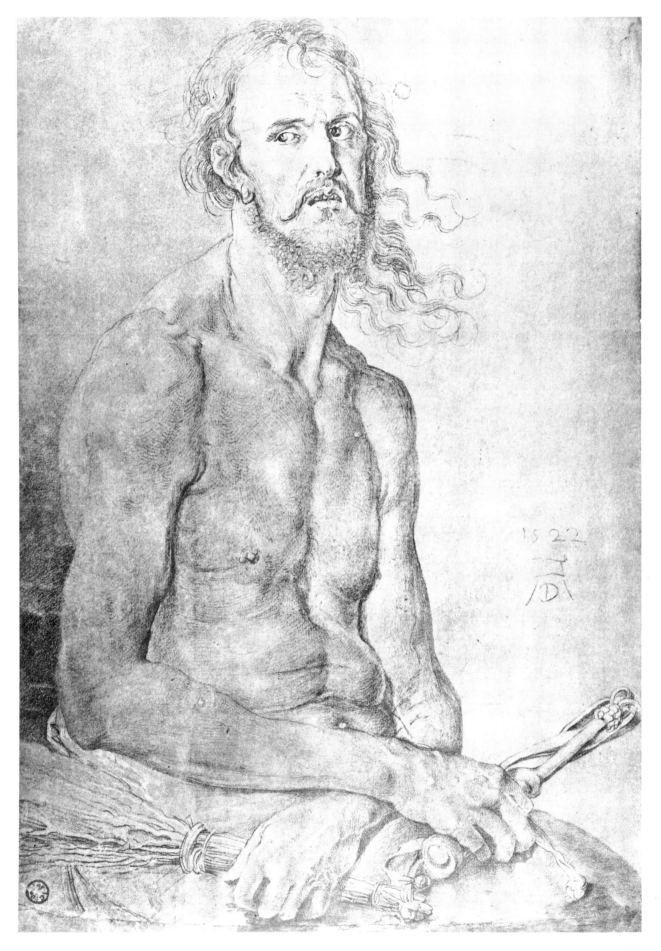

The Artist's Coat of Arms

W.941 T.917 P.1509
Charcoal. 165 × 136mm. (reproduced original size)
Signed and dated 1500 very faintly by another hand
Provenance: Sloane. *London, British Museum*

A RAPID PREPARATORY SKETCH for the woodcut of *Dürer's Arms* (B.160), executed in
1523. The name of the small town in Hungary, Atjas, where Dürer's father was born,
appears to be connected with the Hungarian word for door, hence *Tür* or *Dür* in
German, which accounts for the family name as well as the inclusion of a door in the
artist's arms.

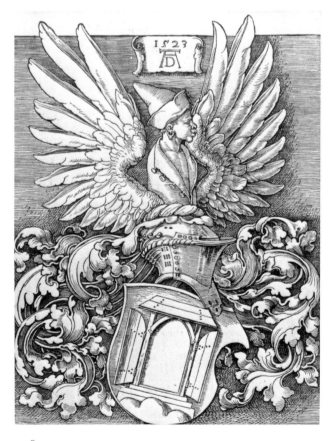

Dürer's Arms. Woodcut, 1523.
355 × 266mm.

An Apostle

w.878 l.580 t.906 p.843
Metal point, heightened with white, on green prepared paper. 318 × 213 mm.
Signed and dated 1523
Vienna, Albertina

THIS DRAWING was originally made as a preparatory study for the engraving of *St Philip* (B.46), completed in 1523, but not issued until three years later, when, as can be seen, the artist changed the final '3' of the date into a '6'. Ever since 1514, when he produced *St Thomas* (B.48) and *St Paul* (B.50), Dürer had worked spasmodically on a series of engraved Apostles, which he never succeeded in completing. In the same year as the present drawing, he issued another pair of engravings, *St Bartholomew* (B.47) and *St Simon* (B.49), and Panofsky has suggested that St Philip was meant to be accompanied by a print of *St James the Less*. The latter was never executed, but the drawing of an Apostle (w.877) in the École des Beaux-Arts, Paris, was probably intended as the preparatory study.

A characteristic of Dürer's preparatory drawings for his late prints is that they are much larger than the works for which they were intended—in this case the figure of St Philip is three times as large in the drawing as in the engraving. (The same phenomenon is apparent in the large-scale studies (w.858–869) in preparation for the unfinished engraving of the Crucifixion.) Possibly the monumentality of the figure in this drawing was the reason which determined the artist to use it again as the preparatory study for the figure in the right-hand panel of the *Four Apostles*, which as it now stands shows St Paul and St Mark. A technical examination of this panel reveals that originally it only contained the single figure of St Philip, which corresponded exactly with the present drawing. His cross-staff would have allowed no room for the

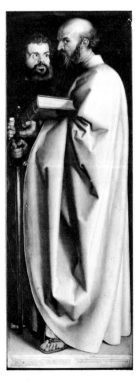
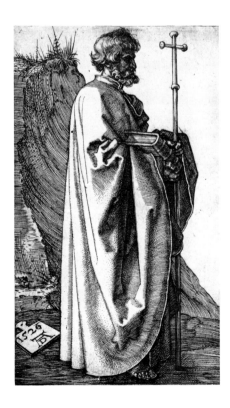

FAR LEFT: *The Four Apostles.* Oil on panel, 1526. Each 2150 × 760mm. Munich, Alte Pinakothek

LEFT: *St Philip.* Engraving, 1526. 121 × 75mm.

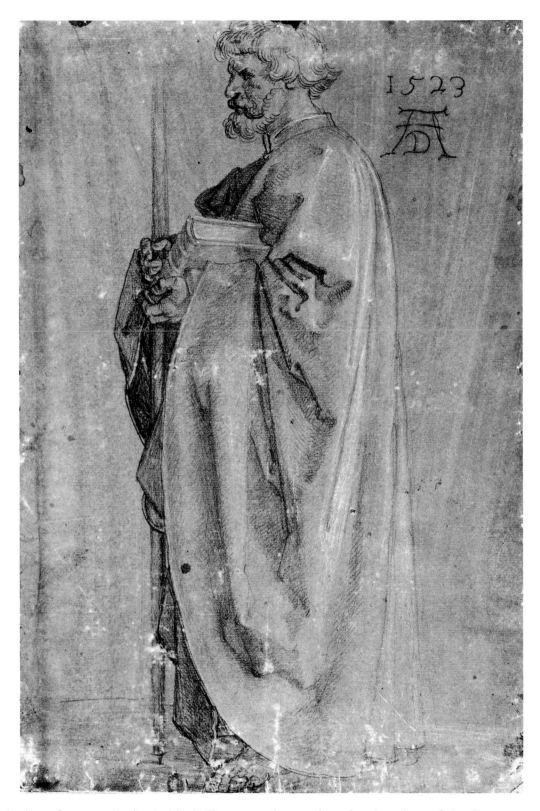

inclusion of a second saint behind. Two years later, when the altarpiece of the *Sacra Conversazione* was abandoned, the figure of St Philip was changed into St Paul, and the head and shoulders of St Mark were added in the background. St Philip's cross-staff was exchanged for St Paul's sword, and the position of the hands altered accordingly. Moreover the head of St Philip was transformed into the bald-headed, bearded type, usually associated with St Paul. To assist him with his task of repainting, Dürer made a large-scale study of the head (w.872), which is dated 1526. (See note to Plate 101.)

St John the Evangelist

w.873 l.368 t.950 p.826
Metal point, heightened with white, on green prepared paper. 405 × 253mm.
Signed and dated 1525
Provenance: Andreossy; Sir T. Lawrence; Russel. *Bayonne, Musée Bonnat*

STUDY FOR THE FIGURE of St John the Evangelist in the left-hand panel of the *Four Apostles* in the Alte Pinakothek, Munich. These very large panels were probably conceived as the wings to the altarpiece of the *Sacra Conversazione*, for which the artist had made a large number of drawings immediately after his return from the Netherlands (see notes to Plates 93 and 94).

The altarpiece was abandoned, probably in 1525 when Nuremberg opted for Luther and the Reformation. Left with one finished panel (see note to previous Plate), Dürer decided to complete the second, at the same time expanding the number of Apostles in each panel from one to two. In 1525 he therefore made the present drawing of St John, whose half-turned position suggests the presence of another figure beside him, and in the following year three large-scale studies of the heads of St Mark, St Peter and St Paul (w.870–872). The changes Dürer made to his original plan were entirely in accordance with the spirit of the times and his own beliefs. St Paul, the spiritual father of Protestantism, replaced St Philip in the right-hand panel, and the head of St Mark was added in the background. The left-hand panel contained the full-length figure of St John, Luther's favourite Evangelist (two years earlier Dürer had drawn the saint with the features of Luther (w.859) in one of his studies for the unfinished engraving of the *Crucifixion*), while St Peter's head was visible in the background. The calligrapher responsible for the long inscriptions at the bottom of the panels records that these four figures represented 'properly speaking, a sanguine, a choleric, a phlegmatic and a melancholic', indicating that the artist used the theory of the Four Temperaments to characterize the four men.

The two panels were finished in 1526, and in the same year he offered them to the city of Nuremberg to hang in the Town Hall. The gift was formally accepted in October 1526, and in exchange sums of money were presented to the artist, his wife and his servant. Unlike the cities of Venice and Antwerp, Nuremberg had shown little interest in Dürer and had not employed him on any commission. Nevertheless, as he stated in his letter, he wished the town to possess a 'memorial'.

As completed, the two panels recall the wings of Giovanni Bellini's *Frari Altarpiece*, which are similarly filled with four large figures of saints. But the result was the most austere and impressive High Renaissance work of Dürer's career. He confided to the reformer Philip Melanchthon, who was in Nuremberg at the time that he was working on the panels, that 'when I was young I craved variety and novelty; now, in my old age, I have begun to see the native countenance of nature and come to understand that this simplicity is the ultimate goal of art'. These two panels stand as a perfect expression of these beliefs.

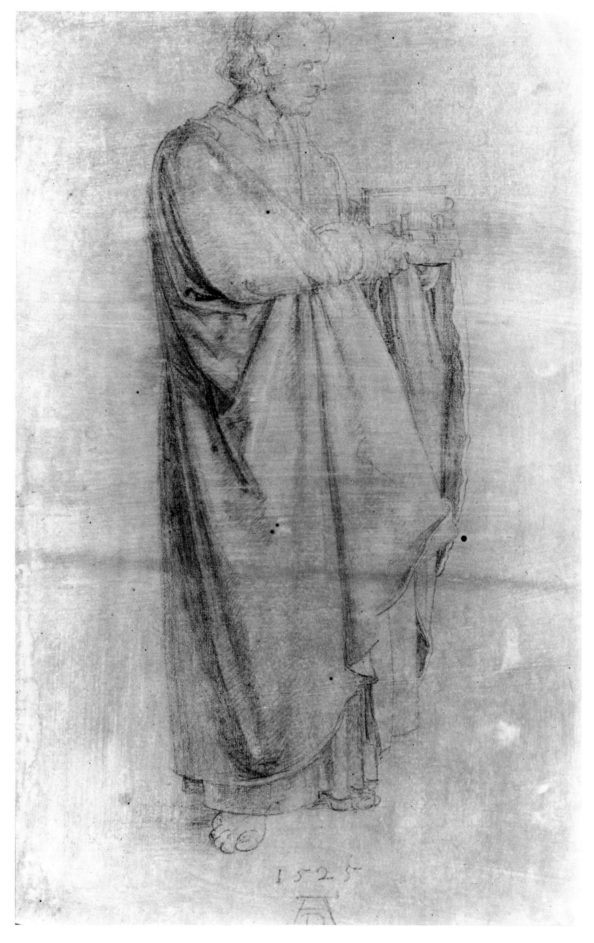

102

Vision in a Dream

W.944 L.423 T.947 P.1410
Pen and watercolour. 300 × 425mm.
Inscribed (see below), signed and dated 1525
Provenance: Pfaundler. *Vienna, Kunsthistorisches Museum*

BENEATH THE DRAWING, the artist wrote: 'In the night between Wednesday and
Thursday after Whitsunday [30, 31 May] 1525, I saw this appearance in my sleep—
how many great waters fell from heaven. The first struck the earth about 4 miles away
from me with terrific force and tremendous noise, and it broke up and drowned the
whole land. I was so sore afraid that I awoke from it. Then the other waters fell and as
they fell they were very powerful and there were many of them, some further away,
some nearer. And they came down from so great a height that they all seemed to fall
with an equal slowness. But when the first water that touched the earth had very nearly
reached it, it fell with such swiftness, with wind and roaring, and I was so sore afraid
that when I awoke my whole body trembled and for a long while I could not recover
myself. So when I arose in the morning I painted it above here as I saw it. God turn all
things to the best. Albrecht Dürer.'

 This dream occurred at a time when the agitation and excitement in Nuremberg over
the Reformation movement was at its most intense, and many people had come to
believe that a flood would destroy the world. Yet in spite of the visionary nature of his
dream, Dürer retained sufficient natural curiosity to give a very precise description
about the distance of the vision.

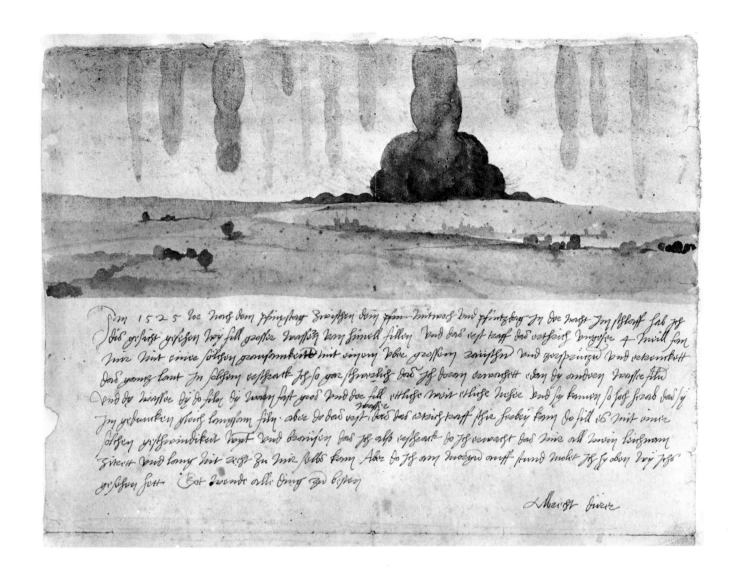

Jm 1525 Jor noch dem pfingstag zwischen dem ... mitwoch vnd pfintztag Jn der nacht Jm schloff hab Jch
dis gesicht gesehen wej fill grosse wasser von himel fillen vnd das erst traff das ertrich ungeuer 4 mill von
mir mit einer solchen grausamkeitt mit einem vbe grossen rauschen vnd zersprützen vnd ertrenkett
das gantz lant Jn solchem erschrack Jch so gar schrocklich das Jch doran erwachett ehe dj andren wasser fillen
vnd dj wasser dj do filen dj woren fast groß vnd der fill etliche weit etliche neher vnd sy komen so hoch herab das sj
Jn gedunken gleich longsam filen aber do das erst wasser das das ertrich traff schir hrbej kom do fill es mit einer
solchey geschwindikeit wint vnd brausen das Jch also erschrack do Jch erwacht das mir all mein lichnam
zittret vnd lang nit recht zu mir selbs kom Aber do Jch am morgen auf stund molt Jch sy oben bey Jch
gesehen hett · Got wende alle ding zu besten

Albrecht Dürer

103

Male Nudes

W.890 L.875 T.955 P.1175
Pen and black ink. 188 × 206mm.
Signed and dated 1526
Provenance: Endris; Jurié; Lanna. *Berlin, Kupferstichkabinett*

THIS DRAWING is a free copy of five figures from an anonymous fifteenth-century
Florentine engraving of the *Deluge*. Though Dürer's dream of the previous year
(Plate 102) may have stirred his interest in this print, his more immediate concern was
probably a rational desire to study various expressions of human fear, in connection
with the theoretical studies which now occupied so much of his time.

Anonymous Florentine: *The Deluge*. Engraving, fifteenth century. 270 × 407mm.

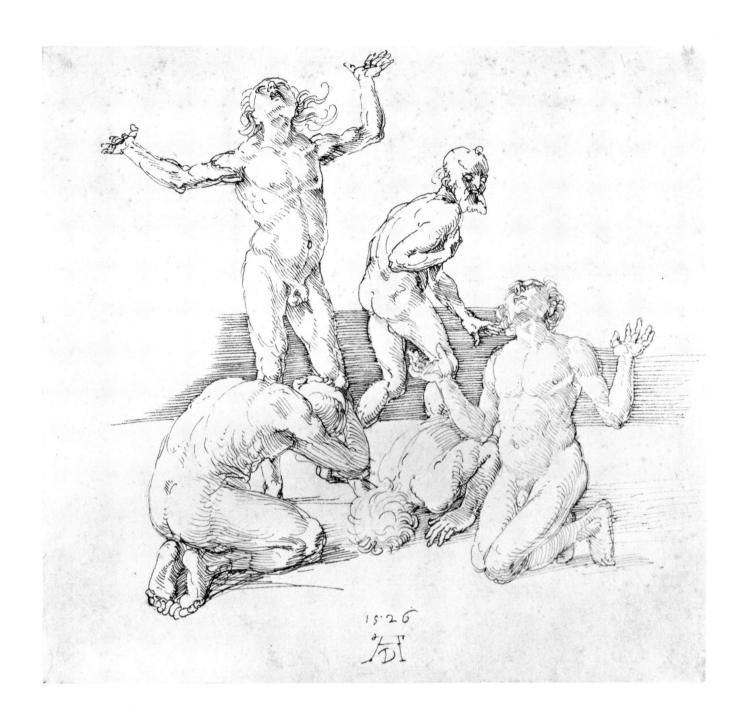

1526

The Annunciation

W.894 L.344 T.966 P.508
Pen and brown ink with watercolour. 288 × 211mm.
Signed and dated 1526
Provenance: Vivant-Denon; Barin; Reiset. *Chantilly, Musée Condé*

THIS DRAWING, both in the actual pen work and in the use of watercolour, has a decorative elegance markedly absent from the austerity of execution of Dürer's other late religious drawings. Instead of the bare room in which the *Last Supper* (w.889) was set, the Virgin is shown kneeling in an elegantly decorated room hung with tapestries. The mood is one of joy and vitality befitting the meaning of the angel's message.

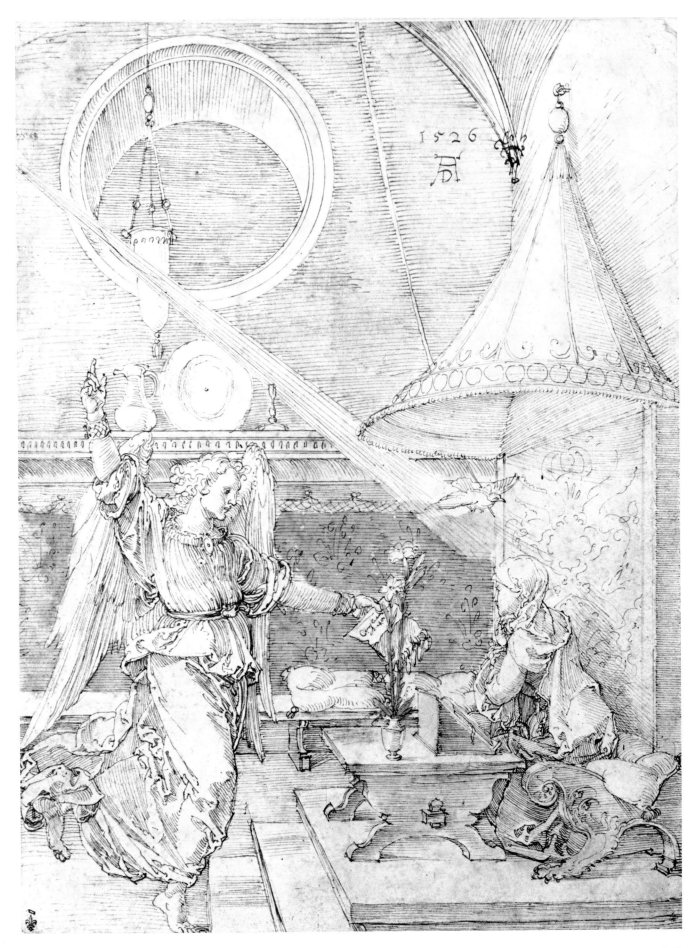

105

Landscape with Cliffs

W.942 L.876 T.967 P.1411
Pen and black ink. 213 × 202mm.
Signed by another hand
Milan, Ambrosiana

SINCE HIS RETURN from the Netherlands, Dürer had remained in his home town, and moreover had no desire to make landscape studies of actual scenery. The present drawing, probably done in the year before his death, remains unique among his last drawings. It is no record of things seen, and must be largely imaginary, though it has been suggested that it may contain a reminiscence of Riva on Lake Garda. The large circular fort at the foot of the cliffs indicates that the drawing was probably made in connection with the *Treatise on Fortification*, which was published in 1527. Compared with Dürer's feeling for nature in the earlier part of his career, this landscape is cold, austere and clinical, untempered by light or atmosphere.

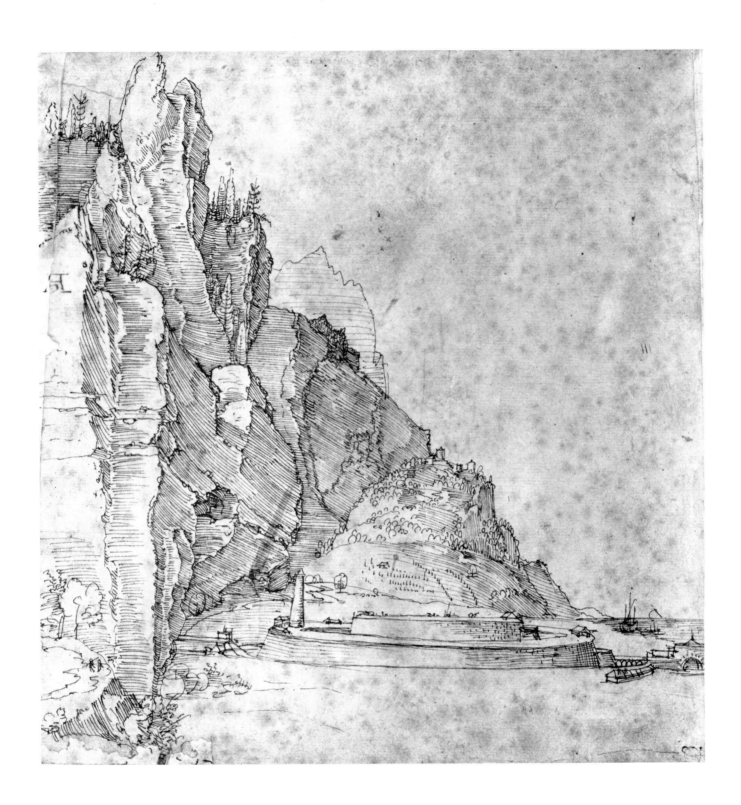

Ulrich Starck

W.919 L.296 T.977 P.1041
Black chalk. 410 × 296mm.
Signed and dated 1527
London, British Museum

MADE IN THE YEAR of his death, it must represent one of Dürer's last drawings. Ulrich
Starck (1484–1549) was a rich Nuremberg patrician, who was married to Katharina
Imhoff. A medal bearing Dürer's portrait of Starck was struck in the same year, and
though at first sight it might seem extremely unlikely that Dürer would have made such
a large and imposing charcoal portrait as a preparatory study for a coin, exactly the
same discrepancy in scale between preparatory drawing and final work is to be found in
his chalk studies (w.858–869) for the unfinished engraving of the *Crucifixion* of the
same period. Dürer had introduced the strict profile portrait for the first time in his
study of Cardinal Albrecht of Brandenburg (w.896) in 1523. It offers one of the basic
views of a human figure and, as well as using it in a few later portraits such as this one,
Dürer made it the underlying design of his two panels of the *Four Apostles* (see p. 210).

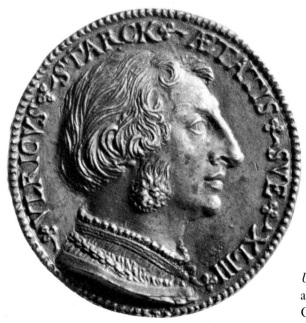

Ulrich Starck. Medal, 1527. 28mm.
across (enlarged). Nuremberg,
Germanisches Nationalmuseum

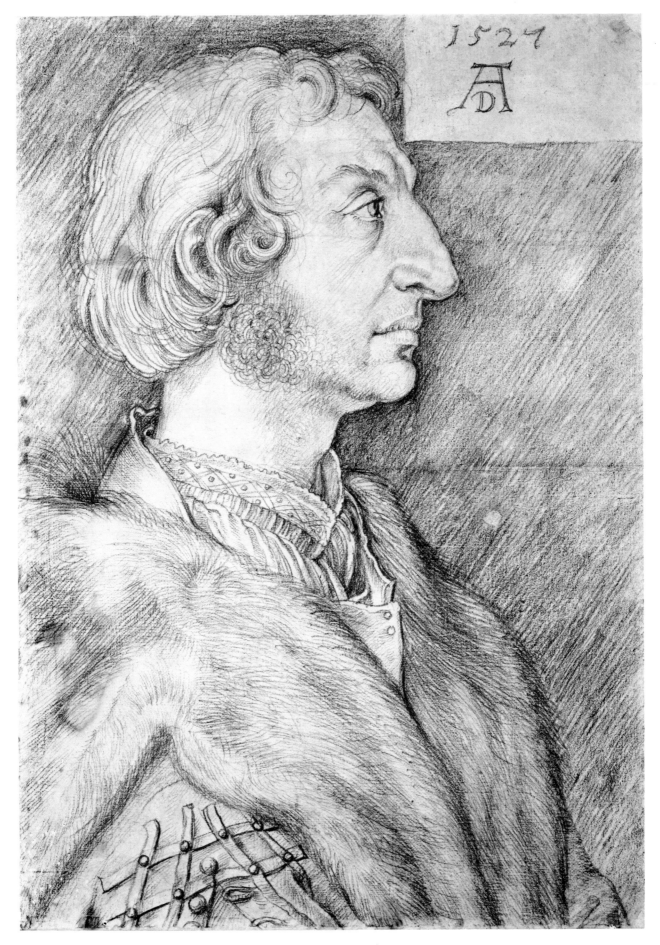

223

Selected literature

Drawings

F. LIPPMANN, *Zeichnungen von Albrecht Dürer in Nachbildungen*, Berlin, 1883–1929 (7 vols.)

F. WINKLER, *Die Zeichnungen Albrecht Dürers*, Berlin, 1936–9 (4 vols.)

K. GIEHLOW, *Kaiser Maximilians I. Gebetbuch*, Vienna, 1907

R. BRUCK, *Das Skizzenbuch von Albrecht Dürer in der Königlichen Öffentlichen Bibliothek zu Dresden*, Strasbourg, 1905

Prints

A. BARTSCH, *Le Peintre-graveur*, Vienna, 1808, vol. VII

General

M. THAUSING, *Albert Dürer, His Life and Works*, London, 1882 (2 vols.) (old-fashioned but informative)

W. M. CONWAY, *Literary Remains of Albrecht Dürer*, Cambridge, 1889

H. WÖLFFLIN, *The Art of Albrecht Dürer*, 1st English edn., Phaidon, London and New York, 1971 (classic interpretation of the artist, first published in Munich, 1905)

H. TIETZE and E. TIETZE-CONRAT, *Kritisches Verzeichnis der Werke Albrecht Dürers* (3 vols.), Augsburg, 1928, Basle, 1937 and Leipzig, 1938

DÜRER: *Des Meisters Gemälde, Kupferstiche und Holzschnitte* (Klassiker der Kunst), 4th edn. (ed. F. Winkler) (reproduces all paintings and prints)

E. PANOFSKY, *The Life and Art of Albrecht Dürer* (2 vols.), Princeton, 1943 (exhaustive monograph with handlist of works)

M. LEVEY, *Dürer*, Weidenfeld and Nicholson, London, 1964 (excellent introduction to the artist)

Index

A. Drawings
(arranged according to Winkler)

B. Engravings, etchings and drypoints
(arranged according to Bartsch)

C. Woodcuts
(arranged according to Bartsch)

D. Paintings

Four Apostles (1526) (Munich), 33, 34, 198, 210,
212, 222
St Jerome in Meditation (1521) (Lisbon), 19, 26,
28, 32, 186, 188, 190, 191
Self-portrait (1493) (Paris), 50
Self-portrait as the Man of Sorrows (1523)
(Pommersfelden), 206
Emperor Maximilian (1519) (Nuremberg), 168
Emperor Maximilian (1519) (Vienna), 168

E. Writings

Family Chronicle, 20, 21, 52, 152
Netherlands Journal (1520–1), 16, 18, 21, 25, 26,
27, 28, 146, 172, 173, 174, 178, 182, 184, 186,
192, 194
Teaching of Measurement (1525), 38
Treatise on Fortification (1527), 34, 38, 220
Four Books on Human Proportion (1528), 15, 37,
39, 148

F. General

Aachen, 25, 26, 173; *Plate 76*
Albrecht of Brandenburg, Cardinal, 25
Andreossy coll., 102, 112, 118, 128, 152, 154, 178,
212
Antwerp, 22, 26, 28, 35, 172, 173, 176, 182, 184,
186, 212; *Plates 75, 79*
Aristophanes, 22
Armand coll., 204
Arundel, Earl of, 163
Atjas, 208
Augsburg, 22, 25, 34, 132, 159, 168, 202

Baldinucci, 80
Baldung, Hans, 159
Bamberg, 25
Barbari, Jacopo de', 35, 36, 100
Barin coll., 218
Basle, 23
Basle, R. von Hirsch coll., 194; *Plate 91*
Bayonne, Musée Bonnat, 48, 94, 130, 196, 212;
Plates 5, 30, 51, 94, 101
Béhague coll., 124
Bellini, Giovanni, 19, 24, 62, 114, 120, 197, 212
Bergen op Zoom, 26
Berlin, Kupferstichkabinett, 46, 68, 86, 88, 118,
120, 152, 154, 174, 200, 216; *Plates 4, 17, 26, 27,
44, 45, 63, 64, 77, 95, 103*
Besançon, Musée des Beaux-Arts, 159
Bianconi coll., 122
Blasius coll., 112, 120
Böhm coll., 120
Bologna, 36, 122
Bombelli, Tommaso, 182
Bonnat coll., 178
Boppard, 27, 175
Bouverie coll., 104
Bramante, Donato, 36
Brandano, Joano, 26, 182
Bremen, Kunsthalle; 44, 66, 206; *Plates 2, 16, 98*

Brophy, Brigid, 22
Brunswick, Herzog Anton Ulrich Museum, 202;
Plate 96
Brussels, 26, 178

Cambodia, King of, 156
Camerarius, 15, 21
Carpaccio, 136
Catharine, Moorish Woman, 26, 182; *Plate 83*
Cembra, 62
Chantilly, Musée Condé, 128, 172, 173, 196, 218;
Plates 50, 75, 76, 93, 104
Charles V, 25, 26, 173
Cima da Conegliano, 24, 62
Cock, H., 184
Colman, Koloman, 34, 162
Colmar, 23, 29, 44, 46
Cologne, 22, 175
Cranach, Lucas, 159
Crozat coll., 45, 112

Daucher, Adolf, 34, 132
Defer-Dumesnil coll., 88
Delacroix, 27
Dieppe, 26
Donatello, 22
Dresden, Sächsische Landesbibliothek, 150;
Plate 62
Dürer, Agnes (née Frey), 21, 22, 50, 52, 88, 152,
175, 212; *Plates 7, 78*
Dürer, Albrecht, the Elder, 25, 41, 52, 152, 208
Dürer, Barbara (née Holper), 21, 152; *Plate 63*
Dyce coll., 138

Endris coll., 216
Erasmus, 22, 26, 146, 178; *Plate 81*
Esdaile, W., coll., 46
Euclid, 36
Eyck, Jan van, 174, 194

Fernandez, Rodrigo, 28, 182, 186
Ferrarese, Anon. 15th century engraver, 72
Fink, F. W., coll., 194
Firmin-Didot coll., 152, 174
Florence, Uffizi, 182, 192; *Plates 83, 89, 90*
Florentine, Anon. 15th century engraver, 216
Francis I, 22
Franck, von, coll., 124
Frankfurt, 124
Frankfurt, Städelsches Kunstinstitut, 194;
Plate 92
Frederick the Wise, 105, 204; *Plate 97*
Frederick III, 202
Frey, Hans, 34, 52, 68, 75
Fries coll., 122
Fugger, Jacob, the Rich, 25
Fugger family, 34, 132

Galichon coll., 46
Garda, Lake, 220
Geuder, Andreas and Martin, 130
Ghent, 26, 174, 175